BLUEPRINTS OF FASHION

Home Sewing Patterns of the 1950s

Laboissonniere

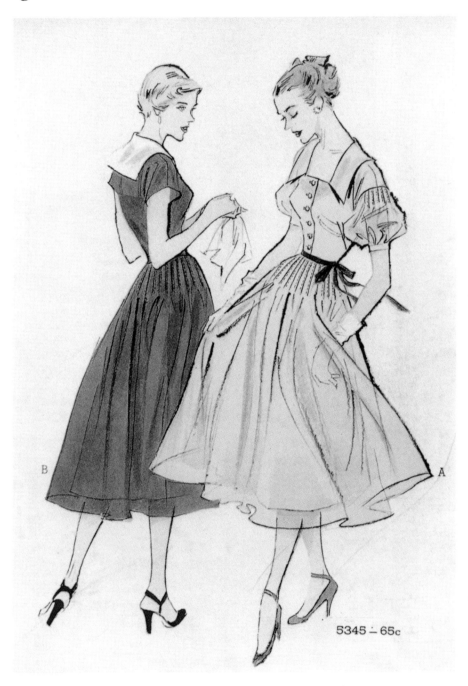

B A

5345 - 65c

Schiffer Publishing Ltd ®

4880 Lower Valley Road, Atglen, PA 19310 USA

Dedication

For Betty Williams
Without her ground breaking discoveries
and continuous encouragement this series
would never have been possible.

Cover photo: *Courtesy of the McCall Pattern Company.*

Copyright © 1999 by Wade Laboissonniere
Library of Congress Control Number: 99-63781

All rights reserved. No part of this work may be reproduced or used in any form or by any means—graphic, electronic, or mechanical, including photocopying or information storage and retrieval systems—without written permission from the publisher.

The scanning, uploading and distribution of this book or any part thereof via the Internet or via any other means without the permission of the publisher is illegal and punishable by law. Please purchase only authorized editions and do not participate in or encourage the electronic piracy of copyrighted materials.

"Schiffer," "Schiffer Publishing Ltd. & Design," and the "Design of pen and inkwell" are registered trademarks of Schiffer Publishing Ltd.

Designed by "Sue"

Type set in Korinna BT/GoudyOlSt BT

ISBN: 978-0-7643-0919-9
Printed in the United States of America

Schiffer Books are available at special discounts for bulk purchases for sales promotions or premiums. Special editions, including personalized covers, corporate imprints, and excerpts can be created in large quantities for special needs. For more information contact the publisher:

Published by Schiffer Publishing Ltd.
4880 Lower Valley Road
Atglen, PA 19310
Phone: (610) 593-1777; Fax: (610) 593-2002
E-mail: Info@schifferbooks.com

For the largest selection of fine reference books on this and related subjects, please visit our website at
www.schifferbooks.com
We are always looking for people to write books on new and related subjects. If you have an idea for a book please contact us at the above address.

This book may be purchased from the publisher.
Include $5.00 for shipping.
Please try your bookstore first.
You may write for a free catalog.

In Europe, Schiffer books are distributed by
Bushwood Books
6 Marksbury Ave.
Kew Gardens
Surrey TW9 4JF England
Phone: 44 (0) 20 8392 8585; Fax: 44 (0) 20 8392 9876
E-mail: info@bushwoodbooks.co.uk
Website: www.bushwoodbooks.co.uk

Contents

Acknowledgements

The Blueprints Of Fashion Series has been made possible through the generosity of many.

I am deeply grateful to the pattern companies, specifically, Butterick Company, The McCall Pattern Company, and Simplicity Pattern Company, for allowing me to reproduce their illustrations and patterns. This series would not have been possible without their assistance.

I would also like to thank the following people who assisted me with their wisdom and friendship: Sherry Onna Handlin of the Butterick Archives; Maris Heller and John Corins of the Fashion Institute of Technology Special Collections; Lynn Macoun of The McCall Pattern Company; Deidre Donohue and Stephane Houy-Towner of the Irene Lewisohn Costume Reference Library at The Metropolitan Museum of Art; Alicia von Rhein of Simplicity Pattern Company; Daniel W. Pugh; Charla Welcome; and my editor, Donna Baker.

Finally, special thanks to my family for never doubting me and as always to my long-time companion, Jack.

Preface

The Blueprints Of Fashion Series could not have been possible without the preliminary work of Betty Williams. Her discoveries and documentation laid the foundation for those interested in researching the commercial sewing pattern industry. It is through her foresight and fortitude that these fragile documents have gained their rightful place in the world of costume history.

Betty's attempt at dating patterns led to her work deciphering the pattern companies' numbering system: "It did seem to me that, since patterns needed to be dated by first appearance in the catalogue, any dating method should be based on how pattern companies put their products on the market...What amounts to an identification index can be created by combining two business factors; first, the pattern numbering system used by each company, second, the graphic envelope style used by each company."[1] Her discoveries are still valid today and are the basis for the dating appendices included with this series.

Another side to this remarkable woman was her ability to include, inspire, and encourage anyone remotely interested in this subject. She was not the leader of a selective club, nor did she hoard information, she embraced and gave openly to everyone. Her example is the spirit in which I write the Blueprints Of Fashion Series.

Introduction

The importance of commercial sewing patterns as resource material for those interested in fashion and costume history is undeniable. These distilled adaptations of the fashion industry's creations contain an amazing amount of information about the styles issued for the masses. Further, the pattern illustrations include a wealth of information in their details—seams, darts, and other design features are shown in minutia, which gives the researcher/recreator much more information than a typical fashion sketch. Originally, all these construction details helped seamstresses understand how each pattern style was put together and they are still relevant today.

This volume begins with a brief history of the pattern industry leading up to and focusing on the fashion styles of the 1950s. After World War II, women returned to their roles as homemakers, wives, and mothers. They were spending their days at home instead of in the factory and that contributed to the home sewing industry's continued growth during this period. Surveys published in the early 1950s indicated that the majority of home sewers were housewives who made between twenty-one and twenty-seven garments a year, with dresses being the largest single item.[2]

During this period, women's clothing no longer had to be "functional" or conserve raw materials as it did during the war. Further, lifestyles were becoming more casual and clothing reflected these changes. The prosperity of this era is also apparent in the frivolity of the designs. Sewing for thrift and economy, which was a necessity during the previous two decades, was quickly becoming obsolete because of the booming economy and well priced ready-to-wear clothing. A 1954 article about home sewing noted that: "For millions and millions of women the utilitarian and economic aspects of their work at the sewing machine is purely secondary...To them, it is not a question of price but a means of self-expression."[3] Home sewing was no longer considered a household chore, it was quickly becoming the American women's number one hobby for relaxation.

The reemergence of Paris couture as *the* style arbiter was also an important factor in propelling the industry during this period. Designer pattern lines made tremendous gains because only a select group of women had the resources to *purchase* original couture garments, while anyone with sewing ability could—for a fraction of the cost—buy a licensed couturier sewing pattern.

Further, post-war consumers reaped the benefits of the new technologies that were developed during the war, many of which were valuable to the home sewing industry. These advances included improvements to home sewing machines (most notably the zig-zag machine), numerous man-made fibers, and improved fabric finishes that repelled water and prevented shrinkage and wrinkles.

Additionally, consumers showed increased interest in "do-it-yourself" projects, which many companies capitalized on by expanding their craft, do-it-yourself, and decorator lines as well as their publications geared to these hobby enthusiasts. One journal article remarked: "In this machine-dominated world, the 'handmade' has become valuable, and pride of craftsmanship has passed from the skilled artisan into the hands of the talented amateur."[4]

In this volume, I have included examples of what was available in the pattern catalogs from most companies in existence during the decade. I have not, however, commented on the fashion trends. I leave it to readers to judge for themselves and refer to a fashion history book for further information. Each caption included with the illustrations contains the original date of publication, the pattern manufacturer, and the collection in which it is currently held. Hopefully, this information will help place these styles in context with the larger trends of the industry.

Chapter 1
Industry Beginnings and Innovations

Pattern Company Beginnings

It is a womanly art to sew, [and] this accomplishment has been made easier [through] the modern sewing machine, the tempting new fabrics, and most significant of all, the marvelous modern pattern.[5]

Commercial sewing patterns are remarkable tools—like architectural drawings that guide in the building of structures, sewing patterns guide home sewers in the assemblage of garments. Without these blueprints the construction of either would be left to happenstance.

The development of the modern sewing pattern is directly related to the invention of the sewing machine. Prior to the latter's invention, clothing was sewn by hand and patterns were copied from existing garments, then altered until the desired fit was achieved. The process was laborious. The new sewing machine and pattern made the process of sewing dramatically easier, and these "modern" devices from the mid-1800s eventually affected the way people dressed by establishing both the ready-to-wear and home sewing industries. Further, these early patterns gave those of moderate means the ability to create clothing that was up-to-date with the fashionable mode. Before this, trend setting fashions were only associated with the wealthy.

In the 1850s, patterns began appearing in ladies publications like *Frank Leslie's Gazette of Fashions* and *Godey's Lady's Book*. These early patterns were one size and each seamstress had to scale-up and alter it to meet her needs. This was all changed in 1863 by Ebenezer Butterick's development of the first mass-produced, sized tissue paper patterns. He is responsible for the creation of the pattern industry as we know it today.

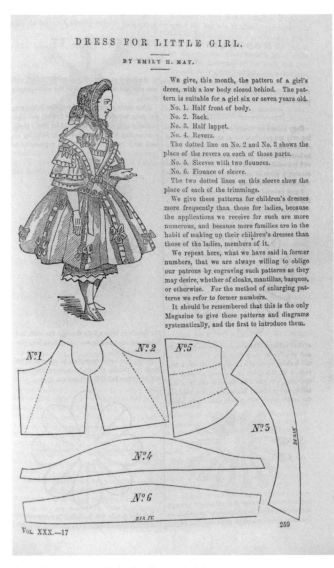

An early pattern published in *Peterson's Magazine* in 1856. *Courtesy of the Irene Lewisohn Costume Reference Library, Metropolitan Museum of Art.*

Early patterns only provided cutting outlines of the pieces needed to make the pictured garment, and although they appear cryptic in relation to later pattern developments, they guided seamstresses who were accustomed to sewing without any technical assistance. This new tissue-paper pattern made creating fashionable clothing at home more accessible and enjoyable by eliminating guesswork and simplifying the process.

The first pattern styles available were for men's and boy's clothing. But, within a few years (about 1868), Butterick's pattern line included women's garments and had expanded to include five hundred styles in five different sizes, retailing at $1.00 each.[6]

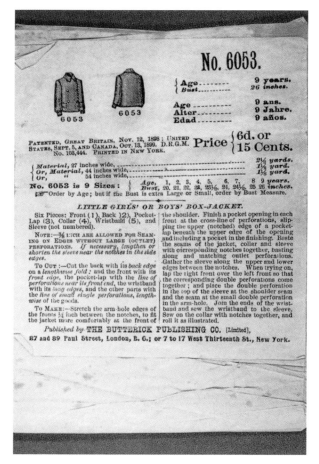

By 1868, the pattern packaging consisted of tissue pieces folded together. The label glued to the outside piece contained an illustration of the garment, simple directions, price and measurements.

"For now you may select from a thousand alluring designs, [go] to your local store, and for an amazingly small sum, buy a pattern, [so] accurate in its lines and so complete in its detailed directions that, [you] can quickly create a [garment] at a fraction of its cost when purchased ready made."[7]

Butterick's Monopoly

These early years saw the formation of numerous pattern companies. However, Butterick dominated the industry because they used exclusive contracts, which prevented merchants from selling pattern lines made by other companies in their establishments. This exclusivity clause eliminated all competition.

Butterick's domination was further compounded by their acquisition of three other pattern lines early in the twentieth century—Standard Fashion Company, New Idea Pattern Company, and Banner Fashion Company. These subsidiary lines (all with their own exclusive contracts) were put into the town's "other" emporiums, which gave Butterick controlling interest in the majority of the pattern outlets. So, if a town had three or four outlets, all of them could conceivably be controlled by Butterick.

Butterick's domination and dictatorship caused much ill-will within the industry and with pattern merchants. As a result, Butterick's exclusive contracts were challenged by pattern merchants as restraint of trade, under the 1914 Clayton Act. Although Butterick contested this up to the Supreme Court, they eventually did away with their exclusivity clauses. This gave competing pattern lines an opportunity to broaden their market share. Some of Butterick's competitor's during this time included:

- Excella Pattern Company
- Home Pattern Company
- May Manton Pattern Company
- McCall Pattern Company
- Peerless
- Pictorial Review Pattern Company

Another company, Vogue Pattern Service, had been in business since 1899, but was not considered serious competition at this time because of their limited distribution.

Product Development

As we look at the "new" products introduced each year, few are really unique. Most products are variations on existing products.[8]

With the exception of a few major innovations, the above holds true for the pattern industry, as their product has basically been the same since its introduction in the mid-1800s. However, the manufacture and distribution has changed dramatically because of twentieth century technical advances.

A few merchandising methods developed in the early years have remained part of the product merchandising still used by pattern companies today. Specifically, the use of in-store counter catalogs, giveaway pamphlets, and pattern packaging have all remained consistent over the time line of this industry. Pattern magazines have been used successfully to sell patterns since the 1860s—some early examples include *Mme. Demorest's Mirror of Fashion*, Butterick's *Metropolitan Report*, and McCall's *The Queen*.

Patents

Patent, n. A grant of right to exclude others from making, using or selling one's invention and includes right to license others to make, use or sell it. ...[f]or seventeen years.[9]

The growth of the pattern industry increased the number of inventions and product innovations submitted for United States design patents. While the majority of these early innovations patented under the U.S. patent law are no longer applicable, they remain one of the few existing records of the industry's history.

Perforated Patterns

Before patterns were printed with construction details, this information was conveyed through perforations and notches cut into each pattern piece. The perforated markings differentiated the individual pattern pieces and indicated the construction details. Both types of markings were necessary for proper identification, layout, cutting, and assembly. The perforated pattern was slowly discontinued once McCall's patent for printed patterns expired in 1938.

Printed Patterns

These patterns, [take] all the element of risk out of dressmaking, because they set up guideposts that point the way to success by the shortest and most direct route.[10]

McCall Printed Patterns

All the indications [result] in an accuracy and clearness quite impossible with the old perforated system.[11]

McCall was the first to apply for a design patent for printed patterns in 1920. They were granted US Patent #1,387,723 in August of 1921, which expired in 1938. The important elements of their patent include:

• a printed outline of each pattern piece
• a tissue margin outside of each outline
• a tinted surface to unify each pattern piece and differentiate it from the margin
• transparent paper so that the printing may be seen from either side

Early patterns were printed with cutting outline, garment section description, seam allowance, stitching line, grain line, minor instructions, assembly sequence denoted by numbered notches, and, of course, the new McCall pattern logo.

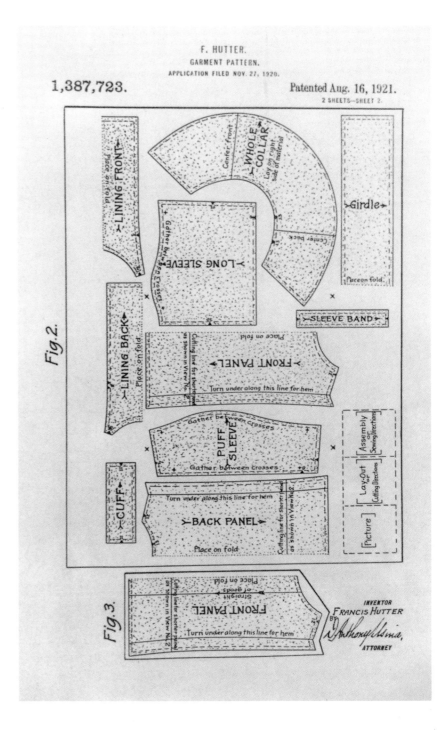

Illustration included with the McCall patent for printed patterns (#1,387,723) which shows their invention. *Courtesy of the Butterick Archives and The McCall Pattern Company.*

Pictorial Review Printed Patterns

The World's Greatest Printed Pattern Printed~Perforated~Cut Out~[12]

Excella Pattern Company also applied for patent protection for their own version of the printed pattern in 1924. Printed patterns were used for their Pictorial Review and Excella Pattern lines. The important elements of their patent include:

- pattern sections with cut edges, printed at points adjacent to where the garment sections are to be matched.
- an instruction sheet referred to from the printing on pattern tissue
- an instruction sheet with an illustration of the finished garment

Well known sewing authority Mary Brooks Picken wrote in her 1925 instruction book for the Pictorial Review Company, "The Average woman is not mechanically inclined. The makers of Pictorial Review patterns have kept this point definitely in mind and have worked to make their patterns so simple that they are easy to understand, easy to use, and require a minimum amount of time."[13]

Perforated vs. Printed

The pattern industry was full of rivalry between competing companies about who issued the most fashionable and easiest to use tissue paper pattern. Each company advertised the virtues of the pattern they manufactured and downplayed all the competing products on the market. An example of this can be found in the McCall printed patent application, which criticized cut patterns as not accurate: "...[With] patterns of the old style, it is impossible to produce a well fitting and well hanging garment. We often find, with the old style of patterns, that two patterns intended to be of the same size [will] show very substantial variations. It is chiefly to this error that we ascribe the 'home made' [sic] look."[14]

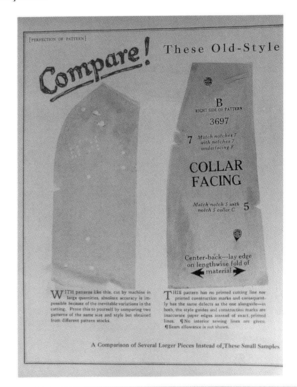

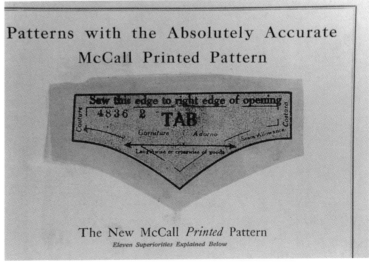

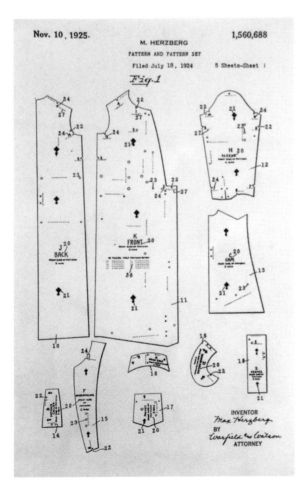

Illustration included with the Excella patent (#1,560,688) for their version of the printed pattern. *Courtesy of the Butterick Archives.*

McCall's comparison of the old style patterns with their new printed patterns. *Courtesy of The McCall Pattern Company.*

Further, Pictorial Review Patterns included a statement on their patterns which was no doubt a jab at McCall's "Margin Of Accuracy." The company printed "This pattern is Cut Out—There are no *superfluous margins* [emphasis added] to be trimmed away. The easy, natural, safe way to cut, with the material always in sight."[15]

Butterick, equally unimpressed by either company's printed pattern, stated: "we do not believe that it is a better pattern than the cut pattern we manufacture...The printed pattern has not proved to be either a great success or a failure. Had it been markedly superior, it would have swept other patterns into the discard."[16]

In the mid-1930s, Simplicity purchased the Excella/Pictorial Review Pattern Companies which gave them all the printed patent rights held by the Excella/Pictorial Review Pattern Companies. Simplicity discontinued the Pictorial Review pattern line in 1939, when they began printing their Simplicity line on a limited basis.[17] Their total conversion to printed patterns lasted roughly seven years, and was completed by 1946.

Butterick eventually conceded that the printed pattern was better than the old fashioned perforated pattern. They moved their manufacturing operations to a new modern plant in Altoona, Pennsylvania in the late 1940s to facilitate the introduction of their printed patterns in 1950.

Further, Advance and Vogue both converted to printed patterns in 1956, however Vogue patterns were *printed and perforated* until 1958 when the perforations were eliminated.

Reader Mail Syndicate, the makers of Anne Adams, Marion Martin & Prominent Designer patterns, began printing their patterns in 1957. Finally, companies that never converted to the printed pattern included Famous Features Syndicate, Modes Royale, New York, and Spadea.

Guide Sheets

In addition to protecting the actual product, companies filed patents to protect the assembly procedures that would clarify the use of their product.

Butterick's Deltor

What contractor ever started to build a house without his detailed drawing, his blue print [sic]? Your blue print [sic] is just inside your Butterick pattern envelope, only we call it the Deltor and it is exclusive with Butterick.[18]

Prior to Butterick's introduction of the Deltor, cryptic assembly instructions were usually printed on the pattern envelope. The Deltor, an illustrated instruction sheet, was a major improvement for home sewing patterns. Butterick applied for patent protection in 1916 and it was granted in 1919. Sometime after that they incorporated their cutting layout, which eliminated fabric waste by illustrating how to lay out each pattern piece, depending on the pattern size and fabric width.

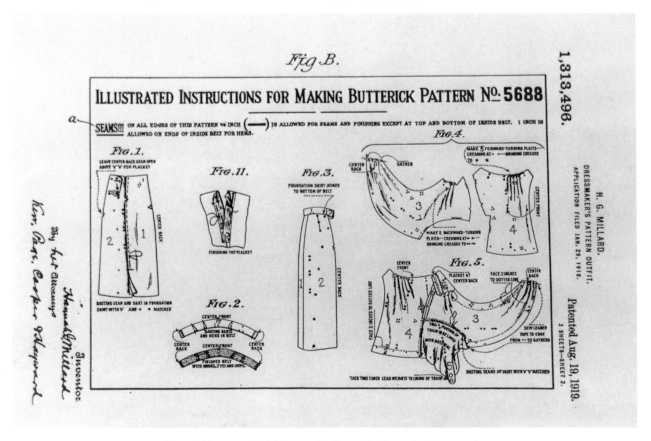

Butterick's patented Deltor was the first guide sheet that illustrated the assembly sequence. *Courtesy of the Butterick Archives.*

Excella's Pictograf

The Pictograf was Excella Pattern Company's version of the guide sheet, used for both their Excella and Pictorial Review pattern lines. They applied for patent protection on September 26, 1924.

McCall's Printo Gravure

McCall's introduced their version of the guide sheet shortly after they began printing their patterns. Their "Printo Gravure," as it was called, was printed directly on the pattern tissue. It was divided into four illustrated sections: (1) the cutting layout, (2) assembly diagram by matching numbered notches, (3) different finished garment options, and (4) instructions for specific dressmaking techniques.

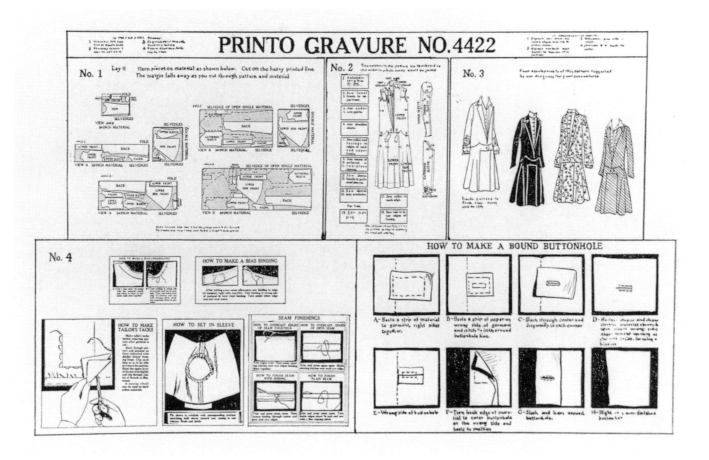

The Printo Gravure was McCall's version of the guide sheet, which was printed directly on the pattern tissue. *Courtesy of The McCall Pattern Company.*

Patent Infringement

A highly publicized patent infringement suit was filed by Butterick against the publisher of Vogue Patterns, Conde Nast Publications Inc., in 1927. They alleged that Vogue's inclusion of an illustrated instruction sheet with their patterns was in violation of Butterick's 1919 Deltor patent. The attorneys for Conde Nast argued that "[t]he patent covers merely an idea of the best method of imparting instructions, rather than a patentable means."[19] Presiding Judge Coleman also questioned the validity of Butterick's patent "...[o]n the ground that such a chart, having no structural characteristics, is not a patentable article of manufacture."[20] The court found in favor of Conde Nast in August 1931 because "...[i]nfringement by the defendant had not been established."[21] Butterick accepted a token payoff from Conde Nast and dropped their appeal. This ruling made it possible for the remaining pattern companies to adopt the use of an illustrated guide sheet without fear of reprisal.

Color Packaging

The Greatest Step Forward Since The Invention Of The Printed Pattern[22]

McCall Pattern Company's introduction of color illustrations on their pattern envelopes in 1927 was another significant innovation initiated by this company, and one eventually utilized by the entire industry. While this innovation was a valuable merchandising tool, the other companies were somewhat slow in converting. By the mid-1930s, however, most had added at least some color to their pattern envelopes.

McCall highlighted their innovative color packaging in their book *An Outline of The Reasons for McCall Pattern Supremacy.*[23] This book was aimed at convincing merchants of the benefits of carrying the New McCall Pattern line by juxtaposing other companies' "old-style" black and white pattern envelopes against their new, full color versions to great effect. Color printing not only "sold" the fashion illustration it "sold" the entire pattern line.

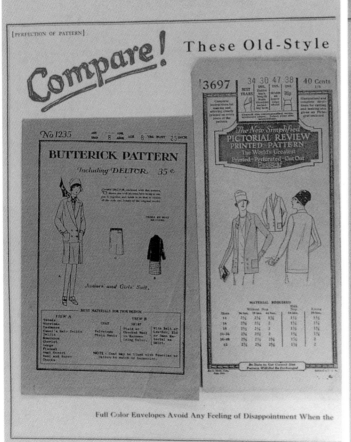

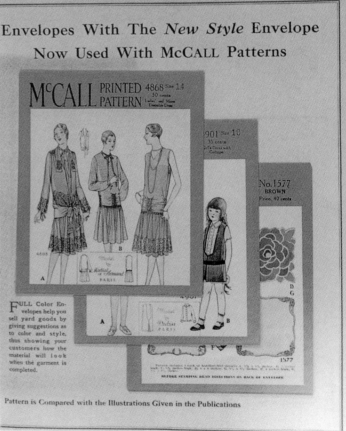

McCall's comparison of their new color printed envelopes with the old style black and white counterparts. *Courtesy of The McCall Pattern Company.*

1950s Product Innovations

The post-war 1950s was another prolific period of improvements and innovations for the pattern industry. Most of these advancements made the product easier to use or targeted a special niche in the marketplace.

Beauty—Patt-O-Rama

The Beauty Pattern Company (pattern division of Famous Features Syndicate) added a visual assembly guide to their patterns in 1956. This feature "combined the best features of both Printed and Perforated Patterns,"[24] by illustrating the pattern pieces in their proper assembly position. It was marketed as "The first really new pattern development in a long, long time...You'll wonder how you ever sewed without it!"[25]

Butterick—Printed Outward Notches

Butterick's advertisements from late 1952 and early 1953 state that "[Printed outward notches] is available only on the *latest* [emphasis added] Butterick Patterns." This could mean that it was their innovation exclusively or that it was not on the older Butterick patterns. Their statement, however, is misleading because Simplicity was using the same innovation at the same time. Advance began using notches sometime after they began printing their patterns in 1956.

McCall's—Easy-Rule

McCall's 1954 advertisements described Easy-Rule as "the first major pattern improvement in 30 years!"[26] and all their patterns issued after April 20, 1954, included the "easy-rule" device.[27] The inclusion of ruled inches printed directly on the pattern piece simplified any length adjustments that were necessary to individualize a pattern to the wearer's correct size.

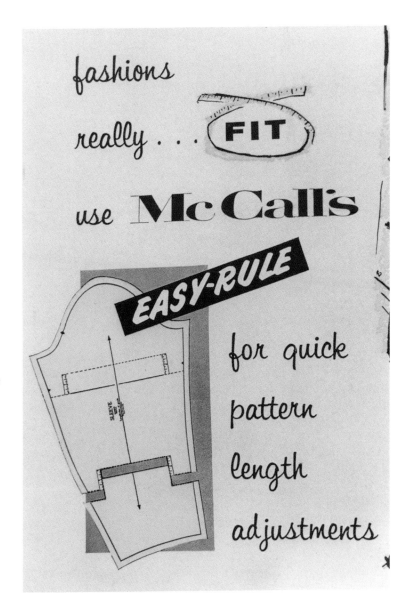

McCall's "Easy-Rule" gauge simplified length adjustments to individualize patterns. *Author's collection. Courtesy of The McCall Pattern Company.*

McCall's—Instant

The Instant pattern series, introduced in 1955, streamlined the sewing process by printing the complete pattern on one sheet of tissue. This eliminated the need to follow a layout chart because all the pattern pieces were arranged in the proper cutting position with relation to the fabric grain. The only requirements were to check the fabric grain once, pin the pattern tissue to the fabric, and cut. This series included aprons, skirts, dresses, and doll clothes. Advance and Vogue each issued patterns based on the same idea sometime after they began printing their patterns in 1956.

EASY 2135 "instant" APRONS

Paper pattern is all one piece; pin to two layers of fabric and cut two complete aprons instantly

APRON

McCall's Instant Patterns reduced the layout and cutting time for these pattern styles. *Author's collection. Courtesy of The McCall Pattern Company.*

McCall's—Proportioned Styles

In 1959, McCall's introduced proportioned patterns. These styles were created to fit a wide range of body types from short to tall (5'3"-5'10") with one pattern. These patterns accounted for the fact that two women may have the same bust and waist measurements, but because of different heights, the length proportions can vary greatly. "No matter what your size, McCall's proportioned skirt will give you a perfect, custom fit,"[28] noted the company.

McCall's—Basically Yours Try-On Pattern

The Basically Yours Try-On pattern was released in 1959. It combined the basic try-on pattern (which was made of tissue paper) and a lightweight non-woven fabric (similar to interfacing). The pattern pieces were printed directly on the non-woven fabric, which, when assembled, could be tried on, pinned, and sewn. This eliminated the tearing associated with fitting a tissue paper pattern. Once fitted properly, this pattern became the guide with which to compare the fit of other patterns.

Modes Royale—The Colorful Pattern

The Colorful Pattern, from the late 1950s, assigned each major portion of the pattern its own color to help differentiate between the pattern pieces—pink for bodice and skirt; green for separate sleeves; yellow for trims, collars, cuffs, and blouses; blue for all facings; beige for linings. This improvement seemed especially useful for this line because Modes Royale Patterns never included printed construction details.

Simplicity—Printed Notches and Arrows

Simplicity's *Modern Miss; the fashion magazine for home economists and their students* introduced two new features to Simplicity Printed Patterns in the spring of 1953: printed notches (like Butterick's) and a printed arrow on the stitching line that showed the correct direction to stitch that particular seam so as not to stretch the fabric grain.

Simplicity—Quick Measure

The Quick Measure was a six-inch rule printed on the edge of the envelope. It was first used in 1958 and trademarked in 1959. Its use: a quick measuring gauge!

Chapter 2
Marketing & Merchandising

Products are designed to match the interests of a particular group of consumers. Marketing sewing patterns, like any other product, involves many design, merchandising, promotion, and distribution decisions. This combination of choices is known as the "marketing mix."

Similar pattern lines can have vastly different "mixes" because each company chooses which combination of components they feel suits their product and intended market. The foundation for these decisions, however, is always based on the projected target market. Without knowing who the customer is, developing a marketing strategy would be difficult.

During the 1950s, most pattern companies increased the number of products geared to specialized markets. Although specialized products were available in earlier decades—like Pictorial Review's patterns for "Larger-Hip" or Advance's "School Patterns"—overall these were not too common. The pattern companies all seemed to be aiming somewhere in the middle of the home sewing market.

With almost any product on the market, the 80/20 rule of thumb concludes that a large percentage (80%) of the sales volume comes from a minority (20%) of the buyers. During the 1950s, the pattern industry broke down this minority into specialized groups, each with individual needs and varying from infant's wear to imported designer styles and all the size ranges in between. As a 1954 article in *American Fabrics* noted, "Styles have become highly individualized to include just about everything a woman could conceivably desire to make herself."[29]

Brand names and specialty lines were created that would appeal to these different demographic groups as well as to all the different reasons woman were motivated to sew—style and fashion, hard to fit figures with specific size requirements, different experience levels, creative satisfaction and leisure, and economics. In addition to targeting a specific market, these brand names and specialty lines helped distinguish each pattern company from its competitors.

Some companies designed many specialized lines, aimed at appealing to more than one group. This approach gave them a better chance of gaining a larger segment of the overall market. Other companies, however, focused on only one or a few specific groups. Such was the case of Vogue Pattern Service, whose focus was on style and the prestige associated with its name. Vogue's high fashion patterns were priced on the high end of the industry, which limited their market share potential. But even within their own catalog, they featured many products that appealed to the differences within their small market segment.

Premium Style Based Pattern Lines

Most of the companies had pattern lines that were exclusively geared toward the latest fashion trends. These premium lines focused on attracting home sewers interested in fashion and style. They were usually more expensive than the regular pattern lines, even though these were created by staff designers and were not licensed styles. Customers interested in fashion and style were willing to pay the additional cost to be on the cutting edge of fashion. Vogue included a woven sew-in label to their lines, which was another way they added prestige and distinction to their product.

Advance— Import Adaptation

These patterns were based on designs originating in Paris. Advance's chief designer Kathleen Hammond adapted the new ideas and trends into styles that met the needs and experience level of the home sewer. The Import Adaptation line was given its own logo, was packaged in the larger 8 1/2" x 10 1/2" envelope, had its own numbering sequence, and retailed for $1.00—double the price of Advance's other lines. By the late 1950s however, this series was incorporated into the company's regular numbering sequence and packaging with the only differentiation being the Import Adaptation logo.

The Patterns of The Times series, which was a weekly feature of *The New York Times*, highlighted five different Advance Import Adaptations in October 1949. They continued to be featured in this column into the 1950s. Shown on next page.

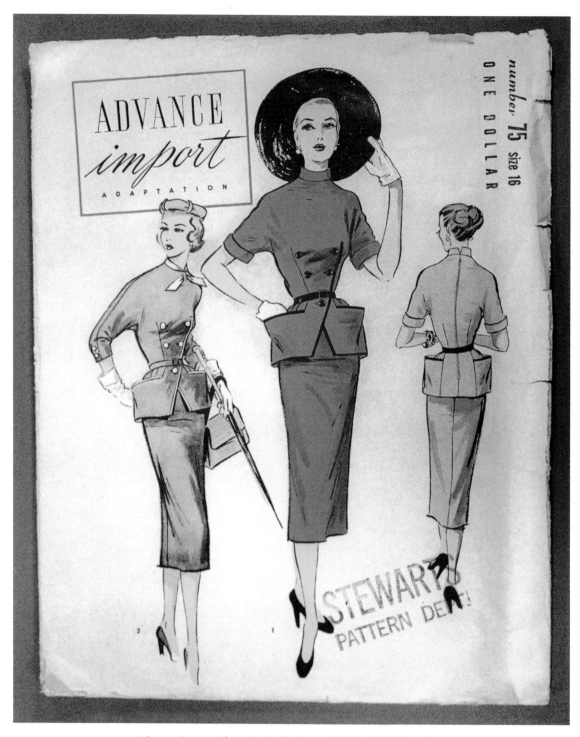

number 75 size 16
ONE DOLLAR

ADVANCE *import* ADAPTATION

Advance Import Adaptation in the larger 8-1/2" x 10-1/2" envelope.

Beauty—New York Fashion Originals

Patterns featured in daily papers were usually aimed at "everywoman," which is evident from this quote published in a Newspaper Enterprise Association sales brochure for Famous Features Syndicate patterns: "NEA Patterns appeal to Mrs. Average America . . . And, they must appeal to the sewing interests of a mass circulation more that the high fashion interests of a few."[30] However, with the Spring 1958 introduction of New York Originals, Beauty Pattern Company started gearing these patterns toward the high end within the syndicated newspapers.

Each of these patterns contained a fashion guide sheet, similar to McCall's Fashion Firsts' Fashion Consultant: "...[each] with a DELINEATOR which is a graphic illustration for coordinating fabrics, colors and accessories."[31] Even though Butterick had ceased publication of their woman's interest magazine *Delineator* in the 1930s and they had stopped using Deltor as the title for their guide sheet by 1945, Beauty's decision to name their illustrated guide sheet DELINEATOR was an odd choice. However, this title lasted only a few months; by the Fall and Winter 1958 issue of their pattern magazine, *Basic Fashion*, the title had changed to Coordinator.

McCall's—Fashion Firsts

Fashion Firsts began in 1953 and were adapted from imported designer styles. "In every way the pattern reproduces the original faithfully."[32] Each of these patterns contained a special insert called "The Fashion Consultant," which helped choose the correct colors, fabrics, and fashion accessories to complete the costume. This line was also given its own logo, pattern envelope graphics, and a $1.00 price.

McCall's—Italian Couture Adaptations

Italian Couture Adaptations debuted in 1952 with the widely acclaimed fashion show "Italian Inspirations." Original couture garments were modeled side by side with the McCall's adaptations. "McCall's translated the importations into practical, makeable fashions...with the fine details and flair of a couture creation."[33]

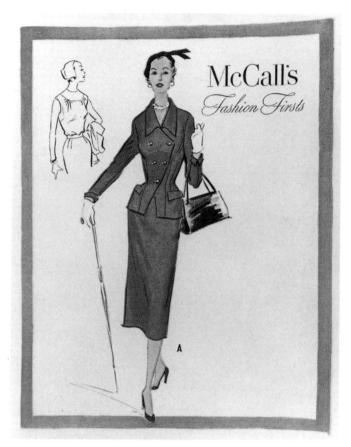

McCall's Fashion Firsts #9280, 1953.
Courtesy of The McCall Pattern Company.

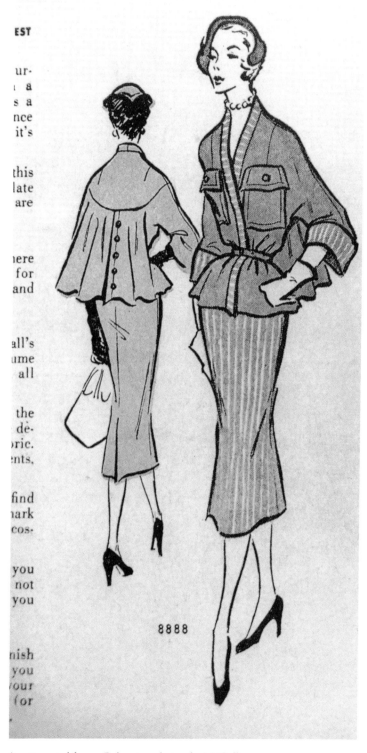

A suit copied from a Balenciaga design for McCall's Italian Couture Adaptations #8888, 1952. *Author's collection. Courtesy of The McCall Pattern Company.*

17

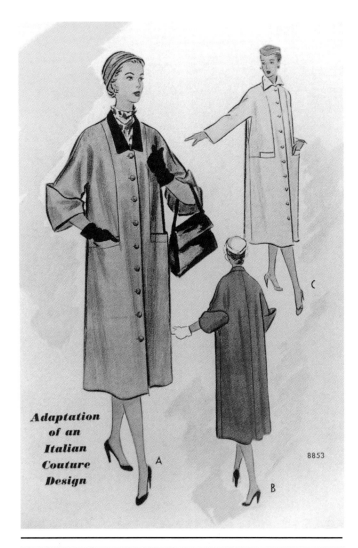

Adaptation
of an
Italian
Couture
Design

A
B
C
8853

Adaptation of an Italian couture design for McCall's pattern #8853, 1952. *Courtesy of The McCall Pattern Company.*

Modes Royale

The Modes Royale Pattern line competed in the high style arena with Vogue, and appealed to women who wanted exaggerated style lines. They began in approximately 1943 and were in business into the 1960s. Their distribution was limited to a small number of outlets, possibly because of their high-end price of $2.00. Like Vogue, they began including a woven fabric label with their patterns. This line never converted to printed patterns and their envelopes never used full color illustrations.

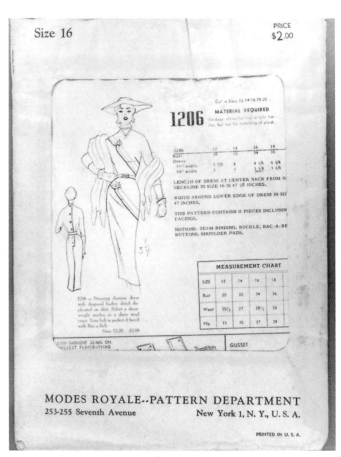

Modes Royale Pattern from the 1950s.

Originator

Although information is sketchy about this company, brochures available from 1949 show a highly stylized and expensive line similar to that of Modes Royale. This company also made their patterns in a light weight kraft paper instead of tissue paper.

Originator Patterns #1222, late 1940s.
Envelope size 8-1/2" x 11".

Simplicity—Designer's

Simplicity Pattern Company was founded in 1927 as a value oriented alternative to the costly pattern lines available at the time. But with their introduction of Simplicity Designer's Patterns in 1949 (the same year that Vogue debuted their licensed Paris Original Models), even this company was attempting to attract a style oriented customer. These styles were, however, created by Simplicity's staff designers and priced well below the competition at 50 cents (Paris Original Models retailed for $2.50 each). Additional proof that Simplicity merchandised this line to capitalize on designer pattern popularity is evident in the larger 8" x 11" envelope packaging (like Vogue's premium lines), use of its own logo, and separate counter catalog promotion.

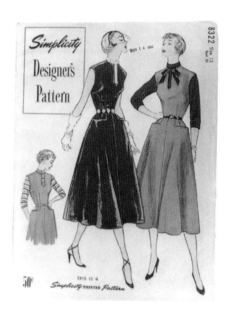

Simplicity Designer's Pattern #8322, 1950.

Vogue—Couturier

Vogue's promotion literature referred to these as "[so] new that they are *forecast* fashions. [They] are created in the manner of the finest custom collections."[34]

Couturier patterns were introduced in 1931, and was the first pattern line packaged in the larger 8" x 10 1/2" envelope. It also had its own logo and separate numbering sequence. Further, this distinctive series included a postcard that could be mailed in to receive a woven silk Vogue Couturier label. This distribution method was changed in the early 1950s, however, when the responsibility was shifted onto pattern merchants—who passed out labels upon the customer's request. In 1956, Vogue licensed European designers to add to this line, which complemented their roster of Parisian couturiers who designed for their Paris Original Models. An example from this line is shown on page 66. (Vogue's licensed pattern lines are discussed later in this chapter.)

Vogue—Mrs. Exeter Fashion Plan

The Mrs. Exeter Fashion Plan was introduced in 1955. It catered to a mature audience and was billed for the "Ageless Women." This grouping of patterns, which focused on style and propriety, was taken from Vogue's entire catalog and included because of their appeal to this specialized market. Although this line did not have its own specific designs or logo, the patterns were given their own tabbed section in the counter catalog.

Vogue—Special Designs

Special Designs consisted of "very new lines and unusual detailing" from the forefront of fashion, "whose styling is even more advanced then that of the 'regulars.'"[35] They were also introduced in the 1930s, had their own logo and separate numbering sequence, and included a woven sew-in label. An example from this line is shown on page 82.

Price Based Pattern Lines

In addition to the premium lines issued, many companies had lower priced patterns, especially those geared for teens and schools, which catered to economically minded home sewers. Companies like Simplicity were founded on being inexpensive alternatives to higher priced lines, and made tremendous gains with this marketing strategy through the 1930s and 1940s. In the mid-1940s, however, most economy based pattern lines such as DuBarry Patterns and Hollywood Patterns were discontinued because the higher priced lines were selling better. With the advent of the prosperous 1950s, this value oriented customer was no longer the industry's main focus as had been the case in previous decades.

Economy based pattern lines DuBarry and Hollywood were discontinued in the mid-1940s.

Modes Royale—Budget Designs

Premium based Modes Royale introduced Budget Designs in 1951, no doubt to capitalize on those reluctant to spend the normal $2.00 price. However, this lower priced line was still expensive at $1.00. Although these designs were not as extravagant as the company's premium line, they were still highly stylized and directed toward a specific customer.

Size Based Pattern Lines

Pattern size ranges differed little between each company. Occasionally a new one would be added to expand a company's line or a new brand name would be coined, but during the 1950s each company basically held to the following size categories:

- Boy's
- Children's
- Girls
- Junior Miss
- Men's
- Mother-Daughter
- Misses'
- Pre-Teen
- Teen-Age
- Toddler
- Women's
- Women's Half Sizes

Another product issued by most pattern companies was the "Basic Fitting Pattern." Once made up and fit properly, this was used to guide alterations on all other patterns. This saved time by not having to re-alter each pattern.

Advance—Chubby Girl

Practical Home Economics reported in the early 1950s that Advance "has suddenly remembered...the chubby girl from 8 to 14 years old. A whole series of patterns have been specially designed and fitted for her in sizes 8½ to 14½."[36]

Simplicity—Slenderette

Simplicity's May 1957 *Fashion Preview* introduced this new group of styles especially designed to flatter women and half sizes.

Vogue—Junior

Junior Vogue Patterns were introduced in 1945. They were sized differently, and priced "within the budget limitations of most." Vogue emphasized that these were based on size, not age, and included in this line designs that appealed to adults who required these smaller proportioned sizes. Additionally, they issued a separate Junior Sizes counter catalog that catered to this market. However, this line was replaced by the Teen line in 1955.

Experience Based Pattern Lines

In addition to appealing to style, fashion, budget, and sizes, pattern lines were created to attract all experience levels, especially beginners. These lines were also promoted to home economics educators who influenced beginners' buying choices. These lines were confidence builders for beginners and time savers for busy home sewers, as most of the styles required a minimum number of pattern pieces and contained only simple details. Clever design was applied to include the sleeves or collar cut in one with the bodice, and they eliminated intricate work like buttonholes. In many pattern catalogs these styles were grouped together in their own tabbed section.

Advance—Bishop Method of Construction

Edna Bryte Bishop, a nationally known clothing construction authority, was hired as early as 1952 by Advance Pattern Company to contribute her Unit Construction techniques to their patterns. By 1954, she was being billed as their "Educational Director." The "Bishop Method" line continued into the 1960s.

Advance—Learn To Sew For Children

These easy to use patterns were designed to teach youngsters and required only the most rudimentary sewing skills. The simplified guide sheet was written in easy to understand language and it illustrated unfamiliar techniques: "Fold your fabric like the picture with the pretty side inside. Place the finished edges of fabric together. These finished edges are called Selvages."[37]

Advance—Sew Easy

These patterns were easy to complete and appealed to both the beginner and the homemaker pressed for time. Advance began using this slogan in approximately 1951.

Advance—3 Easy Steps

"3 Easy Steps...Pin...Cut...Sew" was a complete pattern printed on one sheet of tissue, with all the pattern pieces placed in the proper cutting layout. This type of time-saving pattern was introduced by McCall's Instant Pattern in 1955. Advance's version was available in 1956 and corresponded with their conversion to printed patterns.

Butterick—Quick & Easy

Butterick began using this slogan in the early 1940s and continued to use it throughout the 1950s. Noted the company: "They save you hours of sewing-time and energy which results in added hours of leisure...We believe Butterick Quick and Easy designs give you style in a capsule and that doesn't mean a sack-like dress with a belt 'round the middle."[38] In the early 1950s, Butterick began including flat pattern line drawings on the front of Quick & Easy envelopes. These helped illustrate how simply the major pattern pieces went together. An example from this line is shown on page 107.

McCall's—Easy To Sew

This slogan referred to the simplest patterns in the McCall's catalog. It began in approximately the mid-1950s and was replaced by "Easy" in 1956, which the company continued into the 1960s.

McCall's—One Piece Ready-To-Cut Skirt

This pattern was the predecessor to McCall's line of Instant Patterns. It was one piece of printed tissue with the pattern pieces arranged in the proper cutting layout. This one piece skirt pattern was popular with most of the companies.

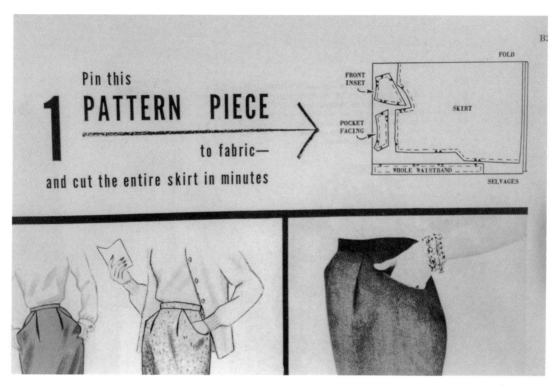

McCall's One Piece Ready-To-Cut Skirt pattern #3308, 1955.
Author's collection. Courtesy of The McCall Pattern Company.

McCall's—Unit Method Of Construction

"...Each unit (any one part of a garment) is completed as nearly as possible before being joined to another unit. As work progresses, pieces are combined and then two or more pieces form a unit."[39] According to a McCall's survey, the unit method of construction was preferred by seventy-five percent of high school and college home economics teachers, because they felt it was faster, easier, better.[40]

Simplicity—Jiffy

Simplicity began using the slogan "Jiffy" to describe easy to make styles in 1953. They filed for trademark protection in 1964 and made it one of their brand names.

Simplicity—Simple To Make

The Simple-to-Make slogan began in the 1930s, for styles that were obviously simple to make. The company added the Simplicity Unit System of Construction to this line by the mid-1950s. Also included with this line was a helpful "How-to-do-it" chart (printed directly on the pattern tissue) that illustrated sewing techniques such as inserting a zipper into pattern #1281(1955) and collar con-

struction tips for pattern #1283 (1955). "Simple to Sew" was another slogan for easy patterns that Simplicity used in the late 1950s.

Vogue—Easy To Make

Easy To Make patterns were introduced in the 1930s and were part of Vogue Patterns' "regular" line. "No pattern is easier to use, yet it has Vogue's fashion, fit and accuracy."[41]

Vogue—Easy Does It Dresses

These dress designs date from approximately 1953 and were early versions of the wrap dress with numerous style variations. "They were Easy To Make, Easy To Launder, Easy To Slip Into, Easy To Wear."

Vogue—Short Cut Pattern

The January 1958 *Vogue Pattern Book* contained a new product for the Vogue Pattern line. The Short Cut To Fashion line was one printed pattern tissue with all the pieces in the proper cutting layout. It was similar to McCall's Instant Patterns and Advance's 3 Easy Steps.

Vogue—Young Fashionables

Introduced in 1956, Young Fashionables were "created solely for educational proposes with distribution limited only to schools and offered at the low low [sic] rate of just 25¢ each."[42] Yet by 1958, this product line began appearing in the counter catalogs and the price had more than doubled to 60 cents. These were packaged in the larger 8" x 10 1/2" envelope with a new flower logo and their own numbering sequence. "So easy to make...It could be your first project." An example from this line is shown on page 173.

Hobby Based Pattern Lines

Hobbies and do-it-yourself projects gained tremendous popularity during the 1950s, and pattern lines were created or enhanced to capitalized on this trend.

Advance—Knitting Instructions

With the renewed popularity of knitwear, Advance introduced a few styles that incorporated rib-knit edging in 1950. These patterns contained knitting instructions for those who chose to hand finish their garment instead of purchasing the rib-knit. In addition to being shown in the *Advance Fashion News* (November 1950), examples of this series were offered in *The New York Times'* weekly feature, Patterns of The Times, on September 25, 1950.

Similar types of knitting/sewing patterns had been offered by Simplicity in the 1930s ("Knit - Sew") and Butterick in the 1940s ("Knit or Sew").

McCall's—Appli-Press

McCall's trademarked Appli-Press iron-on appliques debuted in 1954. These pre-cut, full-color fabric appliques did not require sewing or embroidery. The designs included decorative motifs and licensed characters, like Walt Disney's *Lady and the Tramp*, U.S. Department of Agriculture Forest Service's Smokey The Bear, and Woody Woodpecker.

Advance included knitting instructions with some of their patterns in 1950.

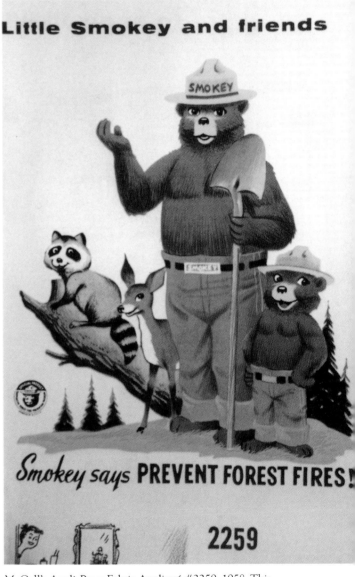

McCall's Appli-Press Fabric Appliqué #2259, 1958. This line of iron-on appliqués used for trimming housewares and clothing included licensed characters like Smokey the Bear. *Author's collection. Courtesy of The McCall Pattern Company.*

McCall's—Decals

McCall's October 1958 *Needlework and Novelty Patterns Catalog* contained decorative decals. "Just wet motifs with water and apply to tile, walls, furniture, glass bottled, mirrors, other smooth surfaces."

McCall's—Do-It-Yourself

The Do-It-Yourself line of transfer patterns for woodworking was introduced in December 1954 to attract home workshop enthusiasts. These full-scale, iron-on transfers included a "Cut-'n-Join guide," which was similar to the dress pattern's "Cut and Sew Guide." "The idea that Father could do his building with the McCall's Patterns while Mother was using them to dress the family fitted well with the magazine's (*McCall's*) "Togetherness" editorial policy."[43] They had their own logo, envelope graphics, and numbering sequence, and were available in hardware, chain, and department stores. They were also offered by mail order through *McCall's Magazine* and *McCall's Pattern Book*.

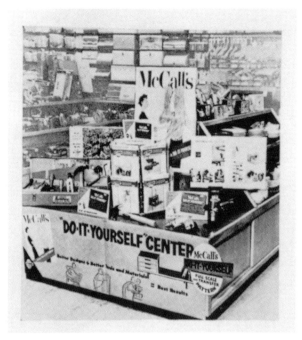

McCall's Do-It-Yourself store display, placed in hardware stores. These transfer patterns attracted a totally different customer to the McCall's product line. *Courtesy of The McCall Pattern Company.*

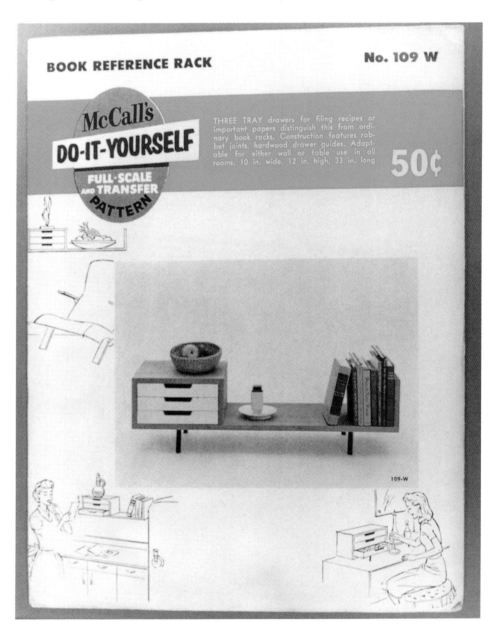

McCall's Do-It-Yourself pattern #109w, 1954. *Courtesy of The McCall Pattern Company.*

McCall's—Foto-Press

McCall's trademarked Foto-Press transfers were actual black and white photographs that could be ironed onto clothing or household items. They were introduced in 1956 and remained in the catalogs through the decade.

McCall's Foto-Press transfer pattern #2224, 1958. *Author's collection. Courtesy of The McCall Pattern Company.*

McCall's—Four-Color Transfers

The Four-Color transfer series began in 1952. These iron-on motifs were designed to add a decorative accent to anything made of fabric. These were available through the late 1950s. Free samples of this product were distributed during the second annual "Do It Yourself" show in New York City in the Spring of 1954, attended by over eighty-one thousand interested home crafters.[44]

McCall's—Pop-Out Ornaments

This was another McCall's trademarked product. Their Pop-Out Christmas ornaments were made from metallic paper in a variety of holiday designs, suitable for Christmas tree, centerpiece, mobile, and mantle. They debuted in 1957.

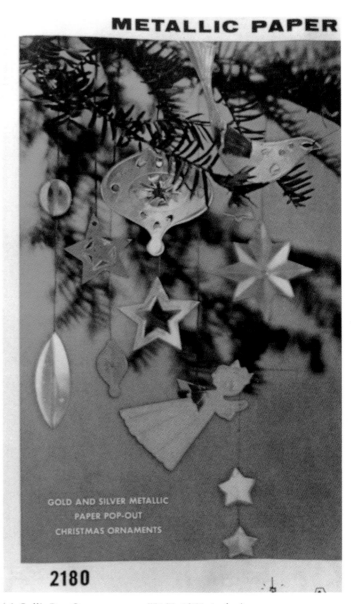

McCall's Pop-Out ornaments #2180, 1957. *Author's collection. Courtesy of The McCall Pattern Company.*

McCall's—Transfer Patterns

Transfers were by no means new to the 1950s. However, their popularity continued through the decade for such projects as smocking, appliqué work, hooked rugs, and embroidered pictures for hanging. McCall's line of needlework patterns was designed by a separate division within the McCall Pattern Company. These patterns also had their own numbering sequence. An example from this line is shown on page 156.

McCall's—Quik-Trick

McCall's trademarked Quik-Trick line of ready-to-cut fashions for 10 1/2" High Heel Figure Dolls was introduced in 1958. The doll pattern pieces were printed in color on a non-raveling, non-woven fabric that was easy for youngsters to cut and sew. "No hemming or trimming required...It's all printed into the fabric!"[45]

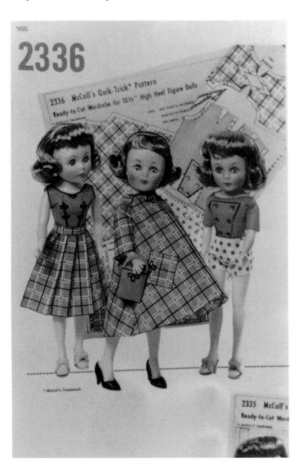

McCall's Quik-Trick pattern for High Heel Figure Dolls #2336, 1959. *Author's collection. Courtesy of The McCall Pattern Company.*

Simplicity—Four Color Transfers

Simplicity's Four Color Transfer line from 1953 was exactly like McCall's Four-Color Transfer line of 1952. Their choice of designs and catalog illustrations were also similar.

Simplicity—Transfer Designs

The *Simplicity Needlework Catalog* catered to project oriented home sewers with designs for embellishing any number of garments, accessories, household items, and toys. These needlework patterns were incorporated into the general line's numbering sequence but had their own packaging graphics. An example from this line is shown on page 157.

Licensing Agreements

Purchasing the rights to reproduce a character, name, or design began early in the twentieth century on a minimal scale by a few companies. By the 1950s, this merchandising method had grown to be incorporated in most companies' product lines.

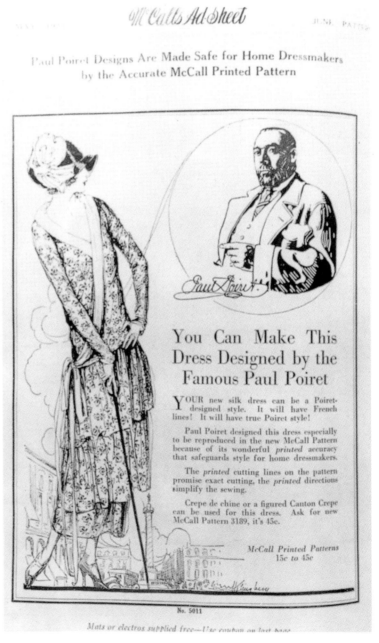

1923 advertisement for a Paul Poiret designed McCall pattern. *Courtesy of The McCall Pattern Company.*

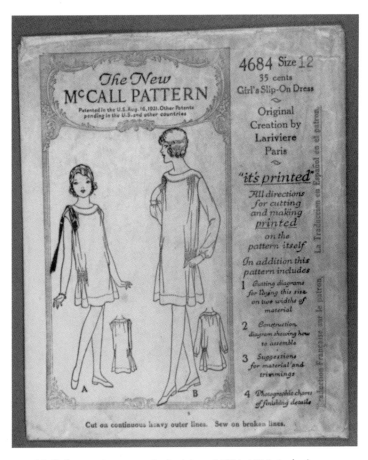

McCall couturier pattern by Lariviere #4684, 1926. *Author's collection. Courtesy of The McCall Pattern Company.*

1930s McCall Kewpie license. *Author's collection. Courtesy of The McCall Pattern Company.*

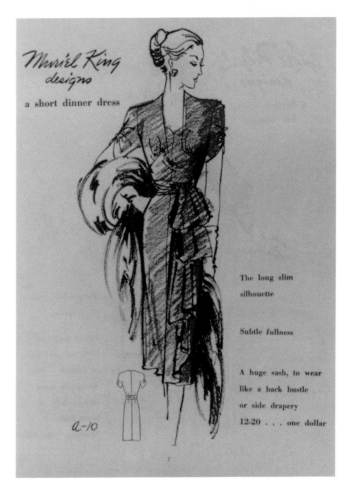

1940s Famous Features' American Designer Original, Murial King design #A-10.

1950s Licensing Agreements

Almost every pattern company expanded their lines with licensing to take advantage of the interest in designer brand names and characters popularized by movies and television. Licenses included those for European and American designers as well as celebrity endorsements.

These designer patterns gave home sewers the ability to create exclusive designer fashions at a fraction of the cost of an original garment—and in most cases a better reproduction than the "adapted" ready-to-wear copies available in department stores. "The most important thing about today's patterns is the aura of high style and fashion authenticity with which they are surrounded."[46]

Designer Licensing

Advance—Import Designs

The Import Designs series has been difficult to date because of the lack of information that has surfaced; further study is needed. However, this pattern line is mentioned in an article about the home sewing industry that appeared in *American Fabrics* in 1954. "Now there are also patterns of foreign inspiration from the Celanese International Collection of Couturier Fashions."[47]

As determined from the information that exists, the pattern's packaging and graphics are a cross between Advance's *The New York Times* American Designer series and their Import Adaptation series. The Import Designs had a similar logo and price point as the Import Adaptation patterns, but they were packaged in a smaller (5 1/4" x 8 1/4") envelope with a picture of the licensed designer like the American Designer series. Under the designer's name the pattern was credited as being from the Celanese International Collection of Couturier Fashions.

Advance—The New York Times American Designer Series

In August 1949, the Advance Pattern Company, in conjunction with *The New York Times*, began a weekly feature know as "Patterns of the Times." This feature was expanded in April 1950 to include a monthly offering from the Advance American Designer Series. As a 1952 article reported, "Virginia Pope, fashion editor of *The New York Times* is responsible for this bit of home sewing good luck. Together with Kathleen Hammond, Chief Designer for Advance Patterns, a plan was worked out whereby design of outstanding American designers would be translated into patterns."[48]

Each month a new Advance American Designer Series pattern was introduced on the woman's page along with a column and interview by Ms. Pope. She reported the designer's views about the importance of each illustrated pattern style and the appropriate fabric choices. A Bonnie Cashin "toga" cape design was chosen as their first offering. "Of it Bonnie Cashin says: 'It has a simplicity that is timeless.'"[49] The American Designer Series continued through the 1950s, but *The New York Times* was dropped from the packaging around 1956.

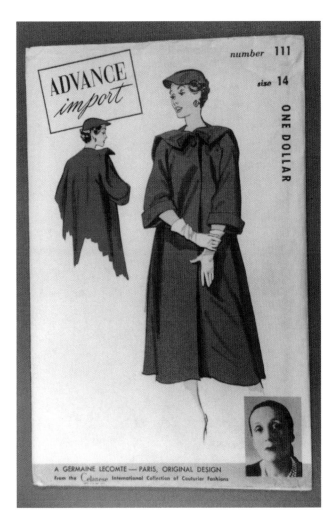

Advance Import pattern #111, designed by Germaine Lecomte.

On April 3, 1950, *The New York Times* began featuring patterns from Advance American Designer Pattern, *The New York Times* Patterns of the Times—American Designer Series, on a monthly basis. This Bonnie Cashin toga design, #5557 was the first style offered.

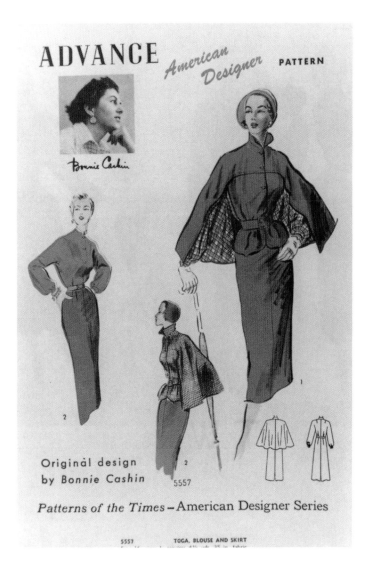

Advance—*Photoplay* Patterns

Advance produced a line of patterns that was featured monthly in the movie fan magazine *Photoplay*. The styles were created by Hollywood costume designers and worn by movies stars in their film roles. The envelope graphics on these patterns changed numerous times from 1948-1951, as did the numbering sequences. The Advance company name was not on the patterns from the late 1940s. But the patterns from the 1950s were packaged in Advance envelopes and were included in their counter catalogs.

Not enough information has surfaced to know who paid for the patterns manufacture and whether the designer/movie studio or *Photoplay* magazine received any royalties from the patterns' sales.

Beauty—American Designer Originals

This pattern series, which began in 1946 and continued into the early 1950s, was the first to license designers' names in the 1940s. The patterns were featured and sold through local newspapers around the United States, with such designers as: Vera Maxwell, Muriel King, and Renie of Hollywood. This licensed designer series predated Vogue's highly lauded Paris Original Models by three years.

Butterick—Suzie Stephens Originals

Butterick featured their first collection of campus-designed styles, Suzie Stephens Originals, in the Fall of 1950. These "college-career fashions in junior sizes were created by outstanding student-designers of Stephens College, Columbia, MO." The initial production included nine designs by seven students. *Practical Home Economics* reported in January 1951 that "... [s]tudent designers voted to allot a portion of their royalties to a scholarship fund and to the improvement of the facilities of the department."

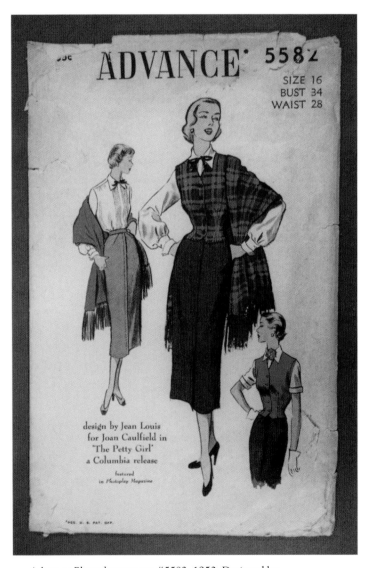

Advance *Photoplay* pattern #5582, 1950. Designed by Jean Louis for Joan Caulfield in "The Petty Girl".

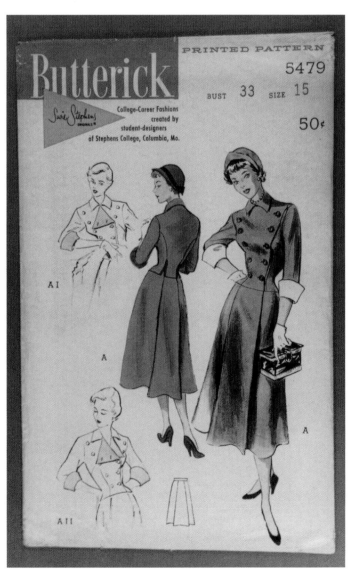

Butterick Suzie Stephens Originals pattern #5479, 1950. *Courtesy of the Butterick Archives.*

McCall's—Capezio Approved Styles

In 1953, McCall's styles for dance costumes and leotards were credited as "approved by Capezio, Famous Makers of Dance Accessories" on the pattern envelopes and in the counter catalogs.

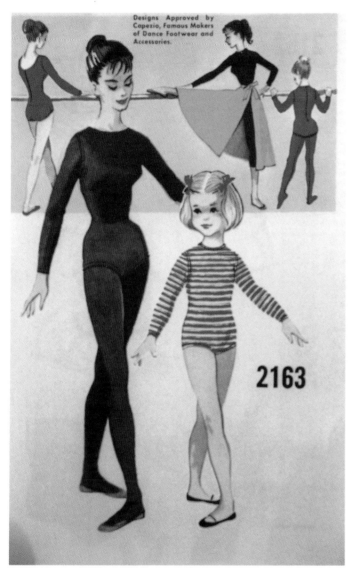

McCall pattern #2163, 1957. Designs approved by Capezio, Famous Makers of Dance Footwear and Accessories. *Author's collection. Courtesy of The McCall Pattern Company.*

McCall's—Couturier Series

McCall was one of the first to license designers for their pattern line in the 1920s. They promoted their association with Parisian couturiers to retailers through their trade publication *McCall's Ad-Sheet*. "Here is an opportunity for you to ally yourself with names such as these—and build up a style reputation for your Pattern and Piece Goods Department."[50] Also in this publication, they reprinted a letter from couturier Paul Poiret praising the virtues of the New McCall Patterns.[51] Although fazed out in the mid-1930s, these patterns reemerged in the mid-1950s (1956) and included two young Parisian couturiers: Givenchy and Pierre Cardin. American designers like Claire McCardell, Pauline Trigère, and children's wear designer Helen Lee were also added at this time.

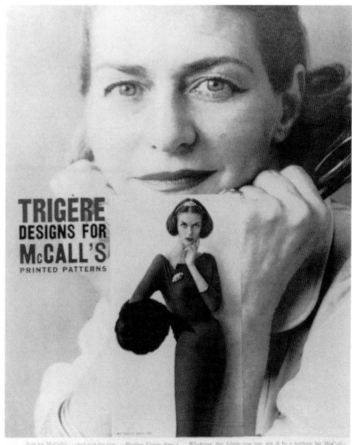

1955 advertisement for McCall's Printed Patterns designed by Pauline Trigère. *Courtesy of The McCall Pattern Company.*

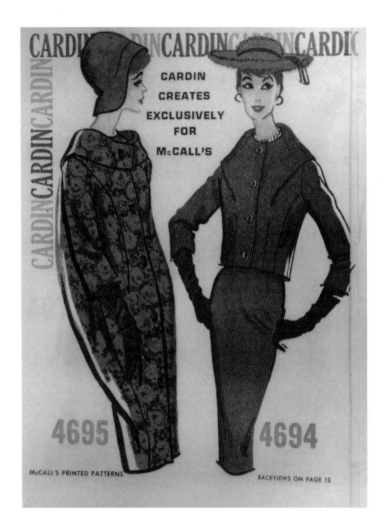

Styles created by Pierre Cardin for McCall's, 1958. *Author's collection. Courtesy of The McCall Pattern Company.*

McCall's—*Scholastic* Art Awards

McCall's co-sponsored the costume division of the Annual *Scholastic* Art Awards in 1952 and 1953. The awards were created to encourage and reward high school student achievement. The entrants had to design clothing that was suitable for their own age group with the winning designs produced as part of the McCall's Pattern line and featured in *McCall's Pattern Book*.

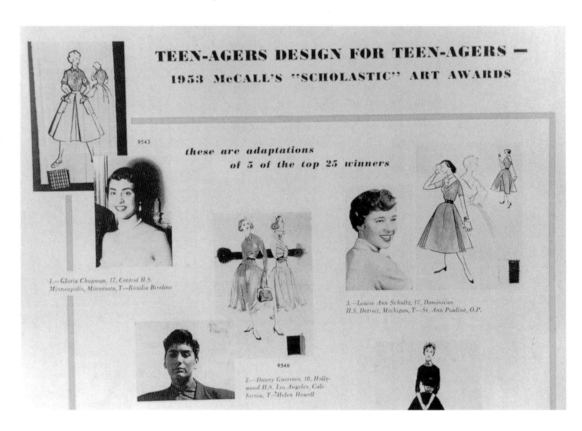

Winning designs from the 1953 *Scholastic* Art Awards. *Courtesy of The McCall Pattern Company.*

McCall's—American Decorator Series

The American Decorator Series was aimed at do-it-yourself home decorators, and was pictured in the Summer 1953 *McCall's Pattern Book*. The article featured four new drapery patterns designed by two leading industrial designers: Virginia Conner Dick and Raymond F. Loewy. This series was priced at $1.00 and featured a designer biography and photograph on the pattern envelope flap.

Reader Mail Syndicate—Prominent Designer

This began in the mid to late 1950s to capitalize on the upscale designer pattern trend. Up to this point, gathering information about the syndicated newspaper pattern companies has been difficult because no archives exist for these lines. Reader Mail is the only syndicated company from this era still in business, but since they have changed owners numerous times very little historical materials remains.

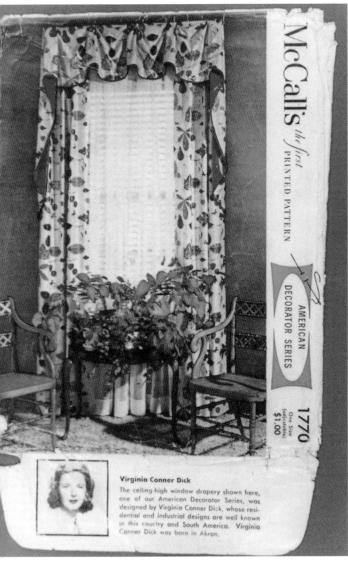

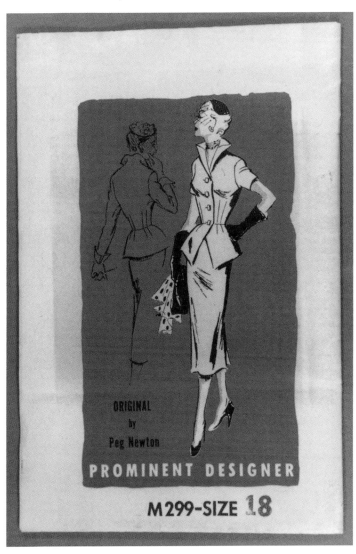

Reader Mail Prominent Designer Pattern designed by Peg Newton.

McCall's American Decorator Series pattern #1770, 1953. Designed by Virginia Conner Dick. *Author's collection. Courtesy of The McCall Pattern Company.*

Simplicity- Millinery Designs

Simplicity is one of the few companies that did not license designers. However, their May 1952 counter catalog contained two designs credited to milliner Sally Victor.

Simplicity pattern #3322, 1950. Hat design credited to Sally Victor.

Spadea—American Designer

Spadea Fashions, Inc. was founded in 1950. They offered high-fashion designer patterns featured weekly through local newspapers. Their entire pattern line consisted of line for line copies of "originals" by famous name designers and sold from 75 cents to $1.00. Their first issue, on January 8, 1950, was a design by Ceil Chapman originally created for Mary Martin in *South Pacific*. "...[In] 1959, while Vogue was signing Dior, he [James Spadea] negotiated with the Duchess of Windsor to design exclusively for Spadea patterns."[52] The Duchess of Windsor license "...[brought] him an enormous clientele. The patterns, selling for double the price of his other designs (two dollars)."[53]

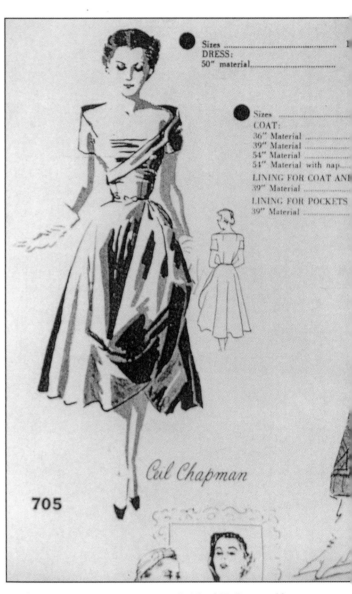

Spadea American Designer pattern #705, 1950. Designed by Ceil Chapman for Mary Martin in *South Pacific*.



54" Fabric	1/2	1/2	1/2	1/2	1/2	1/2	1/2	yard

LINING

36" Fabric	1 1/2	1 1/2	1 1/2	1 1/2	1 5/8	1 5/8	1 5/8	yards
39" Fabric	1 1/2	1 1/2	1 1/2	1 1/2	1 1/2	1 5/8	1 5/8	yards

INTERFACING

25" Fabric	3/4	3/4	3/4	3/4	3/4	3/4	3/3	yard
35" Fabric	5/8	5/8	5/8	5/8	5/8	5/8	5/8	yard

SEWING NOTIONS: Five 1" Buttons, Snappers, Seambinding, 2 1/4 yds. of Braid 1/4" wide (optional).

FABRIC SUGGESTIONS — Linen, Shantung, Plain or Printed Cottons, Rayon or Silks, Faille, Brocaded Silks, Lightweight Woolens or Tweeds. CONTRAST: Linen, Wool Crepe. LINING: China Silk, Rayon Crepe. INTERFACING: Evershape, Cotton Lawn.

#4

...nd a collar set prettily ...scarf. It can be as formal ...ce of fabrics.

COAT $2.00

18 20

.../2 49 49 1/2 inches

70 72 inches

.../2 5 5/8 5 3/4 yards
.../8 4 5/8 4 5/8 yards
.../2 3 5/8 3 5/8 yards
.../8 3 1/2 3 1/2 yards
.../8 3 1/4 3 1/4 yards
.../8 3 1/8 3 1/4 yards
.../8 2 2 1/4 yards
.../2 1 5/8 1 5/8 yards
.../8 1 1/8 1 1/8 yards
...nding, Purchased Scarf.
...rduroy, Velveteen,
... Slipper Satin, Woolens,
...k, Crepe, Satin, Rayon
...ight weight) Cotton
...r) Lightweight Canvas.

Spadea Duchess of Windsor pattern #4, 1959. Designed by the Duchess of Windsor.

Vogue Couturier pattern #974, 1957. Designed by Michael of England.

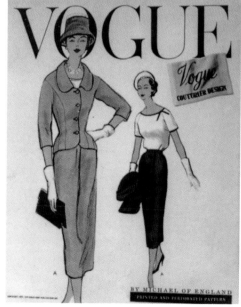

Vogue—Couturier

Vogue incorporated international designers into their Couturier line in 1956; prior to this, all the styles were created by their staff designers. The initial five European designers—John Cavanagh of England, Sybil Connolly of Ireland, Michael of England, Rodrigues of Spain, and Simonetta of Italy —complemented Vogue's roster of Parisian couturiers that designed for their Paris Original Models. The Couturier line, which debuted in 1931, catered to style conscious sewers, had its own logo and numbering sequence, was packaged in a large 8" x 10 1/2" envelope, and included a woven sew-in label.

Vogue—Millinery

Vogue Pattern Book announced exclusive millinery designs from Mr. John, beginning in 1953. Even though these were licensed designs, they were incorporated into the company's regular pattern line and numbering sequence. Throughout the remainder of the decade, this line was expanded to include milliners John Frederics, Patou, and Sally Victor. An example from this line is shown on page 149.

Vogue—Paris Original Models

To much fanfare, Vogue began licensing Parisian couturier designs in the spring of 1949. Their exclusive contract gave them the right to produce line for line copies of selected models from eight internationally known Parisian couturiers— Balmain, Jacques Fath, Jacques Heim, Lanvin, Molyneux, Paquin, Robert Piguet, and Schiaparelli. "Vogue [had] contracts for forty original Paris designs per year from their eight Paris Couturiers."[54] In addition, they had their own logo, envelope graphics, and numbering sequence. And, as with all of Vogue's premium lines, a woven sew-in label was included as an additional sales incentive for these patterns, which were the most expensive on the market at $2.50 each.

Celebrity and Character Licensing

The most popular celebrities and characters from movies and television were also licensed for merchandising purposes. Association with a popular celebrity or character was likely to augment a product's appeal and increase its sales. Character licensing lent itself especially well to applications in children's wear, costumes, toys, and embroidery. Celebrity endorsements, on the other hand, were usually of a stylistic, glamorous nature. Using character tie-ins and celebrity endorsements as a merchandising strategy was not new to the 1950s. In fact, McCall used it in the 1920s with pattern styles capitalizing on Irene Castle's popularity and again in the 1930s with Mickey & Minnie Mouse patterns. An additional example can be found in Vogue's use of celebrity appeal to sell their lower priced Hollywood Patterns line in the 1930s and 1940s.

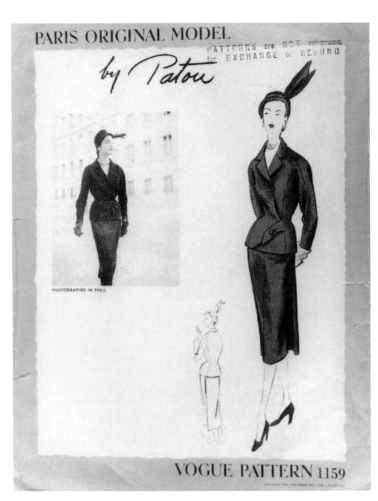

Vogue Paris Original Model #1159, 1951. Designed by Patou.

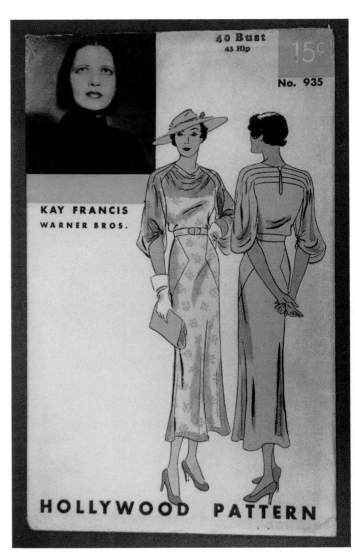

1930s Hollywood Pattern picturing Kay Francis of Warner Bros.

The New Castle Dresses

Specially Designed for Mrs. Irene Castle Treman

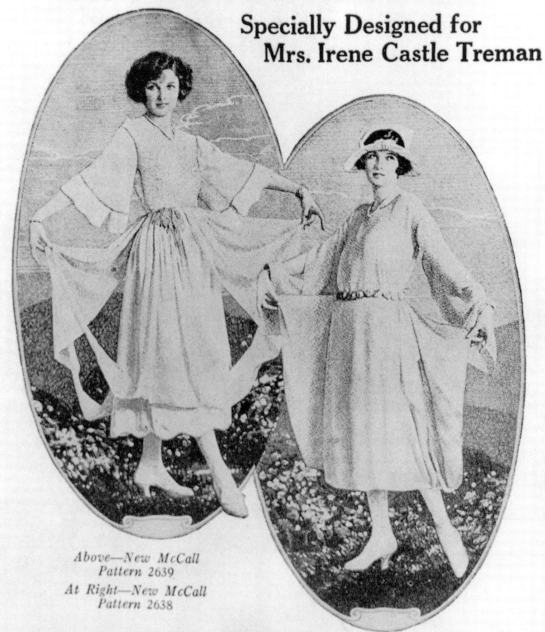

Above—New McCall Pattern 2639

At Right—New McCall Pattern 2638

Irene Castle Photographs On April Fashion Sheet Cover

Send Out April Fashion Sheet As Home Sewing Bulletin

McCall patterns designed for Mrs. Irene Castle from the 1920s.
Courtesy of The McCall Pattern Company.

Advance—Lucille Ball and Desi Arnaz Styles

Sometime after the debut of the *I Love Lucy* television show in 1951, Advance incorporated a number of styles that pictured Lucy and Desi on the pattern envelope.

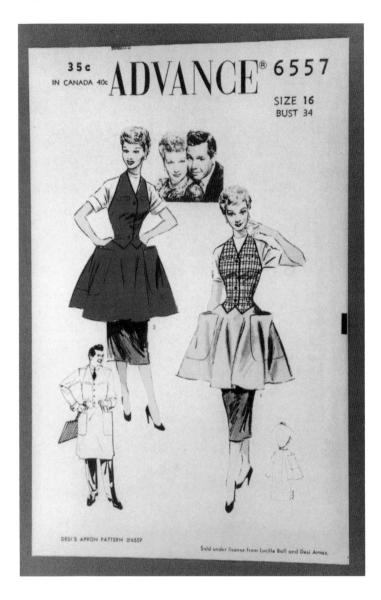

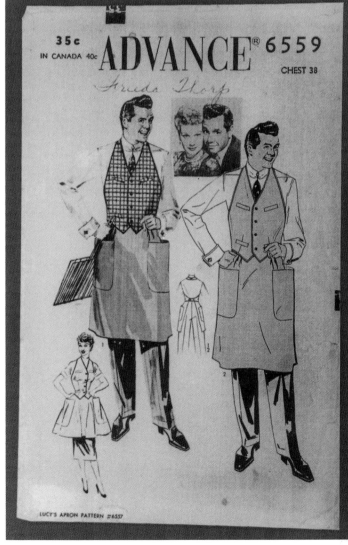

Above and right:
Advance patterns #6557 & 6559, 1953, featuring Lucille Ball and Desi Arnaz. *Courtesy of Teri Jennings.*

Advance—Pat Boone ' Twixt-Twelve-and-Twenty Fashions

This teen line was a tie-in with Boone's popular non-fiction book of the same name, which sold 260,000 copies in 1959.[55] Included were styles for both boys and girls with a few of the designs sized for adults.

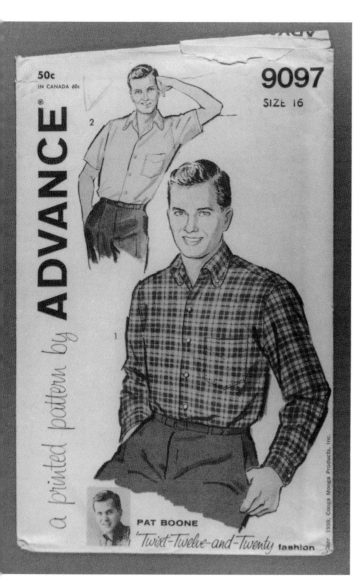

Advance pattern #9097, 1959. A Pat Boone ' Twixt-Twelve-and-Twenty Fashion.

Advance—Peter Pan Character Costumes

This licensed line of costume adaptations coincided with the 1953 release of Walt Disney's motion picture *Peter Pan*. These patterns were included in the 700s numbering sequence of the early 1950s .

Advance—Photoplay and Star Patterns

Advance produced patterns that were featured monthly in the movie fan magazine *Photoplay*. The styles were created by Hollywood costume designers and worn by movie stars in their film roles, such as Helen Rose's design for Jane Powell in MGM's *Nancy Goes To Rio* or Michael Woulfe's design for Janet Leigh in RKO's *Jet Pilot*.

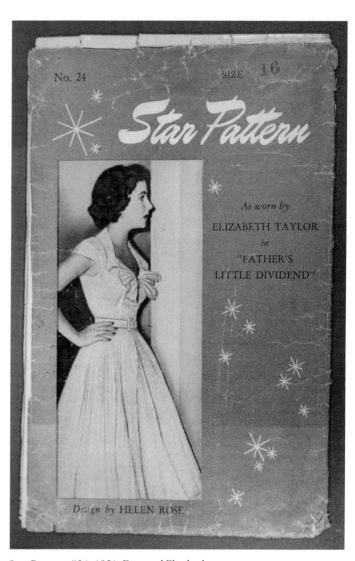

Star Pattern #24, 1951. Featured Elizabeth Taylor, from *Photoplay Magazine*.

Advance—Shirley Temple Doll Wardrobe

Advance issued a wardrobe pattern # 8813 in 1958 to coincide with Ideal Toy Corporation's re-release of their Shirley Temple Doll. The Advance Counter Book described it as clothes designed to help the "Little Mother" keep her Shirley Temple Doll in the height of fashion.

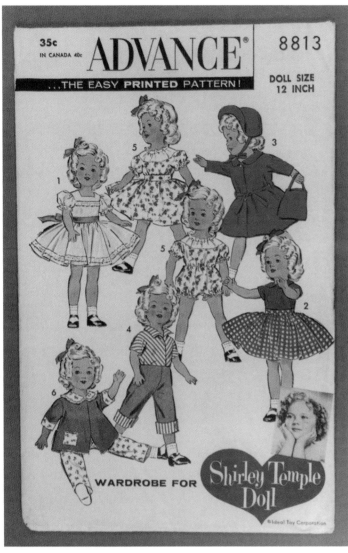

Shirley Temple Doll Wardrobe, Advance pattern #8813, 1958. *Courtesy of James Walski.*

Beauty—Celebrity Photo Patterns

Beauty Pattern Company used celebrities in their catalogs, wearing styles available as patterns in the 1940s and early 1950s. It is unclear if Beauty used publicity stills to base these styles on or if they actually had the celebrities pose in their designs. Although possible, the latter seems unlikely because Beauty Pattern Company worked on a smaller scale than most of the other companies..

Butterick—Chiquita Banana Costume

This character costume pattern #5971 was issued in the fall of 1951 and was available in girls' and misses' sizes. The same pattern style was issued simultaneously by McCall's. They each used the same full page advertisement in their own pattern books, which was most likely supplied by Chiquita Banana's trademark holder, United Fruit Company.

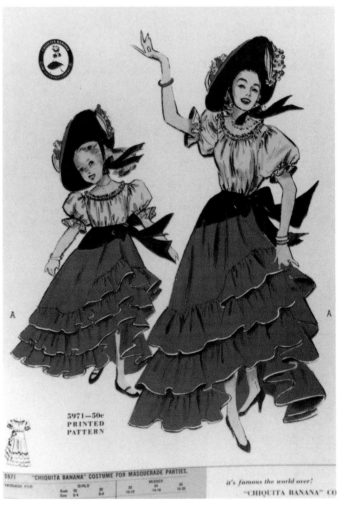

Chiquita Banana costume, Butterick pattern #5971, 1951. *Courtesy of the Irene Lewisohn Costume Reference Library, Metropolitan Museum of Art.*

Butterick—Mrs. Arthur Murray Dance Dresses

Mrs. Arthur Murray, a noted dance expert and the Mistress of Ceremonies of the *Arthur Murray* television show from the early 1950s, designed a line of dance dresses for the Butterick Pattern Company in 1951.

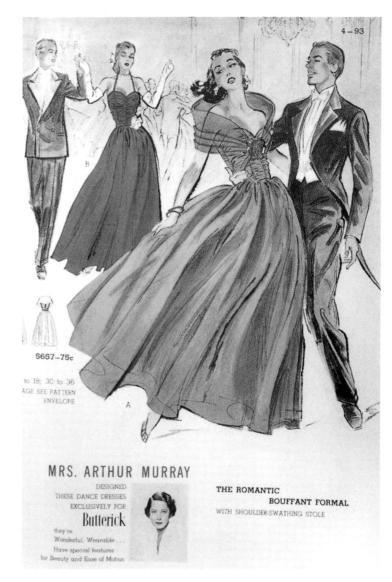

Mrs. Arthur Murray dance dress, Butterick pattern #5657, 1951. *Courtesy of the Butterick Archives.*

McCall's—Appli-Press

For this line of iron-on transfers, McCall's licensed animated characters that included Walt Disney's *Lady and the Tramp*, Woody Woodpecker and friends, and the USDA Forest Services' Smokey The Bear.

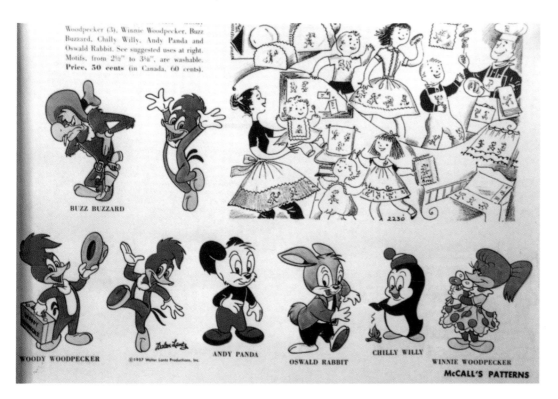

1958 McCall's Appli-Press Fabric Appliqué pattern #2230, featuring Walter Lantz cartoon characters. *Author's collection. Courtesy of The McCall Pattern Company.*

McCall's—Betsy McCall

The Betsy McCall doll, produced by the Ideal Toy Corporation, was based on the popular paper doll character introduced in *McCall's* magazine in May 1951. Throughout the 1950s, many patterns were designed by McCall's using this character as a sales incentive. They also made a Betsy McCall doll house as part of their "Do-it-Yourself" line.

McCall's—Campbell Kids Embroidery Transfers

The Campbell Kids were created in the early twentieth century and used to sell Campbell's Soups. With the advent of their use in television commercials in the 1950s, their popularity soared. McCall's pattern #1909, a child's apron and chef cap, included an iron-on, four-color transfer featuring the Campbell Kids.

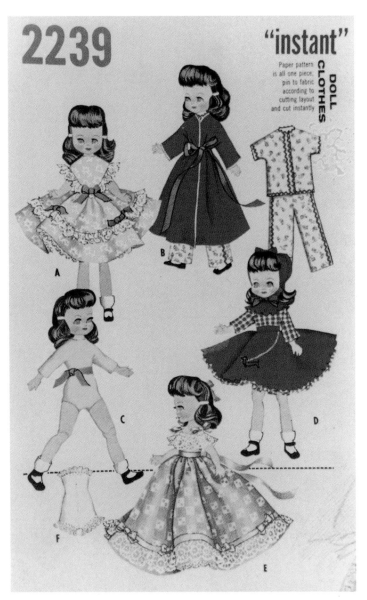

1958 McCall's Instant Pattern #2239, designed for the Betsy McCall doll. *Author's collection. Courtesy of The McCall Pattern Company.*

1954 McCall's child's apron and chef cap pattern #1909, featuring the Campbell Kids. *Author's collection. Courtesy of The McCall Pattern Company.*

40

McCall's—Chiquita Banana Costume

This pattern was issued at the same time as Butterick's version, 1951. In fact, they both used the same full page advertisement in their respective pattern magazines, with the only difference being that Butterick's was incorporated into their regular pattern line and McCall's version was a mail-in offer.

McCall's version of the Chiquita Banana Costume, 1952. This pattern was available through mail order. *Courtesy of The McCall Pattern Company.*

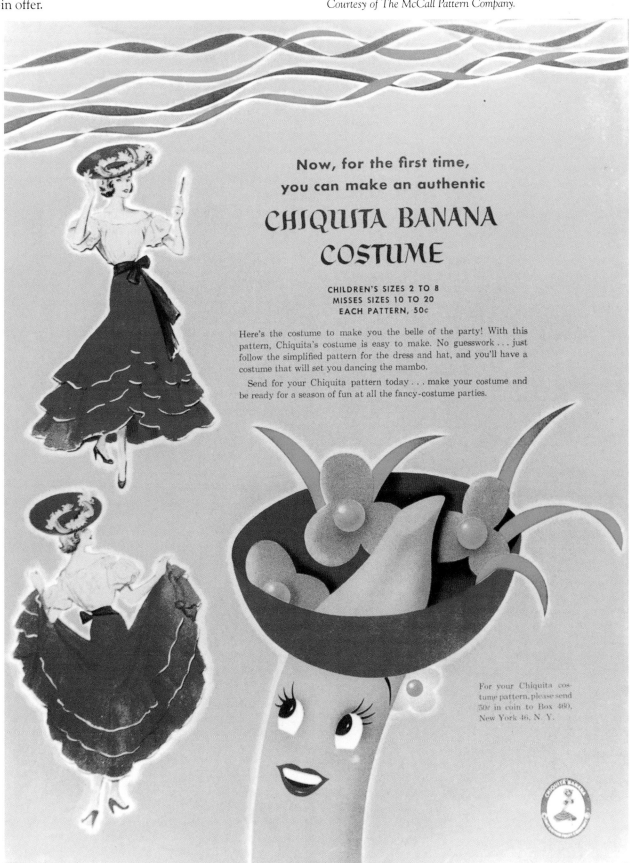

Now, for the first time, you can make an authentic

CHIQUITA BANANA COSTUME

CHILDREN'S SIZES 2 TO 8
MISSES SIZES 10 TO 20
EACH PATTERN, 50c

Here's the costume to make you the belle of the party! With this pattern, Chiquita's costume is easy to make. No guesswork . . . just follow the simplified pattern for the dress and hat, and you'll have a costume that will set you dancing the mambo.

Send for your Chiquita pattern today . . . make your costume and be ready for a season of fun at all the fancy-costume parties.

For your Chiquita costume pattern, please send 50¢ in coin to Box 460, New York 46, N. Y.

McCall's—*Ding Dong School*

These patterns were developed to appeal to children, with the help of television teacher Miss Frances, of NBC's nursery school program, *Ding Dong School.*

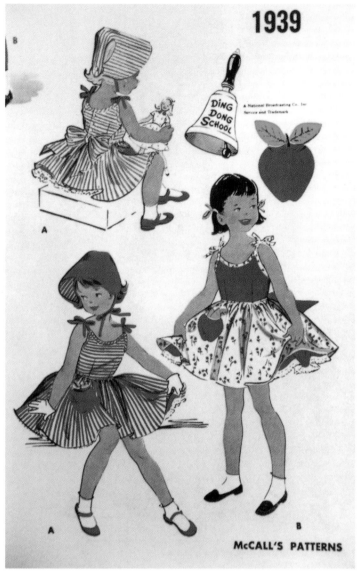

1954 McCall's *Ding Dong School* pattern #1939, approved by Miss Frances, America's most popular television teacher. *Author's collection. Courtesy of The McCall Pattern Company.*

McCall's—Walt Disney's
Alice in Wonderland Costumes

Costumes inspired by Walt Disney's motion picture *Alice in Wonderland* were featured in *McCall's Pattern Book,* Fall 1951. Three designs included Alice's dress and apron as well as the Mad Hatter and the March Hare costumes.

Advertisement featuring McCall's Alice in Wonderland costume patterns, 1951. *Courtesy of The McCall Pattern Company.*

42

McCall's—Miss America Wardrobe

McCall's began its association with the Miss America Organization in 1953, an association that lasted into the 1960s. A wardrobe was designed for Miss America, exclusively using Everfast cottons. Miss America promoted her all-cotton wardrobe on a national fashion show tour of leading department stores, in Everfast advertisements, and in *McCall's Pattern Book* fashion editorials.

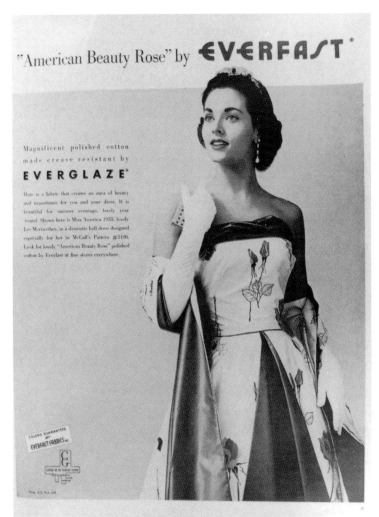

"American Beauty Rose" by EVERFAST*

Magnificent polished cotton made crease resistant by EVERGLAZE*

Advertisement for Everfast Fabrics featuring Miss America 1955, Lee Meriwether, wearing McCall's pattern #3106 designed especially for her. Also shown on page 140. *Courtesy of The McCall Pattern Company.*

Miss America wearing McCall Pattern #9257, 1953. *Courtesy of The McCall Pattern Company.*

Simplicity—Shirley Temple Doll Wardrobe

Again, this was a license that coincided with the re-release of the Shirley Temple Doll in 1958.

Vogue—Ginny Doll - Child & Doll Dress Alike Styles

The Ginny doll was issued by The Vogue Doll Company in 1950. Vogue created patterns for girls that included a matching outfit for their Ginny dolls.

<p style="text-align:center">Chapter 3</p>

Promotion & Advertising

This area of marketing is used to increase visibility and sales of a product or service and it can be directed at both consumers and merchants. It encompasses four separate aspects whose combination can vary between products: 1) sales promotion provides a short-term inducement to purchase; 2) personal selling provides for face to face appeals; 3) public relations provides publicity and other forms of no cost communication intended to influence; and 4) advertising communicates a paid sales message to a targeted market.

Consumer Sales Promotion

Consumer promotions are aimed at the end user of a product. In the case of sewing patterns, this would be the home sewer. Types of promotions can include: product samples, free giveaways, coupons, contests, and informational materials.

Product Samples

Free samples and reduced price coupons were issued to get the product into the hands of the consumer, and this, in turn, hopefully created a new customer.

In the 1920s, Excella and Pictorial Review introduced their new printed patterns with a Special Demonstration Pattern. This campaign gave home sewers the opportunity to try the company's new product without fear of spending money for something that didn't fit their needs. Over the years this type of giveaway sample pattern has been used by most companies.

Pictorial Review Special Gratis Demonstration Pattern.

1950s doll clothes sample pattern from McCall's.
Courtesy of The McCall Pattern Company.

McCall's sample apron pattern, 1958.
Author's collection. Courtesy of The McCall Pattern Company.

In 1950, Butterick created a special "2 patterns for the price of 1" campaign to introduce their new printed patterns. The Weekend Change-About (#5388) included two separate patterns for only 50 cents. McCall's issued 10 cents off coupons to promote five special holiday transfer patterns in their Winter 1957-58 pattern magazine. "These five 'specials' are just a tiny sampling of the catalog-full of Christmas inspiration you'll find in McCall's 'Needlework and Transfer' Pattern Catalog," notes an ad for this campaign. To redeem the coupons, they had to be taken to a McCall's pattern merchant.

Butterick's 1950 promotion campaign "2 patterns for the price of 1" introduced their printed patterns. *Courtesy of The McCall Pattern Company.*

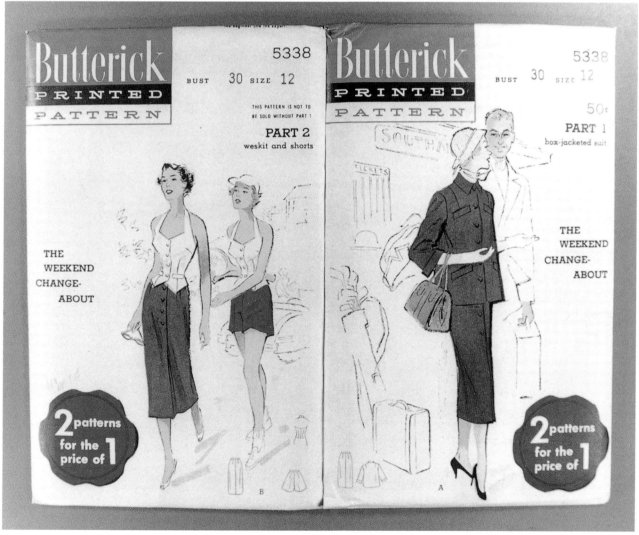

aprons and Western shirts. These are special just a tiny sampling of the catalog-full of Christmas inspiration you'll find in McCall's "Needlework and Transfer" Pattern Catalog.

Save 10c on EACH of these Patterns or BUY UP TO FIVE of one design.

Offer expires December 31st. Subject to local regulations.
Note: Prices slightly higher in Canada.

| McCall's 1990 | McCall's 2180 | McCall's 2150 | McCall's 2182 | McCall's 2177 |

1. SAVE 10¢ with this coupon on any of these patterns: McCall's 1990, 2177, 2180, 2182, regularly 50c; 2150, regularly 35c. Take coupon to McCall's Pattern Counter, at your favorite store.

2. SAVE 10¢ with this coupon on any of these patterns: McCall's 1990, 2177, 2180, 2182, regularly 50c; 2150, regularly 35c. Take coupon to McCall's Pattern Counter, at your favorite store.

3. SAVE 10¢ with this coupon on any of these patterns: McCall's 1990, 2177, 2180, 2182, regularly 50c; 2150, regularly 35c. Take coupon to McCall's Pattern Counter, at your favorite store.

4. SAVE 10¢ with this coupon on any of these patterns: McCall's 1990, 2177, 2180, 2182, regularly 50c; 2150, regularly 35c. Take coupon to McCall's Pattern Counter, at your favorite store.

5. SAVE 10¢ with this coupon on any of these patterns: McCall's 1990, 2177, 2180, 2182, regularly 50c; 2150, regularly 35c. Take coupon to McCall's Pattern Counter, at your favorite store.

McCall's 10 cents off coupon campaign from 1957. *Courtesy of The McCall Pattern Company.*

For a final finishing touch to your garment, you may have without cost a silk label similar to this sketch.
Simply fill in your name and address and mail this card.

Vogue Special Design

NAME _____
STREET _____
CITY _____ STATE _____

Vogue's mail-in post card from the 1940s, entitling the bearer to receive a woven silk sew-in label.

Premiums & Giveaways

Including a woven sew-in label with patterns is one of the oldest premiums used in the pattern industry. This inventive promotion was used in the 1920s by Modele Parisien Patterns.[56] Vogue Pattern Service began using this premium in the 1930s. They included a mail-in postcard with each pattern, entitling the bearer to receive a woven silk label that could be sewn into their home sewn garment—just like couture or store bought.

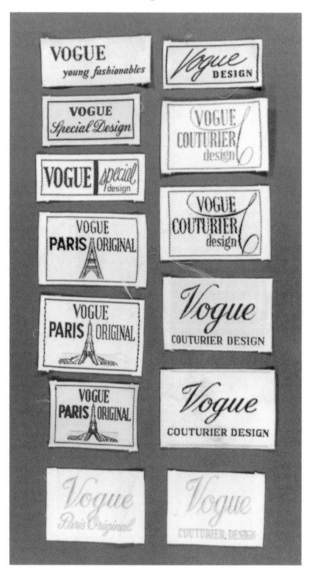

Assorted Vogue premium sew-in labels.

Another premium, started decades before but still used in the 1950s, was the inclusion of a free pattern printed in pattern magazines. This was usually a ladies' hat or similar type project, one that would motivate magazine sales. This same premium was also used in the early 1950s by the Talon company, who designed free patterns exclusively for *McCall's Pattern Book*. Each of these patterns called for the use of a Talon zipper—this not only promoted their product but developed consumer goodwill as well.

The "Sand Satchel" designed by Talon was a free pattern promotion included in *McCall's Pattern Book* Mid-Summer, 1953. *Courtesy of The McCall Pattern Company.*

Premiums were also used to promote new products—a free hostess apron was given away in 1957 on the CBS television program *Arthur Godfrey Time* to promote Singer's Slant-O-Matic Sewing Machine. Further, a giveaway "Cinderella" apron pattern, which was a tie-in with both the release of Walt Disney's animated motion picture and national "Sew and Save Week," was issued in February 1950 by the J.C. Penney Company. Butterick also participated in the "Sew and Save" promotion by issuing a free handbag pattern for their merchants to give away. This promotion received additional press from *Women's Wear Daily*, which reported on the week's events and activities. Finally, industry associations such as the National Cotton Council issued giveaways like the *IDEAS For Sewing With Cotton Bags* booklets, designed to promote sewing with cotton fabrics used to package feed, flour, fertilizer, and sugar.

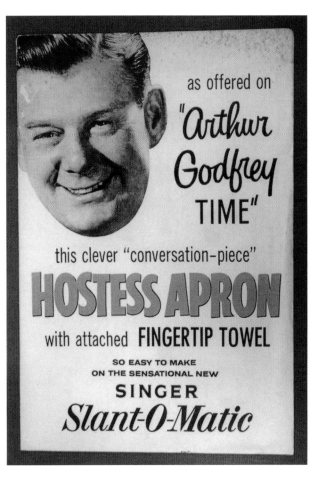

Singer offered a hostess apron pattern on the *Arthur Godfrey Time* television program to promote their new Slant-O-Matic sewing machine.

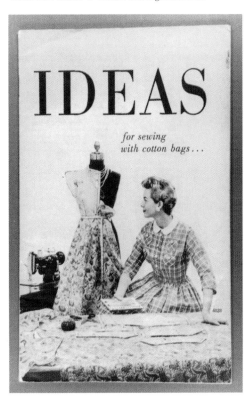

The *IDEAS for sewing with cotton bags* booklet was given away by the National Cotton Council to promote the use of sewing with cotton feed sacks. This 1954 issue featured Simplicity Patterns.

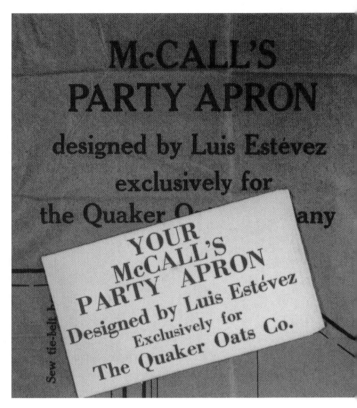

Undated McCall's Party Apron designed by Luis Estévez and used as a Quaker Oats Company premium. *Author's collection. Courtesy of The McCall Pattern Company.*

Undated giveaway pattern from Butterick and Macy's Fabric Centre. *Courtesy of the Butterick Archives.*

Personal Selling

Even though the most important sales tool for selling patterns is the in-store counter catalog, brochures issued to the managers of pattern sales departments stressed the importance of personal selling. "...[The] sale of a [pattern] is not just a matter of handing a customer an envelope containing pieces of tissue paper and ringing up the amount on the cash register. She needs your guidance!"[57] Sales clerks were encouraged to wear their own home sewn garments on the job to instill confidence with their customers.

Further, personal selling was done by pattern company representatives in conjunction with retailers on co-promotions such as sewing contests, fashion shows, and technical demonstrations. These special events gave pattern company representatives the opportunity to meet the customers, answer questions, inject excitement into the new styles, and motivate purchases of both patterns and piece goods.

Contests

Sewing contests were also used as a promotion to encourage product usage and brand name recognition. Many of these were co-sponsored by fabric, sewing notions, and sewing machine manufacturers, who would also benefit from this type of promotion. The contests usually required the use of specified products (such as a brand X pattern used in conjunction with a brand Y zipper) in order to enter. Contests were co-sponsored by the pattern companies and fabric stores in order to promote the sale of fabrics and patterns purchased in the co-sponsoring stores. This type of promotion provided the press with material for write-ups and consumer interest stories. An early example from the 1920s was initiated by McCall to publicize their "New Printed Patterns." This was a co-sponsored promotion with piece goods merchants. McCall advised stores that: "The object of the Doll Dressmaking Contest is to show little girls how to sew, to interest mothers in the Printed Pattern and to turn attention to the sewing service of your store."[58] Special miniature printed doll dress patterns were distributed to be used by the contest participants.

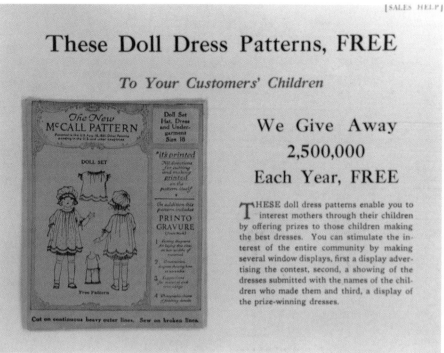

McCall used mini-patterns as a giveaway promotion for their doll dress making contests. This example is from the 1920s. *Courtesy of The McCall Pattern Company.*

McCall's Easter Parade Fashion Contest. This contest called for entrants to submit a complete costume plan, including color, fabric, and accessory choices, as well as a short statement about why they chose that particular McCall's design. They also had to attach the McCall's pattern envelope to their entry form, which acted as their proof of purchase.

Scholastic Art Awards. McCall's Pattern Company co-sponsored the costume design division of the *Scholastic* Art Awards in 1953 and 1954. The winning designs of this contest, open to secondary school students, were made into patterns by McCall's.

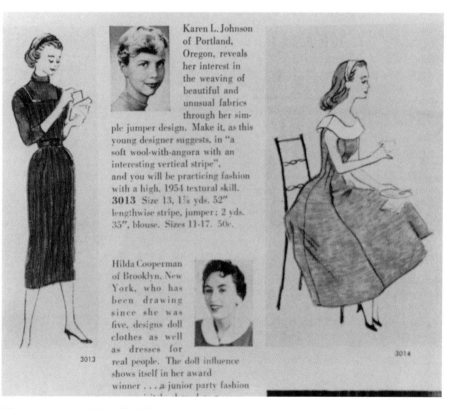

Winning designs of the 1954 *Scholastic* Art Awards adapted by McCall's for their pattern line. *Courtesy of The McCall Pattern Company.*

Singer Junior Dressmaking Contest. Singer began sponsoring the Junior Dressmaking Contest in 1953 to increase enrollment in the Teenage Dressmaking Course at their Singer Sewing Centers. All entrants had to have taken the dressmaking course, which cost $8.00 and consisted of eight lessons, two and a half hours each. This annual event lasted into the 1960s.

Singer "Grand Sew-Off" Contest. In 1956, Singer Sewing Machine Company sponsored the first $125,000 Singer Sewing Contest. Again, this promotion was open to those enrolled in a Home Dressmaking Course at the local Singer Sewing Center. Thirty-three finalists from across the country were flown to New York City to compete in the "Grand Sew-off." Each contestant had to make a garment for a professional model. The contestants began the "Sew-off" on Saturday morning and ended on Tuesday evening. The finished garments were individually judged for fit, technique, and style. This contest was also used by the pattern companies to promote any of the winners who happened to have used patterns from the respective company. Numerous examples of this promotion can be seen in the pattern magazines of Butterick, McCall's, and Vogue from the 1950s.

Cotton Bag Sewing Contest. The National Cotton Council's "Cotton Bag Sewing Contest" from the mid 1950s was promoted through state and regional fairs. All of the articles entered in the numerous categories, such as Pair of Curtains, Stuffed Toy, Place Mats with Four Napkins, and Mother-Daughter Dress Ensemble, had to be made entirely from cotton bags with the exception of trimmings or buttons. The grand prize winner was crowned the Cotton Bag Sewing Queen!

Consumer Public Relations

Public relations is aimed at influencing sales through publicity and editorial promotions in any form of the media. In addition to the pattern companies, trade associations and governmental agencies were also important for industry public relations and promotion. These included the cotton, silk, and wool manufacturers' associations as well as agencies like the USDA's Bureau Of Human Nutrition and Home Economics and the Cooperative Extension Service. Organizations like the National Needlecraft Bureau issued sewing leaflets and sponsored an annual "Sew And Save Week" campaign to promote sewing and the sale of piece goods. This national event was heavily promoted to the public by both the pattern companies and the merchants. All of these efforts were aimed at promoting more sewing and needlework.

Sewing Industry Company Education Departments

Pattern company education departments also fit under the guise of public relations. Their duties and policies were in place to create enthusiasm and influence the development of new sewers, thus ensuring the livelihood of the market and the sale of their products. The numerous charts, brochures, and sample patterns issued by these departments assisted sewers interested in developing their skills. These brochures also instilled confidence that anybody could achieve a custom look with patience and practice and that the pattern companies were ready to help solve any problems that arose. They also developed education programs and seminars that were co-sponsored with retail merchants who sold their products and with associations like the Girl Scouts of America and the 4-H Clubs.

Further, fabric, notion, and sewing machine companies also had a vested interest in the development of new home sewers. Their education departments served to keep sewers apprised of their new products, innovations, and technologies as well as encourage more home sewing. A Coats & Clark's sales brochure noted that, "Since 1930, [Coats & Clark's Educational Bureau's] professional staff of home economists has been proving that the more a woman knows, the more she sews...and buys. A unique service unit within the Bureau is the sewing laboratory, staffed with specialists charged with developing 'housewife simplicity' in sewing techniques. In addition, their consumer consultants hold sewing and needlework clinics in over 250 stores per year."[59] Other major companies, like Talon, Celanese, and Singer, all had similar education departments.

USDA Bureau of Human Nutrition and Home Economics

The United States Department of Agriculture's Bureau of Human Nutrition and Home Economics was involved with consumer education and research that specifically related to home sewing. In the 1930s, the Bureau designed children's clothing that was easy for children to put on themselves and affordable to make. During the 1940s, they designed work clothing or "functional garments" to meet the needs of women entering the work force. These designs were made available to the commercial pattern industry at no charge, in hopes that these styles would be included in their catalogs. See *Blueprints Of Fashion, 1940s* (Schiffer Publishing, 1997) for further discussion and illustrations.

The Bureau's education efforts were expanded in the late 1940s to include the use of television. This new medium was becoming an important educational tool because of its ability to disseminate information to large numbers of people. It was felt that "...[any] subject that has been found good for demonstrations by extension people in the past can be used on television."[60] In addition, the Bureau created many booklets and pamphlets to instruct and assist homemakers in such areas as basic dressmaking, converting men's suits into ladies' suits, and sewing machine repair.

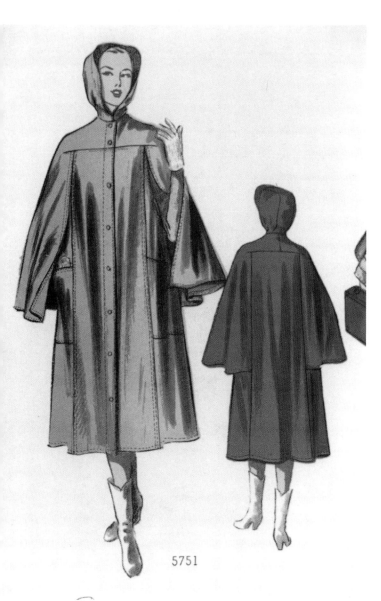

5751

The New York Times reported on August 16, 1950, that clothing specialists from the USDA Bureau of Human Nutrition and Home Economics had shown two new designs for rainwear that could be made at home. Advance pattern #5751, issued in 1951, features cape-sleeves that zip from top to bottom and can be adjusted to allow for varying degrees of mobility.

Editorial Promotions

Editorial tie-ins between fabric manufacturers and pattern companies were common promotions featured in pattern catalogs and magazines. Model garments were made up in new fabrics, with credit given to the manufacturer and occasionally to the retailer where the fabrics could be purchased. Additional promotion opportunities were provided by women's interest magazines, which featured patterns on a monthly basis. This tie-in promotion gave the readers a fashion/pattern feature, provided exposure for the pattern company, and paid the publications a royalty based on the number of featured patterns sold.

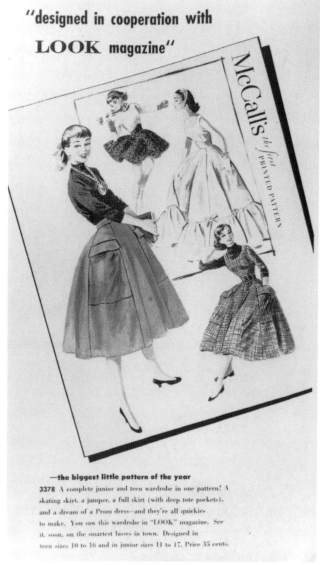

"designed in cooperation with LOOK magazine"

McCall's *the first* PRINTED PATTERN

—the biggest little pattern of the year

3378 A complete junior and teen wardrobe in one pattern! A skating skirt, a jumper, a full skirt (with deep tote pockets), and a dream of a Prom dress—and they're all quickies to make. You saw this wardrobe in "LOOK" magazine. See it, soon, on the smartest lasses in town. Designed in teen sizes 10 to 16 and in junior sizes 11 to 17. Price 35 cents.

Editorial promotion between *Look* magazine and McCall's. *Courtesy of The McCall Pattern Company.*

An example of an editorial promotion is *Mademoiselle* magazine's monthly feature of McCall's Patterns beginning in February 1956. "Their fashion editors and our designing group will be working together closely to create patterns that reflect the fashion viewpoint of Mademoiselle's young readers,"[61] noted the *McCall's Pattern Book* that year. These patterns were given a special imprint on their envelopes designating them as a "Mademoiselle Editors' choice." Another example of promotion was McCall's participation in the Museum of Modern Art's 1956 textile exhibition, "Textiles, U.S.A." Thirty new McCall's patterns, including their new couturier line (Givenchy, Trigère, and Helen Lee), were made up in over-the-counter fabrics. A fashion show based on the fabrics selected for the exhibit was also offered to leading stores for a fall presentation.

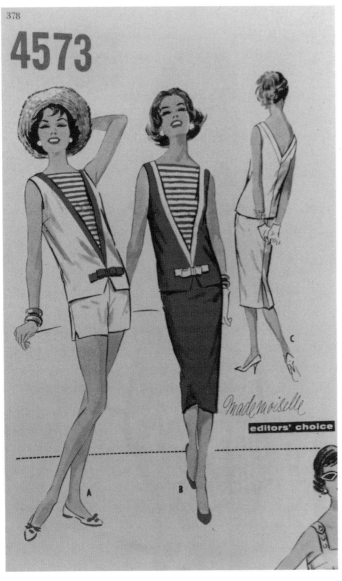

McCall's styles featured in editorial promotions from *Mademoiselle* magazine were labeled a "*Mademoiselle* editors' choice." *Author's collection. Courtesy of The McCall Pattern Company.*

McCall's pattern styles featured in the 1956 Museum of Modern Art exhibition, "Textiles, U.S.A." *American Fabrics* No. 38 August 1956. *Courtesy of the Irene Lewisohn Costume Reference Library, Metropolitan Museum of Art and The McCall Pattern Company.*

Celebrity Editorial Promotions

Celebrities were also used to increase sewing pattern company visibility through editorial promotions and television appearances. Some examples include:

Jinx Falkenburg wore McCall's and Vogue pattern styles in her numerous television appearances in the 1950s. Lee Meriwether wore Simplicity pattern styles for her 1956 appearances as "Today's Girl" on NBC-TV's *Today* show with Dave Garroway.

NBC-TV's *Queen For A Day* program promoted McCall's patterns by having the show's fashion authority, Jeanne Cagney, model three specific numbers during the week of April 22, 1957. These were all made up in Alreco Fabrics, which promoted their tie-in with a full page ad in *McCall's Pattern Book*, Summer 1957.

McCall's promoted The Maid Of Cotton Beauty Pageant in the early 1950s. This promotion was similar to the Miss America Wardrobe, in that it was a companion promotion between the fabric manufacturers and McCall's Patterns and was promoted by a touring fashion revue and pictorial layouts in *McCall's Pattern Book*.

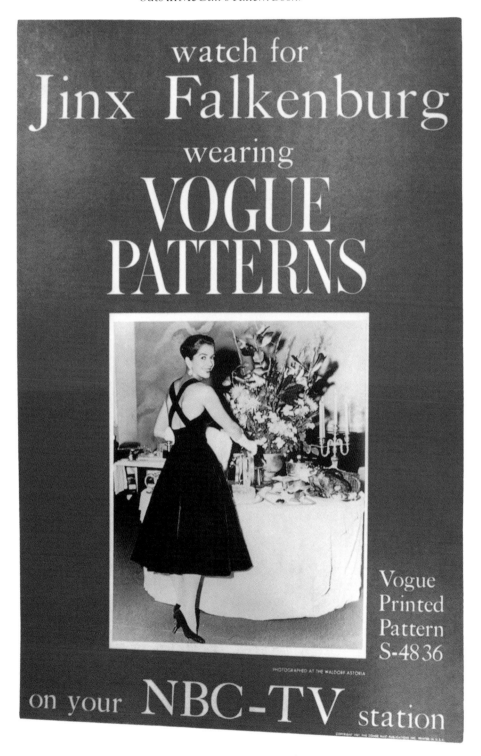

Vogue Patterns poster featuring television celebrity Jinx Falkenburg. *Courtesy of the Butterick Archives.*

Simplicity Patterns/NBC promotional
advertisement from *Modern Miss*, Spring, 1956.
Courtesy of Simplicity Pattern Company.

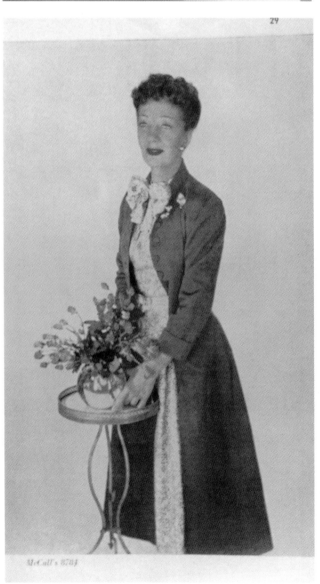

TONY PERKINS
and
JANE FONDA
star in the movie,
"TALL STORY."
Here, Miss Fonda
wears
McCall's Pattern
5200

Jane Fonda wearing McCall's Pattern #5200 to promote the movie
Tall Story. Author's collection. Courtesy of The McCall Pattern Company.

Gertrude Lawrence featured in a 1952 *McCall's
Pattern Book* fashion editorial, wearing pattern
#8784. *Courtesy of The McCall Pattern Company.*

Consumer Advertising

The industry also advertised in consumer oriented media such as magazines, newspapers, or television to help sell their product. In addition, they used their own counter books, pattern magazines, and giveaway pamphlets to continually remind customers of their latest products and services.

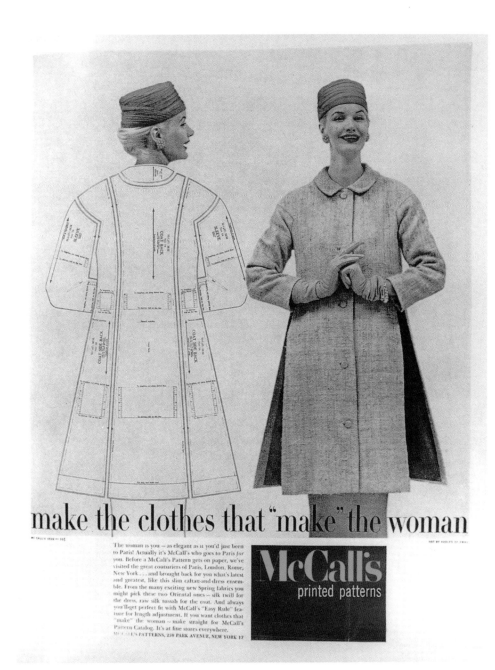

make the clothes that "make" the woman

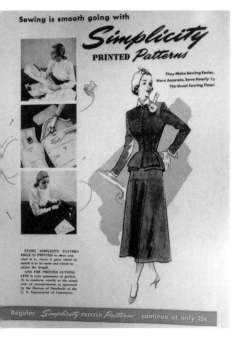

Simplicity Printed Pattern advertisement featured in a 1950 *Simplicity Needlework Catalog.*

"McCall's Printed Patterns Make The Clothes That Make The Woman" advertising campaign from the mid-1950s. *McCall's Pattern Book. Courtesy of The McCall Pattern Company.*

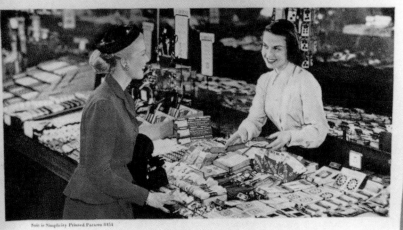

F.W. Woolworth's sewing department advertisement featuring Simplicity Pattern #8454. *Unknown publication.*

Professional Promotion

The home economist in business is the liaison between the manufacturer and the consumer— not only bringing to the consumer information about new products and how to use them but to the manufacturer the most reliable reports on what the consumer is asking for.[62]

Professional educators were targeted with special promotions as well as advertisements in such trade publications as *Practical Home Economics* and *The Home Economics Research Journal*. Further, specialized magazines and school catalogs were created by the pattern companies specifically for home economics teachers and students. These magazines included Simplicity's *Modern Miss; the fashion magazine for home economists and their students* and McCall's *School Stylist*. Attracting teachers was important because of the influence they had on the purchasing power of impressionable beginners. The companies created low cost educational filmstrips, brochures, and patterns designed for classroom use, fashion shows for teachers to preview the latest styles, and lecture demonstrations at home economics conventions. McCall's also created the "Teen Fashion Board" to award students for outstanding achievement in sewing class work. To be granted membership in this honorary organization, teens had to be nominated by their home economics teachers.

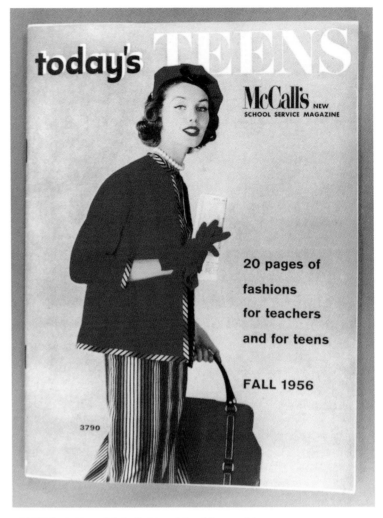

1956 *Today's Teens*, McCall's New School Service Magazine for home economics educators and their students. *Author's collection. Courtesy of The McCall Pattern Company.*

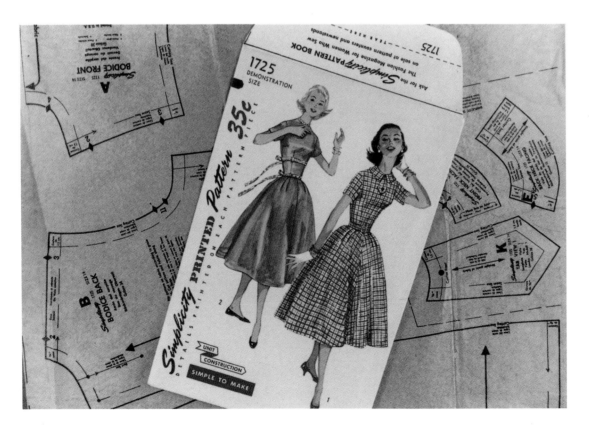

Demonstration half-size pattern designed for classroom use, Simplicity #1725, 1956.

During the 1920s, McCall advised pattern merchants how to motivate teachers with their McCall School Patterns. This early educational pattern line was printed all in one piece to facilitate easy blackboard display. In the 1950s, their Basic Teaching Pattern was provided free to teachers for classroom demonstrations. "All the Steps in making the average garment are included in this basic fashion: setting in sleeve, neck facing, inserting slide fasteners, attaching bodice to skirt, darts in bodice and skirt hems."[63]

Simplicity Basic Pattern for educational purposes.

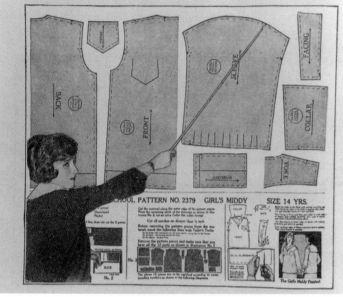

1920s McCall School Patterns were printed all in one piece to facilitate easy blackboard display. *Courtesy of The McCall Pattern Company.*

McCall's Basic Teaching Pattern from the early 1950s, distributed to home economics teachers free of charge. *Courtesy of The McCall Pattern Company.*

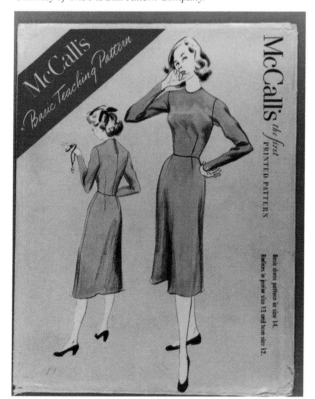

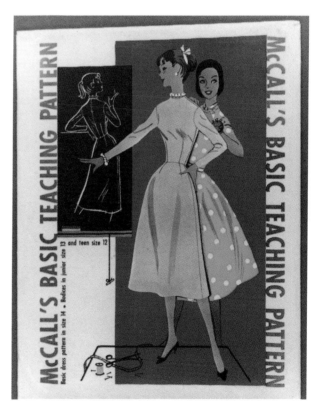

A later version of McCall's Basic Teaching Pattern from 1956. Notice the difference in the skirt shape. *Author's collection. Courtesy of The McCall Pattern Company.*

Singer Sewing Machine Company also promoted heavily to these professionals. They provided many different types of educational materials for classroom use—Sewing Guides, Student Manuals, Stitching Practice Charts, Threading Charts, and Instructional Wall Charts. They also advertised their new model Combination Sewing And Cutting Table, which was manufactured specifically for school use. Another advertisement placed in *Practical Home Economics* enticed teachers to, "Bring your sewing machines up-to-date with a Singer replacement plan!" All of this promotion was aimed at influencing home economics teachers to request Singer Sewing Machines and equipment for their classrooms.

Singer also promoted their Teen-Age Sewing Classes in professional journals, so that teachers would encourage students to continue their sewing education at a Singer Sewing Center. "Come and bring your class for a guided tour' of your Singer Sewing Center."

Further, Vogue's "Young Fashionables" Patterns, introduced in 1956, were advertised in the *Journal Of Home Economics* as designed for school use and geared to a variety of classroom projects—they were graded for progressive degrees of sewing skills, style integrated for good wardrobe coordination, and packaged with a beginner's sewing guide in each pattern envelope.[64] Also available were Basic Demonstration bodices in pre-shrunk percales. Another tool introduced by Vogue in 1959 was their Magnetic Board Kit, designed to teach fashion consciousness to junior high and high school students.

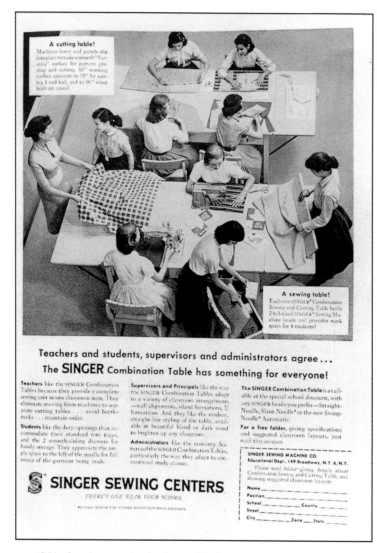

1956 advertisement for the Singer Combination Table aimed at the home economics market.

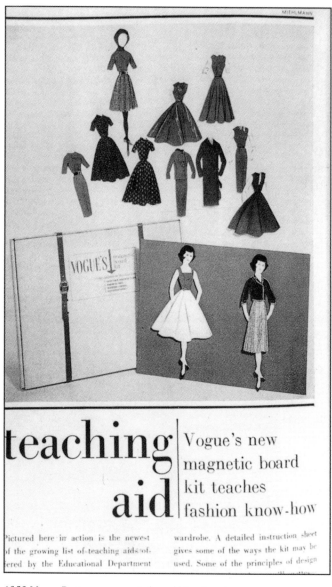

1959 Vogue Patterns magnetic board kit advertisement. *Courtesy of the Butterick Archives.*

Trade Promotion

Promotion was also important for attracting attention from pattern merchants. Competing companies vied to gain a portion of the limited floor and display space allotted to the sale of patterns. Merchants were provided with a wide variety of display and point-of-purchase materials because this type of support for products at the retail level was important for increasing visibility and sales. "There are special promotions geared for different types of stores, all the way from the large department stores and chains to the smaller stores."[65]

Pattern manufacturers also promoted the idea of multiple sales to pattern retailers. A pattern sale was more than just a ten cent sale, it was a sale that would lead to the purchase of dress goods and notions, and, for department stores, all the typical accessories that completed an ensemble—shoes, hats, bags, gloves, and hose.

Merchant Support

Pattern manufacturers assisted their merchants with merchandising, promotion, and advertising ideas designed to build consumer traffic, thereby increasing sales and profits. These included numerous publications, professional fashion stylists, and pattern company sponsored fashion shows. The industry's publications and newsletters, like the *Butterick Barometer*, *Butterick's Fabric Market Report*, *McCall's Ad-Sheet*, and *McCall's Piece Goods, Yarn & Notions Merchandiser*, were specifically created as motivational tools for pattern merchants. These publications illustrated different promotion, advertising, and display ideas that could be adapted to fit each merchant's needs. They also served to keep merchants informed of new products and the prevailing trends in fashion and fabric.

Further, another merchant promotion was created to assist merchants with fabric sales. Specially designed patterns like Butterick's "One-der Skirt" pattern of August 1951 were hyped as a means to increase fabric retailers' wool jersey sales figures: 1 Yard + 2 Hours + Butterick Pattern # 5883 = The One-der Skirt. "Your Customers will want to make the One-der Skirt because: It's fashion-right; It's economical; It's easy to sew."

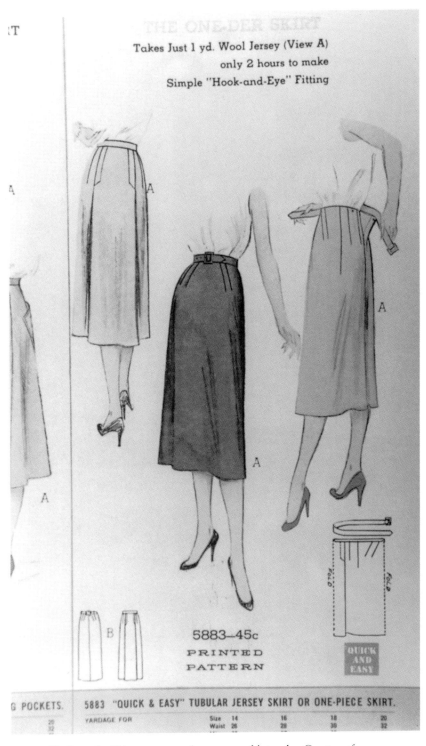

Butterick's One-der Skirt pattern used to promote fabric sales. *Courtesy of The Irene Lewisohn Costume Reference Library, Metropolitan Museum of Art.*

Merchandising Materials

Pattern companies printed an amazingly large number of materials to help sell their products. As pattern styles were discontinued, however, so too were the merchandising materials associated with those patterns. As new styles were added, the sales catalogs had to reflect these changes as well.

Counter Catalogs

These large, in-store catalogs contain each company' s entire line of available styles. These are the most important tools in selling patterns because most customers become familiar with the styles through catalogs found in the pattern outlets. Smaller specialty catalogs were also issued to promote special lines, such as McCall's Gift line, Simplicity Designer Patterns, or Vogue Junior Patterns.

Giveaway Pamphlets

This monthly mini-catalog was given away in pattern departments to promote the latest styles and seasonal sewing ideas. Customers took these home and looked through them at their leisure. Some of the companies also used this as a forum to introduce new products and sewing technique hints. *McCall's Style News* included a monthly column feature called "Adventures In Sewing" that gave sewing technique tips on how to insert a zipper or make bound buttonholes. Even though this was free to customers, the merchants who contracted for the service had to pay for a minimum number each month. They were also given the option to imprint their name and store location on these pamphlets for an additional charge.

Pattern Magazines

These glossy, fashion-like magazines editorialized the new trends, styles, and products available to home sewers. They also provided the publishers with additional advertising revenue from other related companies interested in attracting the specialized home sewing market. Most of the pattern companies had their own form of this type publication, featuring their latest patterns, sewing techniques, etc.

Point Of Purchase Materials

Point of purchase display advertising is prepared by the manufacturer to be used where the product is sold. These displays give visual support to the products. In the retail sales environment, this type of promotion was an important part of any merchandising strategy and was used by most companies. Retailers were offered the opportunity to purchase specially designed store fixtures that held and displayed each company's products to their best advantage.

Pattern storage and display cabinets from Butterick. *Courtesy of the Butterick Archives.*

Butterick's 1958 Annual Report illustrated their newest merchandising method—an open display rack that "...[c]ombines powerful display with the convenience and effectiveness of a self-service operation." This addition to the traditional merchandising method of the pattern catalog and pattern cabinets was specifically geared to the needs of smaller traffic areas. "It permits us to sell Butterick Patterns in small towns, neighborhood shopping areas, and other new areas of distribution."[66] Some companies issued display posters monthly, featuring the newest pattern styles in the latest fabrics. These were used in window and fabric displays, again aimed at increasing fabric and pattern sales.

DIVISION

traditional method of merchandising patterns.
and illustration) continues as the predominant
ay (right-hand illustration) combines powerful
veness of a self-service operation. It has been
ibroad in hundreds of stores that are moving

Butterick introduced this new self-service approach to merchandising patterns in 1958. *Courtesy of the Butterick Archives.*

Pattern companies also offered miniature manikins with which to display their pattern styles. These manikins were another way of promoting a merchant's new fabric and pattern styles without the expense and labor of making-up a full scale version. When used properly, they provided customers with a three dimensional representation of a garment the customers could make for themselves. A McCall's publication advised merchants that "[s]ome patterns will turn out to be hot reorder numbers when given the proper exposure,...put it into a model garment on a mannikin, and watch it take off!"[67] McCall's used this type of merchandising program from the 1930s to the 1950s, with "Minikins" designed by renowned doll sculptor Margit Nilsen. This pro-

gram provided a special pattern service of four current patterns monthly to all the merchants who ordered these Minikins.

Trade Advertising

Trade advertising was aimed at retailers who sold patterns, fabrics, and sewing supplies. It was a way to introduce new products, announce special promotion or advertising programs, or convince retailers to stock and sell the advertiser's brand. Examples from the home sewing industry can be found in trade publications such as *Women's Wear Daily* and *American Fabrics*.

Chapter 4
Manufacturing And Distribution

*...The pattern is created to express the styles that are in
vogue at the time you wish to make your dress.*[68]

The pattern industry has never initiated style trends, it has always followed the fashion industry's lead. As a result, the styles produced as sewing patterns are directly related to popular culture and fashion trends. Because sewing patterns are sold as fashion, new trends are carefully evaluated, adapted, and incorporated; outdated styles are continually replaced. Further, each trend is adapted so that it relates to the company's whole pattern line as well as to the skills of home sewers. Pattern manufacturers had the additional burden of having to anticipate the demands of the coming season, due to the extra time needed to adapt and issue their version of the style. As the industry has incorporated new technologies, this lag time between inspiration and adaptation has decreased dramatically.

Design of a Sewing Pattern

Design inspiration for pattern styles comes from any number of sources—couture and ready-to-wear markets, new fabric technologies, and current trends in art and design. Pattern company designers develop their ideas from any combination of these sources that they feel will suit their customers' needs. Once the styles are sketched and approved they are made up into a muslin or mock-up. From this muslin (once it is adjusted and approved), a master pattern is cut. The pattern is then sent to a test dressmaker who makes up the garment to test the pattern's accuracy. Further adjustments are made to the master pattern if necessary. The master pattern is then graded or sized into the various sizes in which the style will be offered. Simultaneously, the sewing instruction sheets are both written and illustrated and then tested for accuracy.

Each pattern style is illustrated in suitable fabrics, showing different ways of interpreting the design. These different views help sewers visualize the varied ways of adapting and individualizing the same pattern. The illustrations are also used for the pattern envelope, the counter catalog, and other types of promotion. Next, the pattern is manufactured—simplified, this involves printing, cutting, folding, and packaging. The actual procedures for each of these activities is far more technical than the scope of this volume.

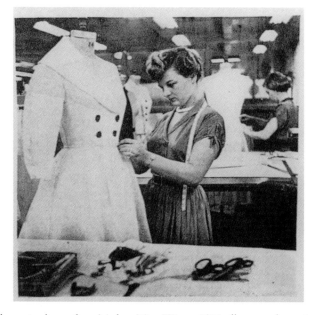

These six photos from *Modern Miss*, Winter 1951, illustrate the major steps in creating a pattern. First, the draper creates a half-model muslin on a dress form, reproducing the designer's sketch. *Courtesy of Simplicity Pattern Company.*

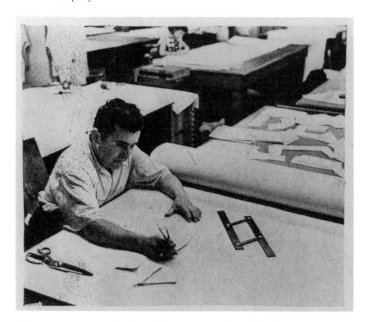

Master pattern is graded into the size range for each style.

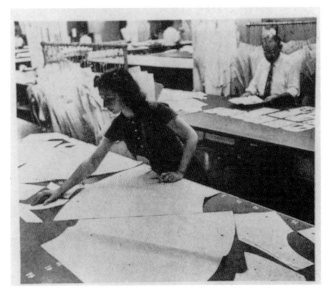
Cutting layouts are carefully arranged to minimize fabric waste.

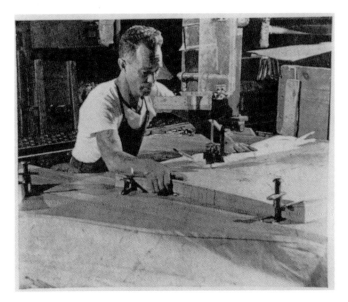
Stacks of printed patterns, 1100 sheets thick, are cut following the outline of each piece.

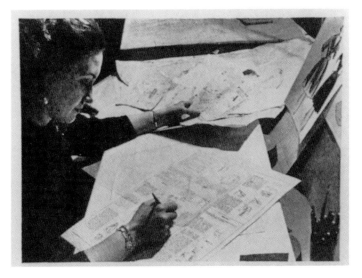
Guide Sheets are written and illustrated to accompany each pattern.

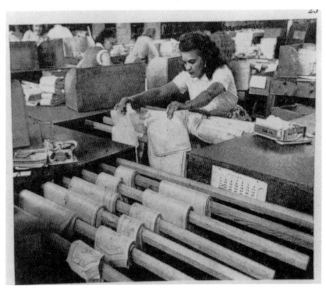
Each pattern must be compiled and folded by hand to fit into the envelope.

Distribution

Sewing patterns have several specific channels of distribution that have been in existence since the beginning of the twentieth century. During the 1950s these included:

- Retail outlets: fabric stores and fabric departments.
- Catalog mail order: Sears, Roebuck & Co., J.C. Penney, Speigel, etc.
- Magazine editorial mail order: *Women's Day, Ladies' Home Journal*, etc.
- Manufacturer mail order: ordered directly from monthly pattern magazines.
- Syndicated newspaper mail order: ordered from daily syndicated newspapers.

Inventory Control

Pattern companies continually change their inventory to remain up-to-date with fashion trends and fads. Periodic shipments of new styles, known as the "standing order," keep the merchant's stock current with the pattern company's changes. Further, slow sellers or out-of-date fashions, known as "discards," are pulled from the line. They are usually in the same ratio as the new styles added. This keeps the merchant's inventory at about the same number of styles in any given month.

Merchants are also encouraged to do a semi-annual inventory, in order to maintain a balanced stock of current patterns that have sold down, but have not been reordered. This is true of perennial sellers that can stay in the line for many years, particularly men's wear, children's wear, sleepwear, and needlework patterns. An out of stock pattern is a lost sale which leads to a lost fabric sale, a lost notion sale, and so on.

Pattern Illustrations

DRESSES

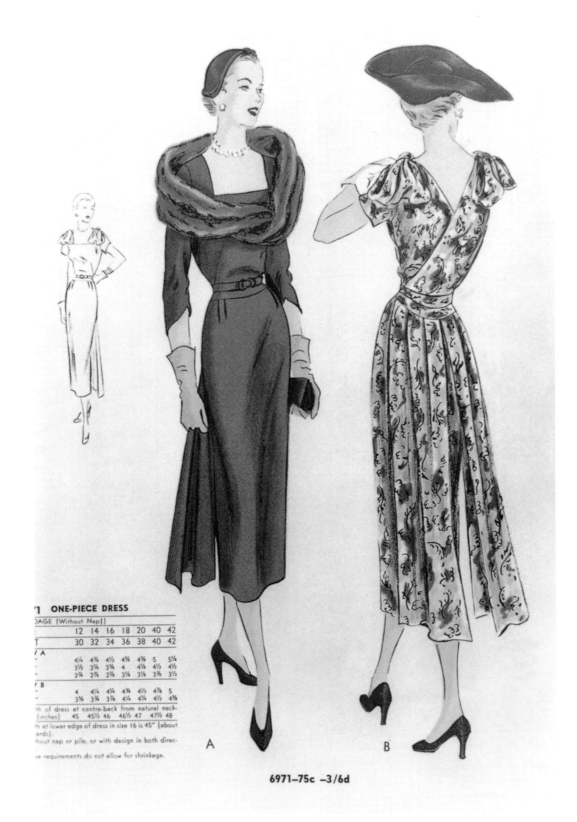

'1 ONE-PIECE DRESS

AGE (Without Nap‡)							
	12	14	16	18	20	40	42
T	30	32	34	36	38	40	42
A							
	4¼	4⅜	4½	4⅝	4⅝	5	5⅛
	3½	3⅝	3¾	4	4⅛	4½	4½
	2¾	2⅞	2⅞	3⅛	3⅛	3⅜	3½
B							
	4	4¼	4¼	4⅜	4½	4⅞	5
	3⅛	3¼	3⅜	4¼	4¼	4½	4⅞

th of dress at centre-back from natural neck-
(inches) 45 45½ 46 46½ 47 47½ 48
th at lower edge of dress in size 16 is 45" (about
rds).
hout nap or pile, or with design in both direc-
e requirements do not allow for shrinkage.

A B

6971–75c –3/6d

Vogue #6971, 1950. Courtesy of the Butterick Archives.

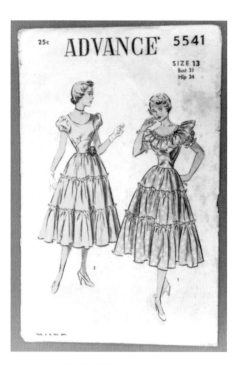

Advance #5541, 1950.

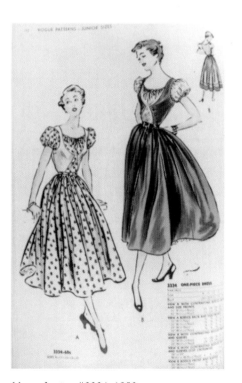

Vogue Junior #3334, 1950.
Courtesy of the Butterick Archives.

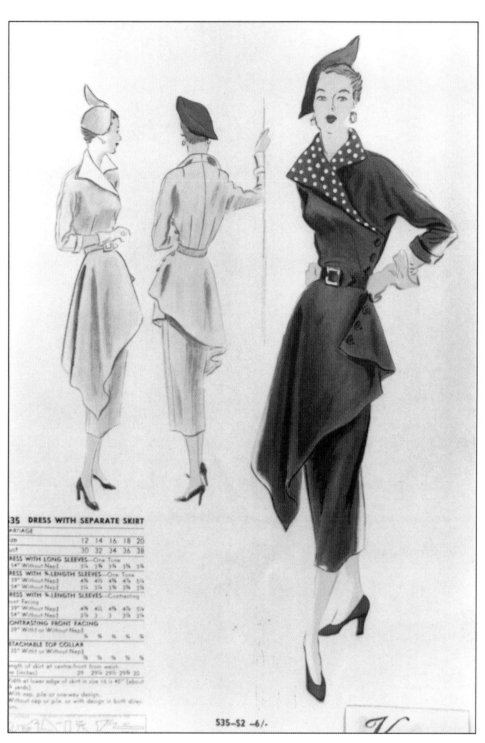

535 DRESS WITH SEPARATE SKIRT

Vogue Couturier Design. *Courtesy of the Butterick Archives.*

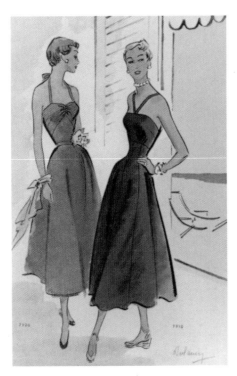

McCall #7920 and 7910, 1950. *Courtesy of The McCall Pattern Company.*

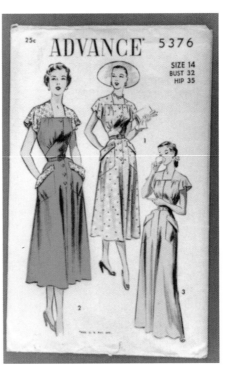

Advance #5376, 1950.

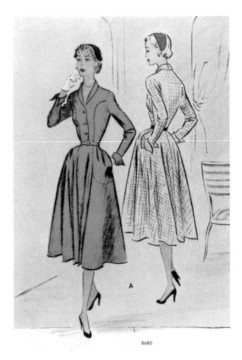

McCall #8680, 1951. *Courtesy of The McCall Pattern Company.*

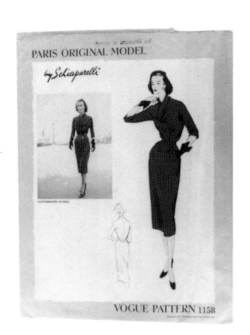

Vogue Paris Original Model by Schiaparelli, #1158, 1951.

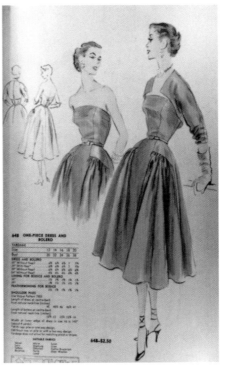

Vogue Couturier Design, #648, 1951. *Courtesy of the Butterick Archives.*

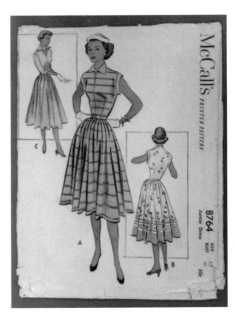

McCall's #8764, 1951. *Author's collection. Courtesy of The McCall Pattern Company.*

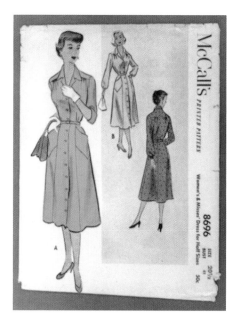

McCall's #8696, 1951. *Author's collection.*
Courtesy of The McCall Pattern Company.

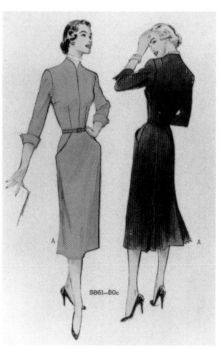

Butterick #5861, 1951. *Courtesy of The*
Irene Lewisohn Costume Reference Library,
The Metropolitan Museum of Art.

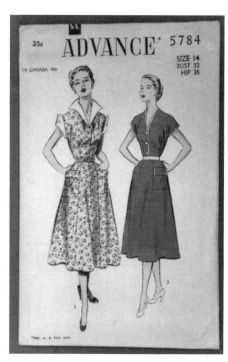

Advance #5784, 1951.

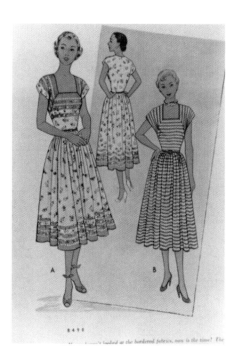

McCall's 8498, 1951. *Courtesy of*
The McCall Pattern Company.

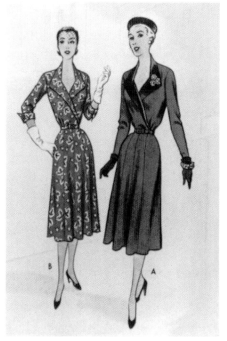

McCall's #8687, 1951. *Courtesy of*
The McCall Pattern Company.

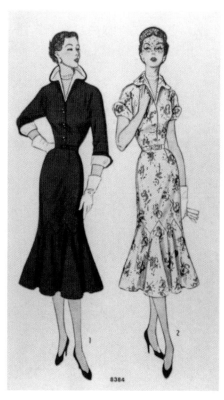

Simplicity Designer's #8384, 1951.

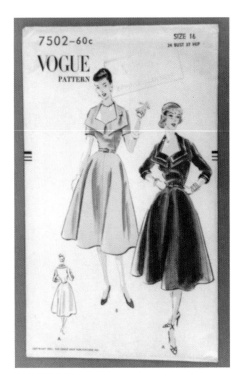

Vogue #7502, 1951.

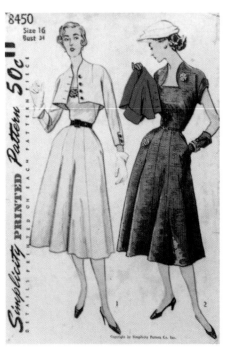

Simplicity #8450, 1951. Note
Designer's 8000 numbering
sequence in regular envelope.

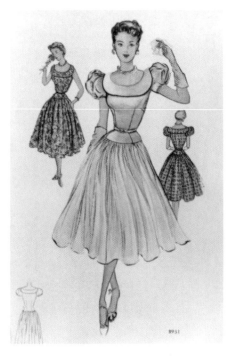

McCall's #8951, 1952. *Courtesy of
The McCall Pattern Company.*

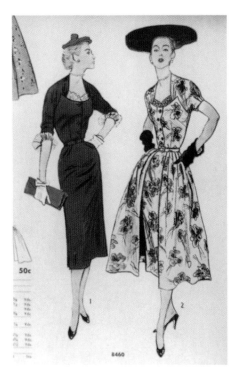

Simplicity #8460, 1951.

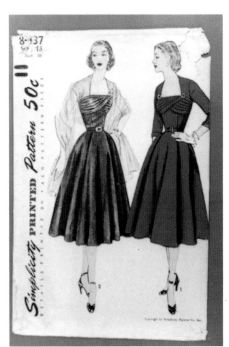

Simplicity #8437, 1951.

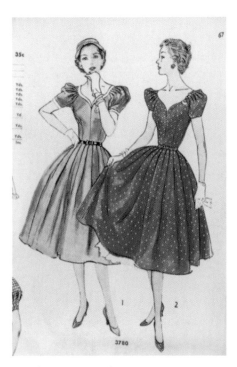

Simplicity #3780, 1952.

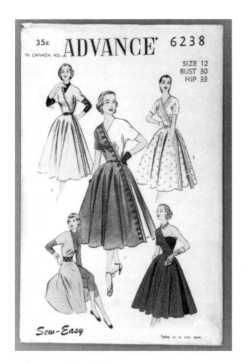

Advance #6238, 1952.

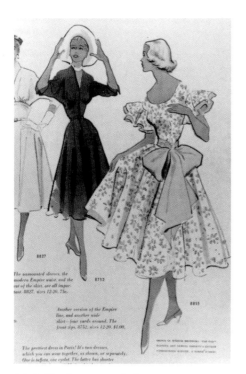

McCall's adaptation of a Paris couture design, #8855, 1953. *Courtesy of The McCall Pattern Company.*

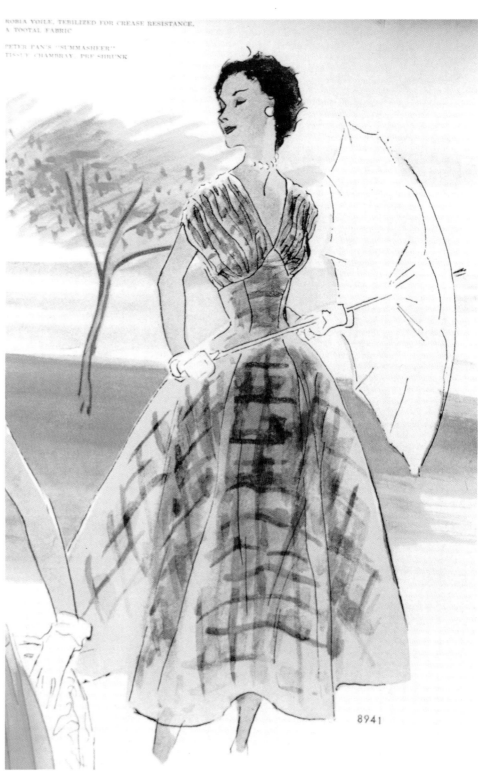

McCall's #8941, 1952. *Courtesy of The McCall Pattern Company.*

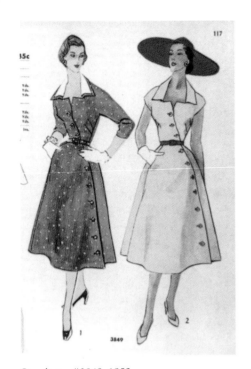

Simplicity #3849, 1952.

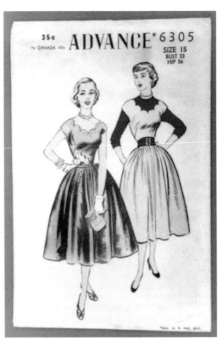

Advance #6305, 1953.

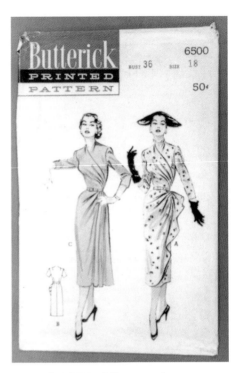

Butterick #6500, 1953.

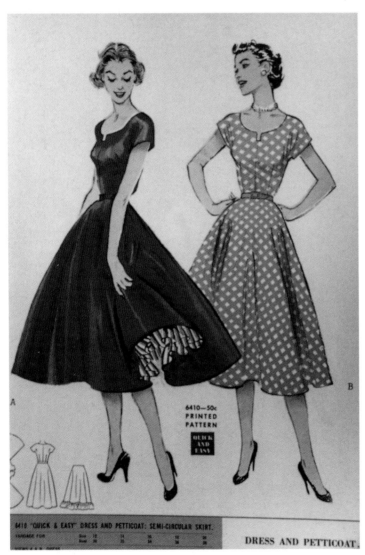

Butterick #6410, 1953. *Courtesy of the Butterick Archives.*

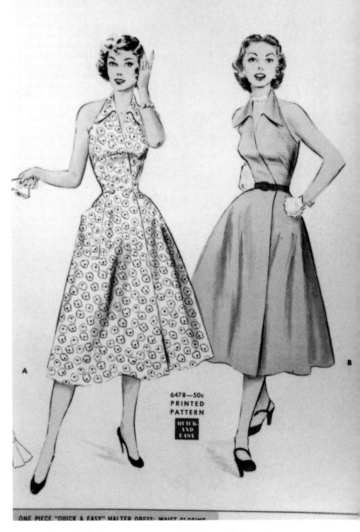

Butterick #6478, 1953. *Courtesy of the Butterick Archives.*

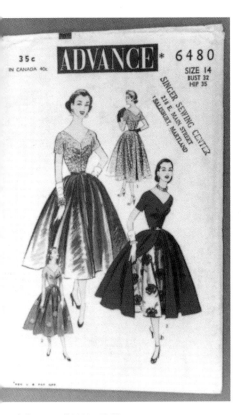

Advance #6480, 1953.

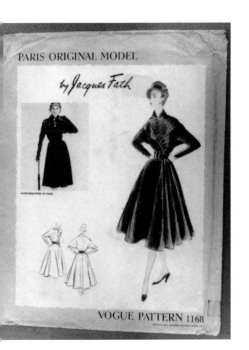

Vogue Paris Original Model by
Jacques Fath #1168, 1952.

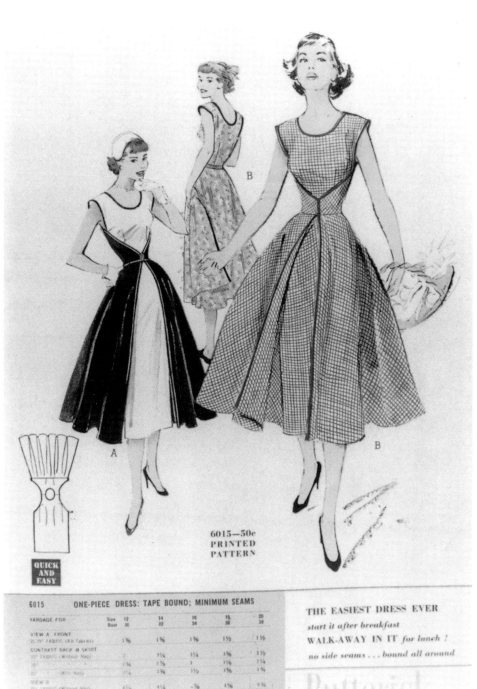

6015—50c
PRINTED
PATTERN

QUICK
AND
EASY

6015	ONE-PIECE DRESS: TAPE BOUND; MINIMUM SEAMS					
YARDAGE FOR	Size	12	14	16	18	20
	Bust	30	32	34	36	38
VIEW A FRONT						
35-39" FABRIC (30 Fabrics)		1⅜	1⅜	1⅜	1½	1½
CONTRAST BACK & SKIRT						
39" FABRIC (WITHOUT NAP)		3	3¼	3¼	3⅝	3½
35"		3¼	2⅞	3	3¼	3½
54"			1⅜	1½	1⅝	1¾
VIEW B						
35" FABRIC (WITHOUT NAP)		4½	4¼	4¼	4⅝	4¾
39"		4	4	4¼	4⅝	4¾
VIEWS A & B						

THE EASIEST DRESS EVER
start it after breakfast
WALK-AWAY IN IT *for lunch!*
no side seams . . . bound all around

Butterick #6015, 1952. *Courtesy of the Butterick Archives.*

73

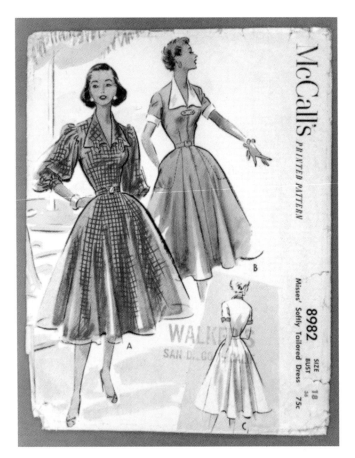

McCall's #8982, 1952. *Author's collection.*
Courtesy of The McCall Pattern Company.

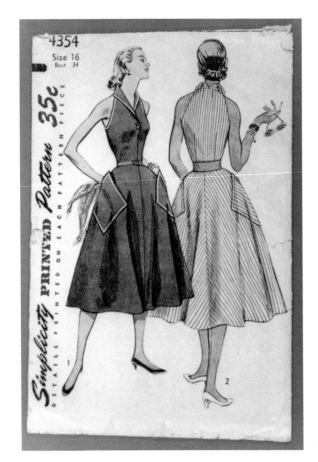

Simplicity #4354, 1953.

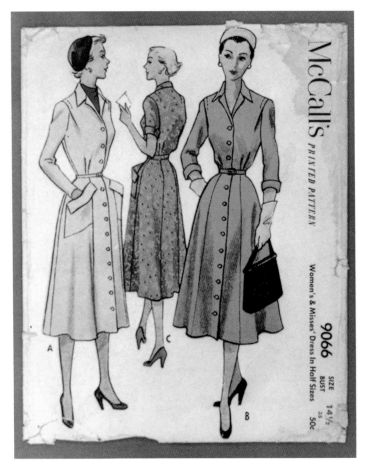

McCall's #9066, 1952. *Author's collection.*
Courtesy of The McCall Pattern Company.

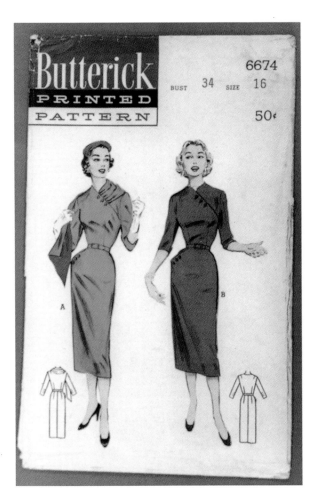

Butterick #6674, 1953.

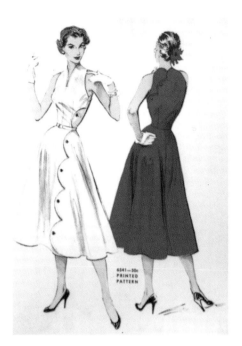

Butterick #6541, 1953. *Courtesy of the Butterick Archives.*

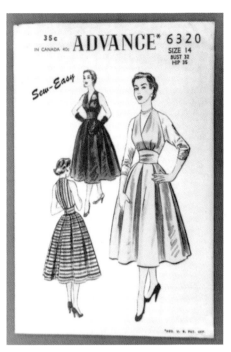

Advance #6320, 1953.

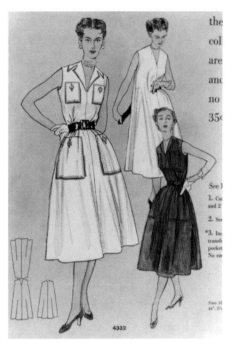

Simplicity #4332, 1953. This "illusion" dress included an iron-on transfer for collar, pocket, and button effects.

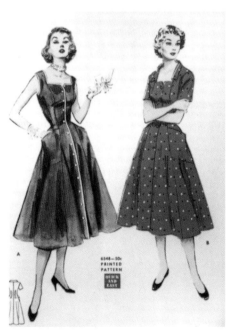

Butterick #6548, 1953. *Courtesy of the Butterick Archives.*

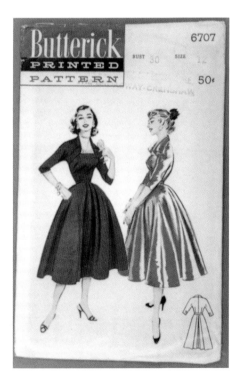

Butterick #6707, 1953.

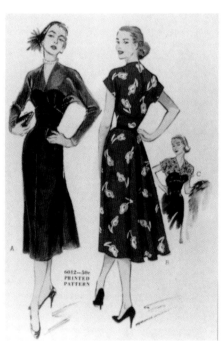

Butterick #6012, 1952. *Courtesy of the Butterick Archives.*

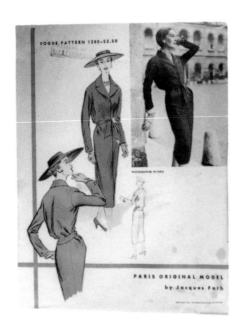

Vogue Paris Original Model by
Jacques Fath #1280, 1954.

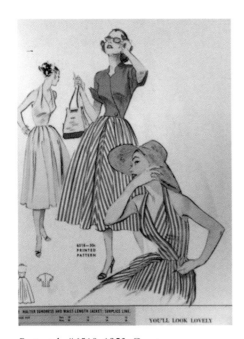

Butterick #6518, 1953. *Courtesy
of the Butterick Archives.*

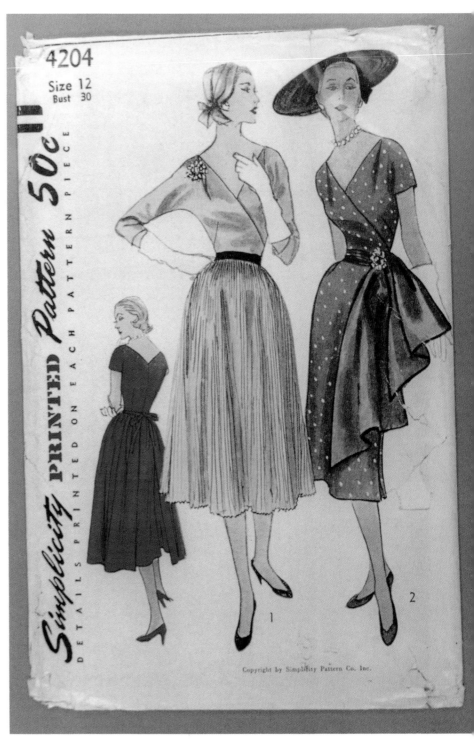

Simplicity #4204, 1953.

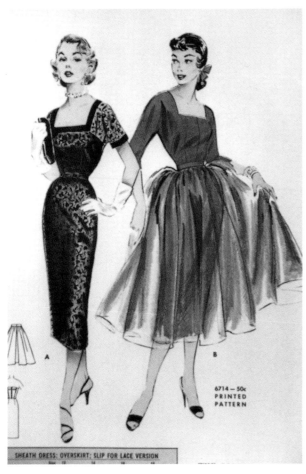

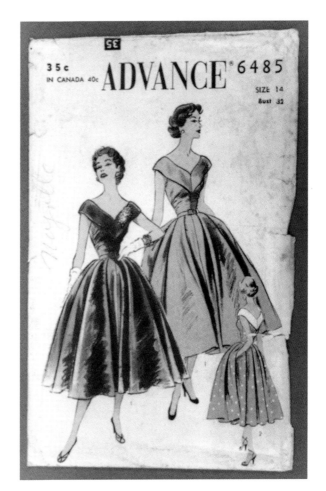

Butterick #6714, 1953. *Courtesy of the Butterick Archives.*

Advance #6485, 1953.

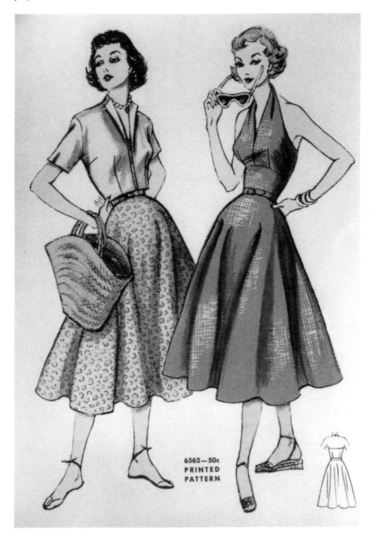

Butterick #6562, 1953. *Courtesy of the Butterick Archives.*

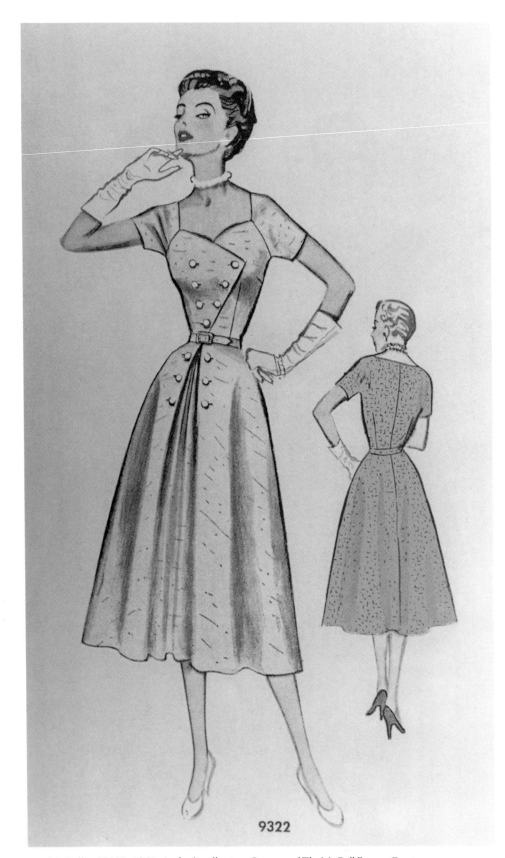

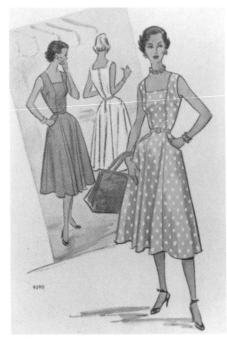

McCall's #9290, 1953. *Courtesy of The McCall Pattern Company.*

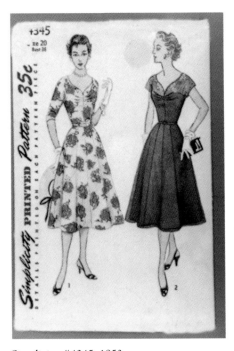

McCall's #9322, 1953. *Author's collection. Courtesy of The McCall Pattern Company.*

Simplicity #4345, 1953.

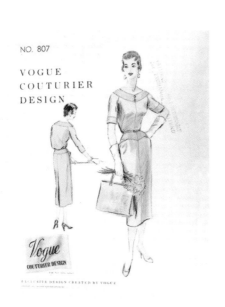

Vogue Couturier Design #807, 1954.

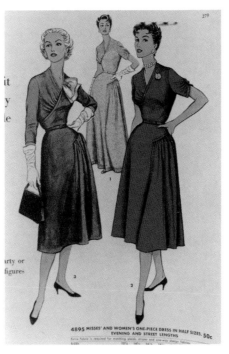

Simplicity #4895, 1954.

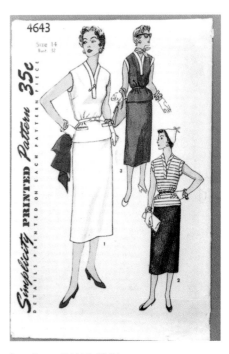

Simplicity #4643, 1954.

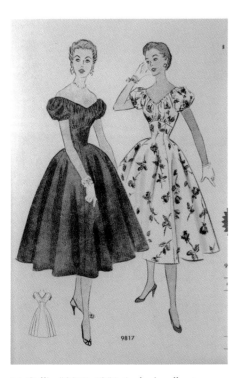

McCall's #9817, 1954. *Author's collection.*
Courtesy of The McCall Pattern Company.

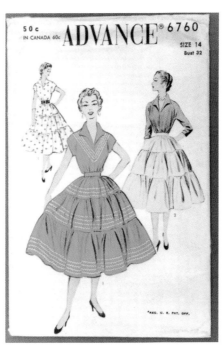

Advance #6760, 1954.

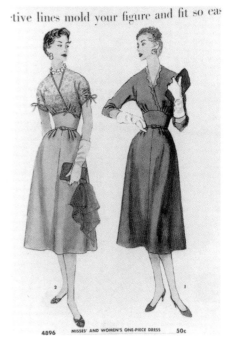

Simplicity #4896, 1954.

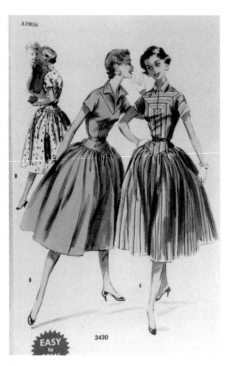

McCall's #3430, 1955. *Author's collection.*
Courtesy of The McCall Pattern Company.

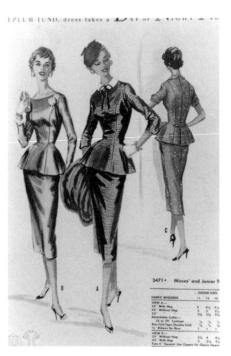

McCall's #3471, 1955. *Author's collection.*
Courtesy of The McCall Pattern Company.

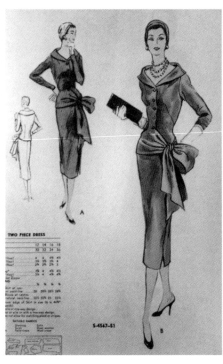

Vogue Special Design #S-4567, 1954.
Courtesy of the Butterick Archives.

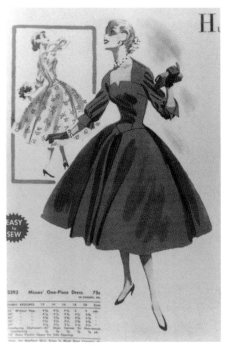

McCall's #3393, 1955. *Author's collection.*
Courtesy of The McCall Pattern Company.

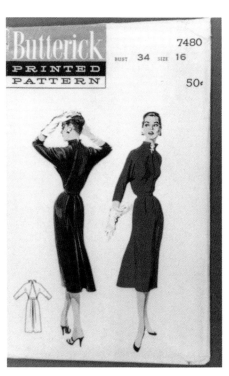

Butterick #7480, 1955.

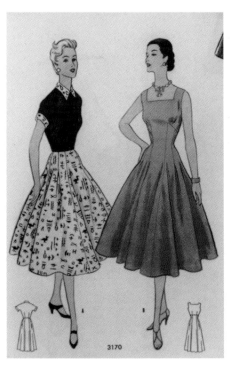

McCall's #3170, 1955. *Author's collection.*
Courtesy of The McCall Pattern Company.

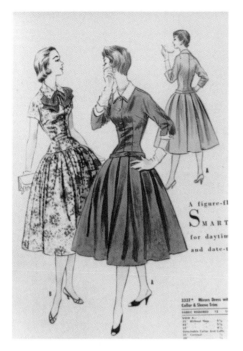

McCall's #3327, 1955. *Author's collection.*
Courtesy of The McCall Pattern Company.

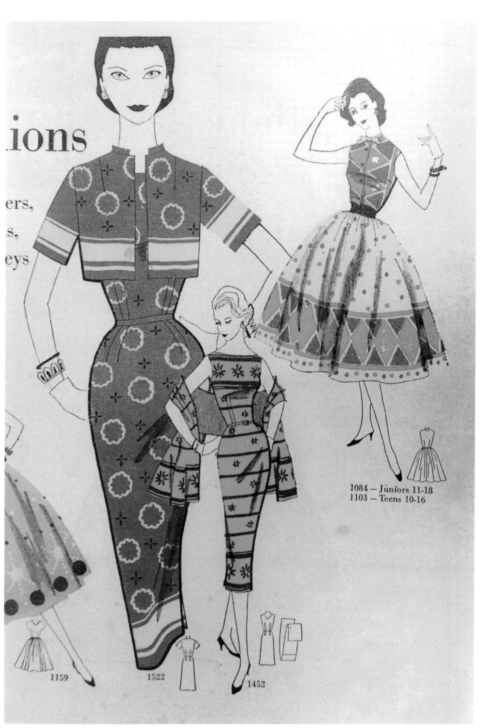

Simplicity #1522 & 1452, 1956.

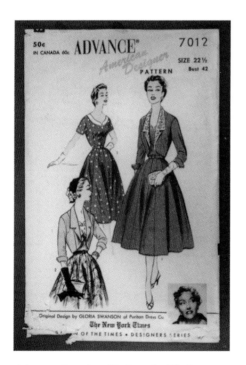

Advance American Designer by Gloria
Swanson of Puritan Dress Co. #7012, 1955.

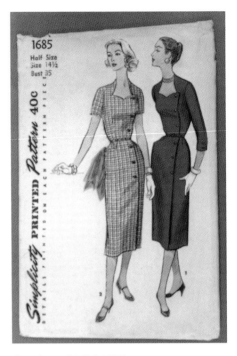

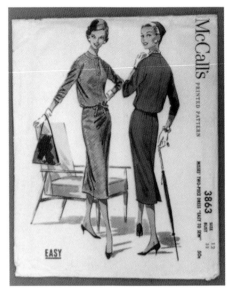

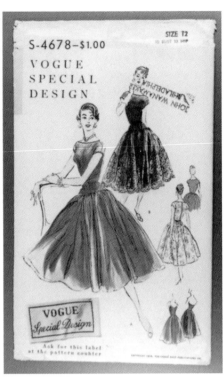

Simplicity #1685, 1956.

McCall's #3863, 1956. *Author's collection.*
Courtesy of The McCall Pattern Company.

Vogue Special Design #S-4678, 1956.

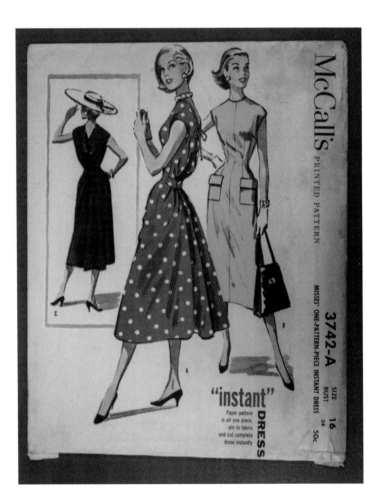

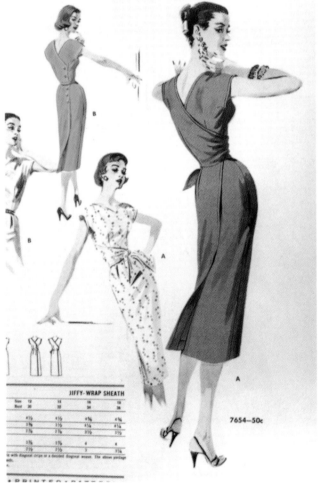

McCall's "instant" dress #3742-A, 1956. *Author's*
collection. Courtesy of The McCall Pattern Company.

Butterick #7654, 1956. *Courtesy*
of the Butterick Archives.

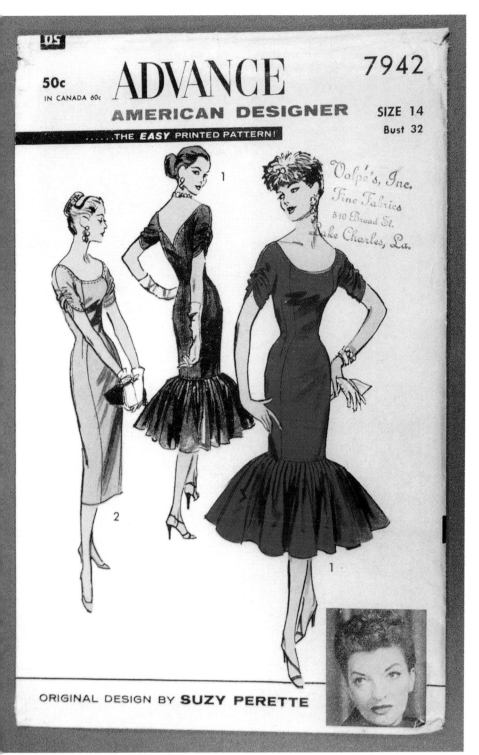

Advance American Designer by Suzy Perette #7942, 1956.

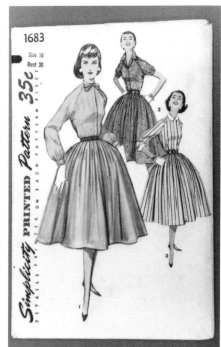

Simplicity #1683, 1956.

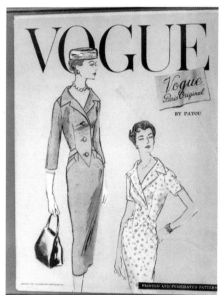

Vogue Paris Original Model
by Patou #1326, 1956.

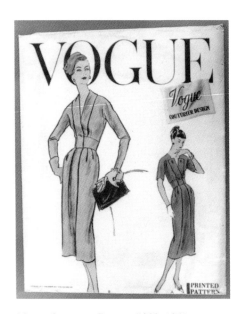

Vogue Couturier Design #989, 1957.

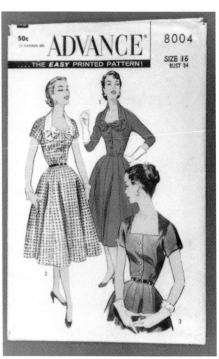

Advance #8004, 1956.

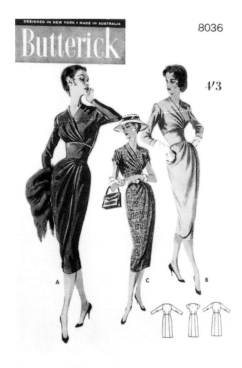

Butterick #8036, 1957. Made in Australia.
Courtesy of the Butterick Archives.

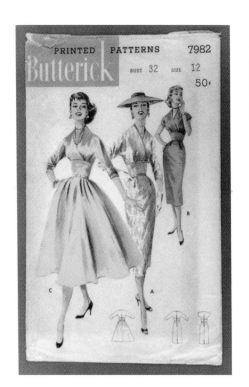

Butterick #7982, 1957.

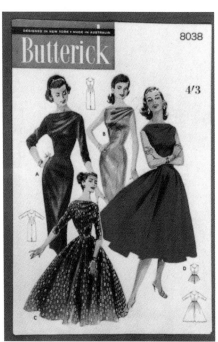

Butterick #8038, 1957. Made in Australia.
Courtesy of the Butterick Archives.

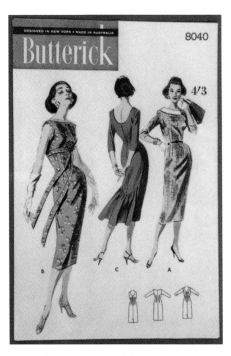

Butterick #8040, 1957. Made in Australia.
Courtesy of the Butterick Archives.

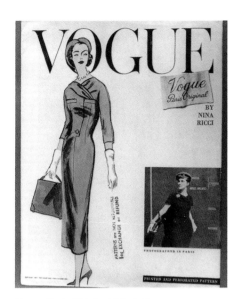

Vogue Paris Original Model by
Nina Ricci #1375, 1957.

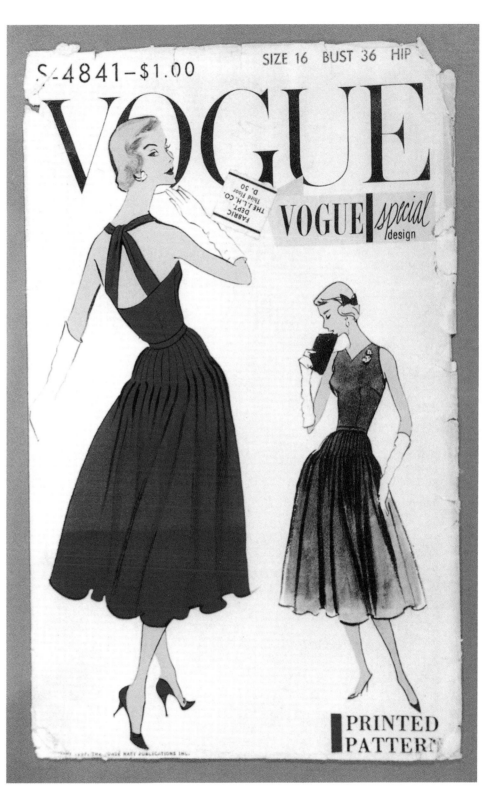

Vogue Special Design #S-4841, 1957.

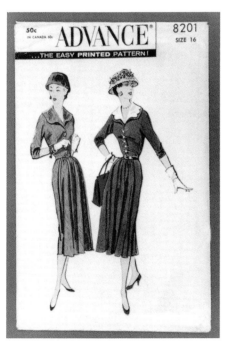

Advance #8201, 1957.

McCall's Givenchy design #4006, 1957.
Courtesy of The McCall Pattern Company.

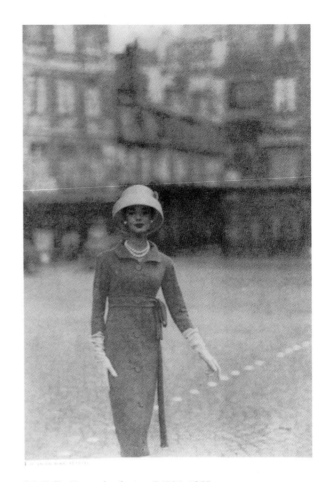

McCall's Givenchy design #4004, 1957.
Courtesy of The McCall Pattern Company.

Simplicity #2730, 1958.

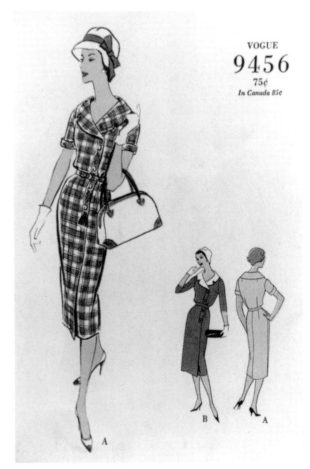

Vogue #9456, 1958. *Courtesy of the Butterick Archives.*

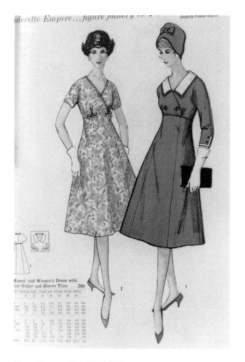

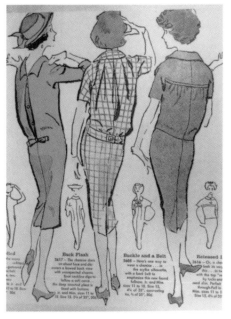

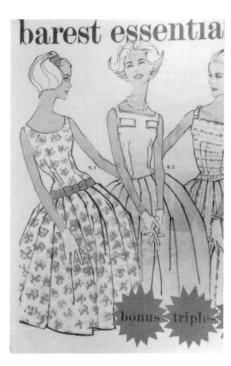

Simplicity #2801, 1959.

Simplicity #2605, 2616, and 2617, 1959.

Simplicity #2570, 1958.

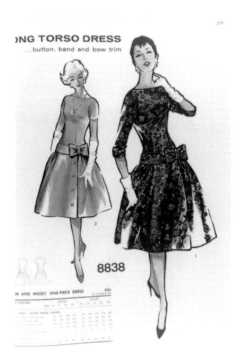

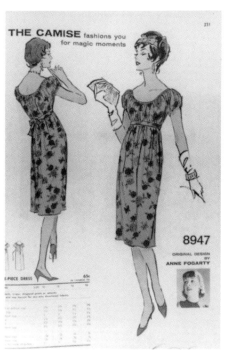

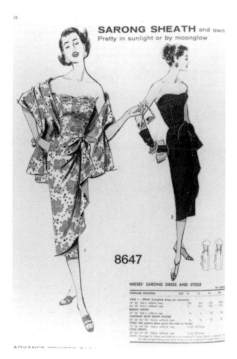

Advance #8838, 1958. *Courtesy of the Irene Lewisohn Costume Reference Library, Metropolitan Museum of Art.*

Advance by Anne Fogarty #8947, 1959. *Courtesy of the Irene Lewisohn Costume Reference Library, Metropolitan Museum of Art.*

Advance #8647, 1958. *Courtesy of the Irene Lewisohn Costume Reference Library, Metropolitan Museum of Art.*

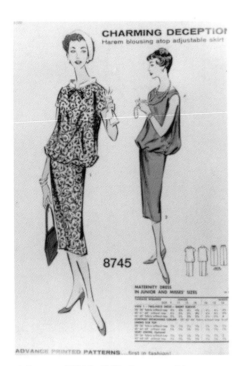

Advance #8745, 1958. *Courtesy of the Irene Lewisohn Costume Reference Library, Metropolitan Museum of Art.*

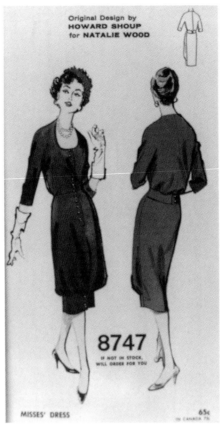

Advance #8747, 1958. *Courtesy of the Irene Lewisohn Costume Reference Library, Metropolitan Museum of Art.*

Advance #8803 and 8811, 1958.

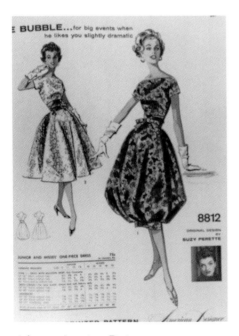

Advance American Designer by Suzy Perette #8812, 1958.

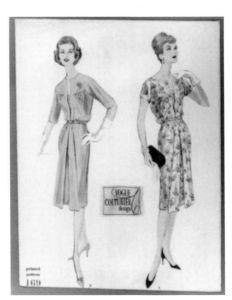

Vogue Couturier Design #169, 1959.

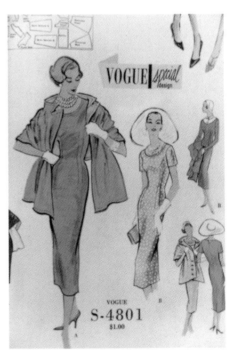

Vogue Special Design #S-4801, 1957.

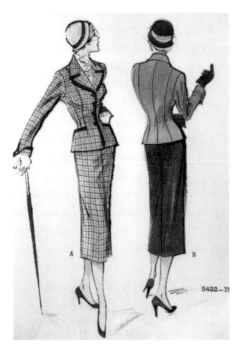

Butterick #5422, 1950. *Courtesy of the Butterick Archives.*

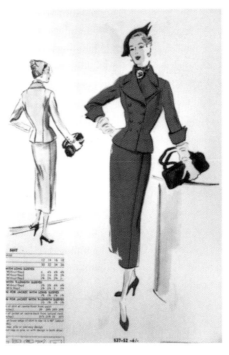

Vogue Couturier Design #537, 1950. *Courtesy of the Butterick Archives.*

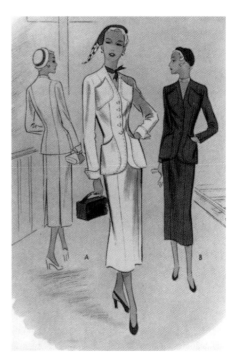

McCall's 7954, 1950. *Courtesy of The McCall Pattern Company.*

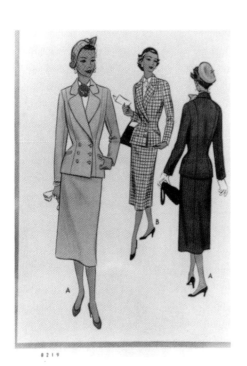

McCall's #8219, 1950. *Courtesy of The McCall Pattern Company.*

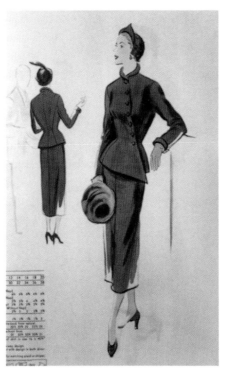

Vogue, 1950. *Courtesy of the Butterick Archives.*

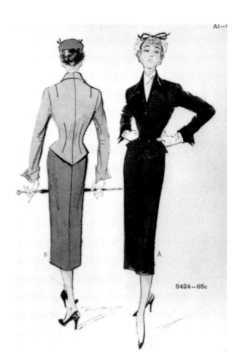

Butterick #5424, 1950. *Courtesy of the Butterick Archives.*

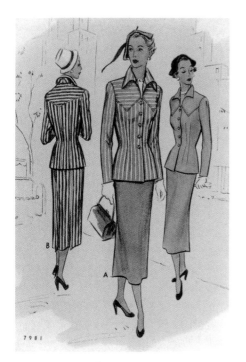

McCall's #7981, 1950. *Courtesy of*
The McCall Pattern Company.

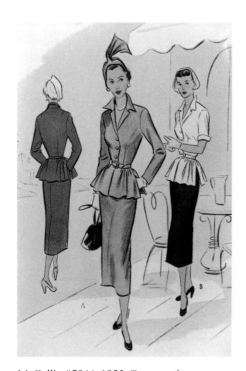

McCall's #7944, 1950. *Courtesy of*
The McCall Pattern Company.

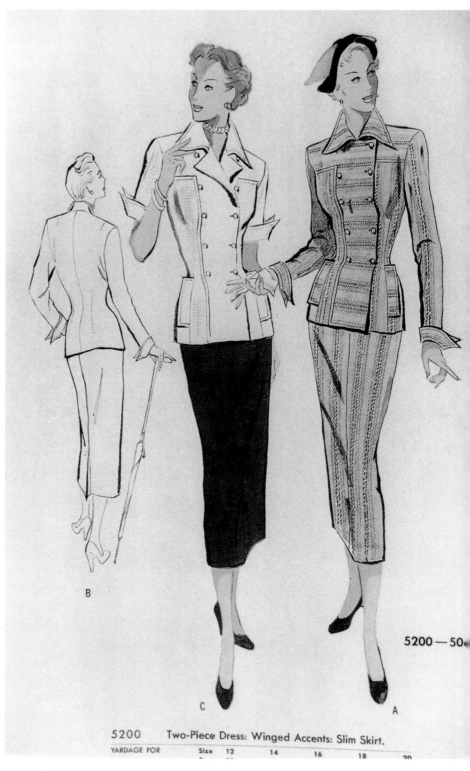

5200 Two-Piece Dress: Winged Accents: Slim Skirt.

| YARDAGE FOR | Size | 12 | 14 | 16 | 18 | 20 |

5200 — 50¢

Butterick #5200, 1950. *Courtesy of the Butterick Archives.*

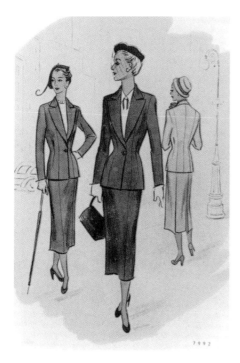

McCall's #7992, 1950. *Courtesy of
The McCall Pattern Company.*

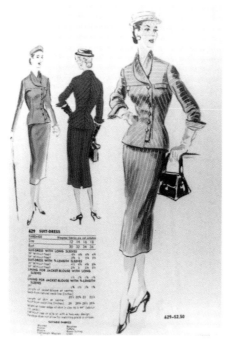

Vogue Couturier Design #629, 1951.
Courtesy of the Butterick Archives.

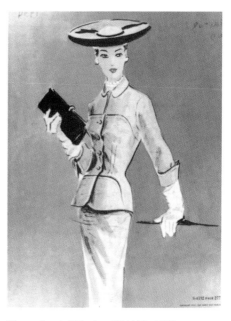

Vogue Special Design #S4192, 1951.
Courtesy of the Butterick Archives.

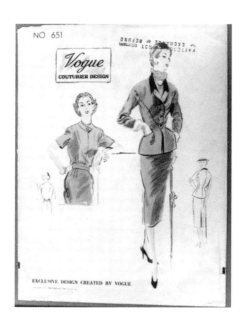

Vogue Couturier Design #651, 1951.

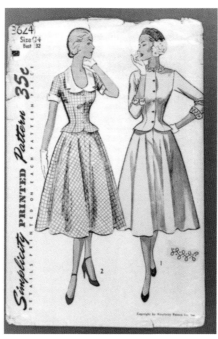

Simplicity #3624, 1951.

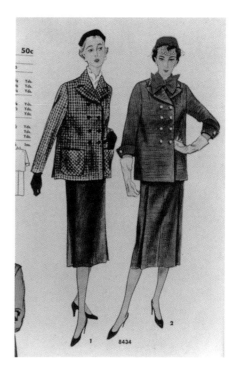

Simplicity #8434, 1951.

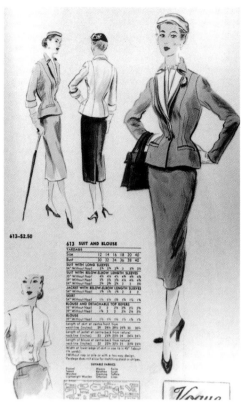

Vogue Couturier Design #613, 1951.
Courtesy of the Butterick Archives.

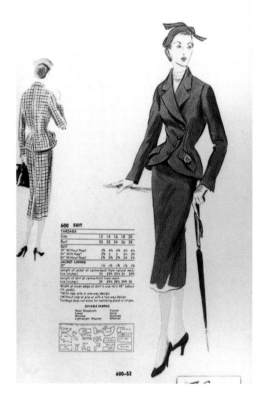

Vogue Couturier Design #600, 1951.
Courtesy of the Butterick Archives.

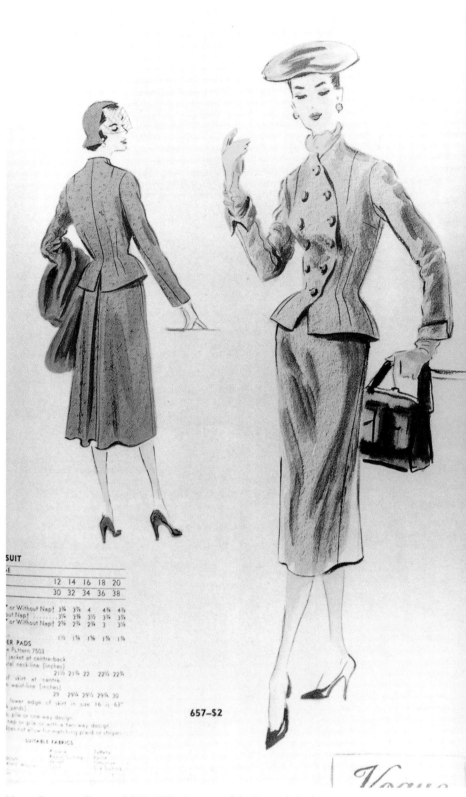

Vogue Couturier Design #657, 1952. *Courtesy of the Butterick Archives.*

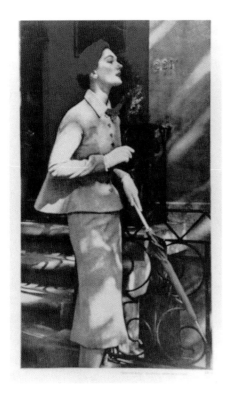

McCall's #8810, 1951. *Courtesy of The McCall Pattern Company.*

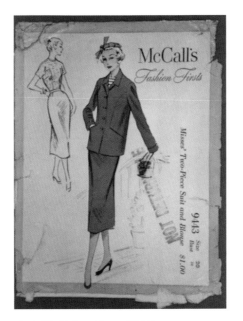

McCall's Fashion Firsts #9443, 1953. *Author's collection. Courtesy of The McCall Pattern Company.*

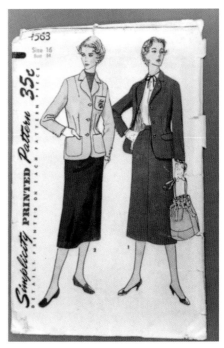

Simplicity #4563, 1954.

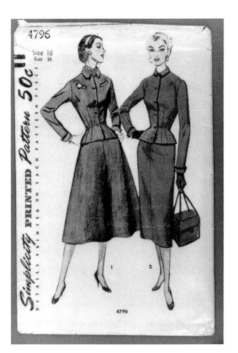

Simplicity #4796, 1954.

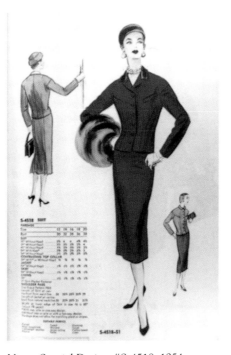

Vogue Special Design #S-4518, 1954. *Courtesy of the Butterick Archives.*

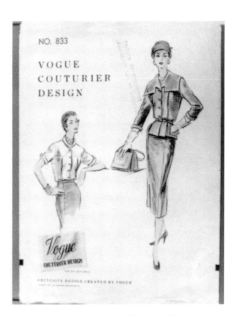

Vogue Couturier Design #833, 1954.

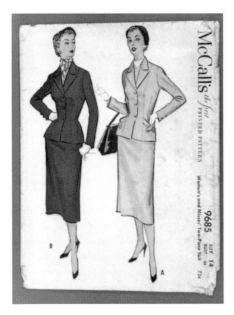

McCall's #9685, 1954. *Author's collection.*
Courtesy of The McCall Pattern Company.

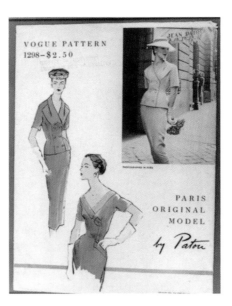

Vogue Paris Original Model
by Patou #1298, 1955.

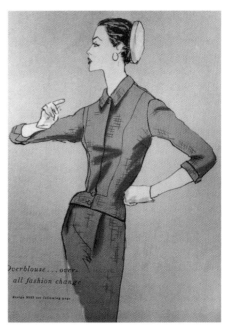

Vogue #8533, 1955. *Courtesy*
of the Butterick Archives.

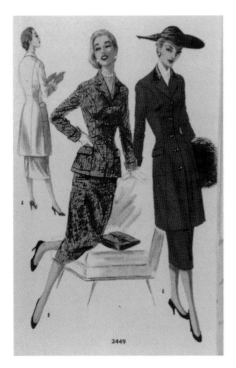

McCall #3449, 1955. *Author's collection.*
Courtesy of The McCall Pattern Company.

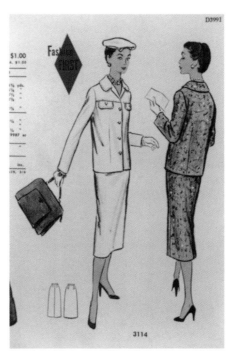

McCall's Fashion First #3114,
1955. *Author's collection. Courtesy*
of The McCall Pattern Company.

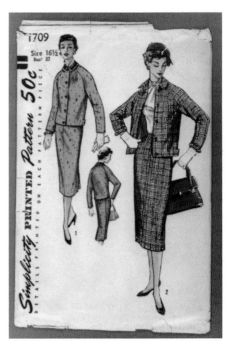

Simplicity #1709, 1956.

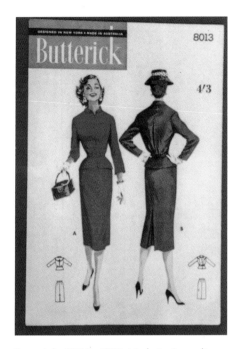

Butterick #8013, 1957. Made in Australia.
Courtesy of the Butterick Archives.

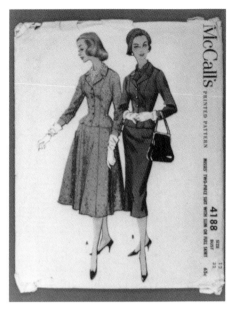

McCall's #4188, 1957. *Author's collection.*
Courtesy of The McCall Pattern Company.

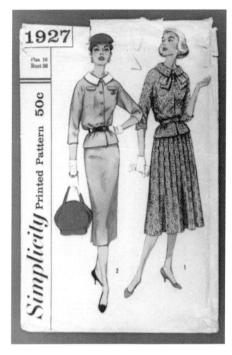

Simplicity #1927, 1957.

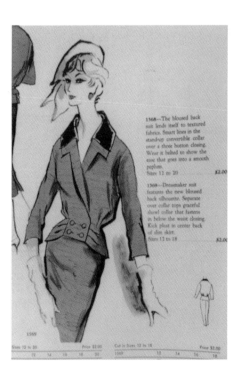

Modes Royale #1569, late 1950s.

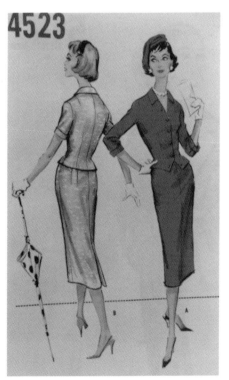

McCall's #4523, 1958. *Author's collection.*
Courtesy of The McCall Pattern Company.

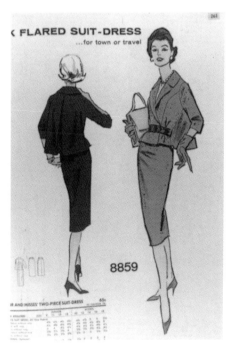

Advance #8859, 1958. *Courtesy of the*
Irene Lewisohn Costume Reference Library,
Metropolitan Museum of Art.

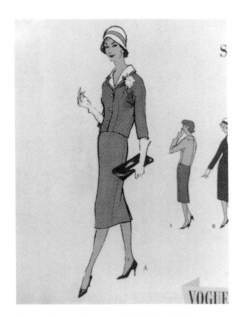

Vogue Special Design #S-4881, 1958.

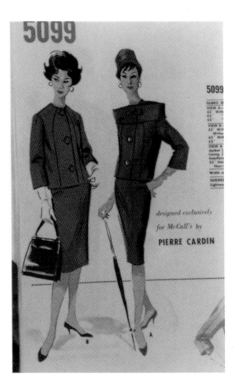

McCall's by Pierre Cardin #5099,
1959. *Author's collection. Courtesy of
The McCall Pattern Company.*

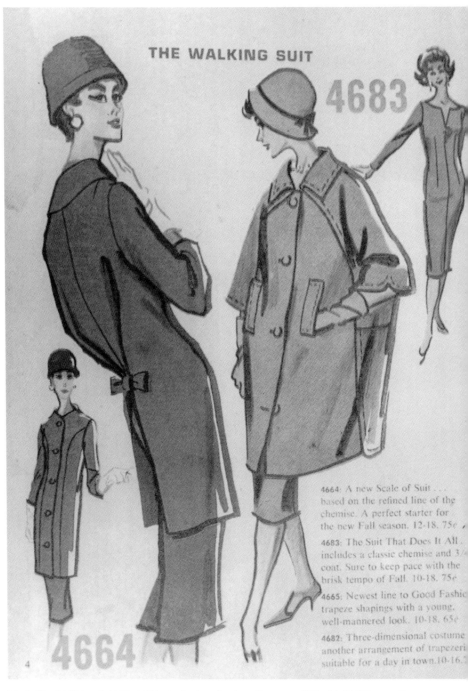

THE WALKING SUIT

4664: A new Scale of Suit . . .
based on the refined line of the
chemise. A perfect starter for
the new Fall season. 12-18. 75¢

4683: The Suit That Does It All
includes a classic chemise and 3/4
coat. Sure to keep pace with the
brisk tempo of Fall. 10-18. 75¢

4665: Newest line to Good Fashion
trapeze shapings with a young,
well-mannered look. 10-18. 65¢

4682: Three-dimensional costume
another arrangement of trapezeri
suitable for a day in town. 10-16.

McCall's #4664 and 4683, 1958. *Author's collection. Courtesy of The McCall Pattern Company.*

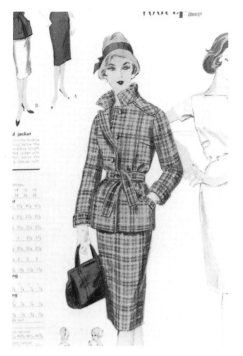

Vogue Special Design #4058, 1959.

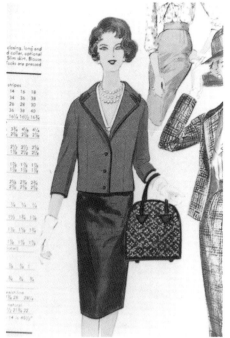

Vogue Couturier Design #192, 1959.

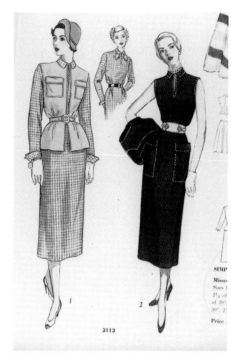

Simplicity #3113, 1950.

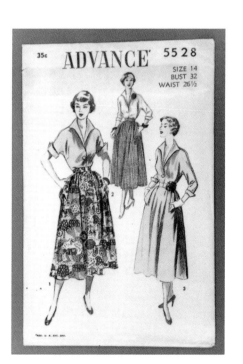

Advance #5528, 1950.

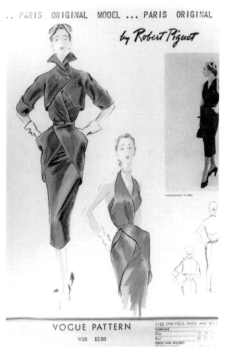

Vogue Paris Original Model by
Robert Piguet #1135, 1951.
Courtesy of the Butterick Archives.

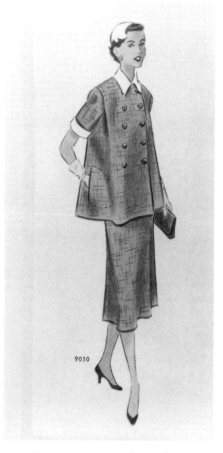

McCall's #9030, 1952. *Author's collection.
Courtesy of The McCall Pattern Company.*

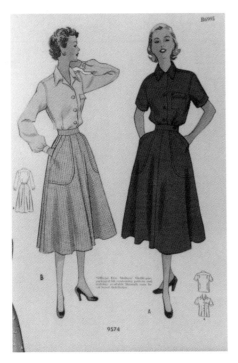

McCall's #9574, 1953. Official Den
Mothers' Outfit. *Author's collection.
Courtesy of The McCall Pattern Company.*

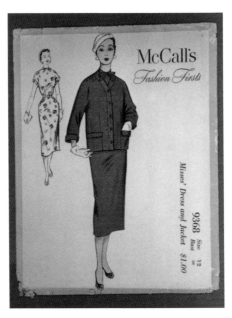

McCall's Fashion Firsts #9368,
1953. *Author's collection. Courtesy
of The McCall Pattern Company.*

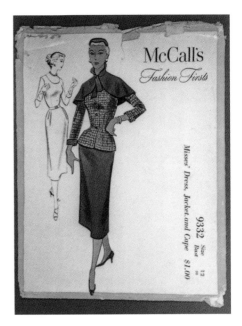

McCall's Fashion Firsts #9332,
1953. *Author's collection. Courtesy of
The McCall Pattern Company.*

Simplicity #4562, 1954.

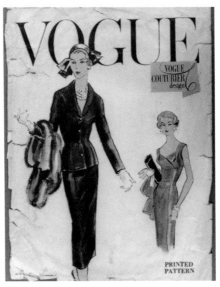

Vogue Couturier Design #981, 1957.

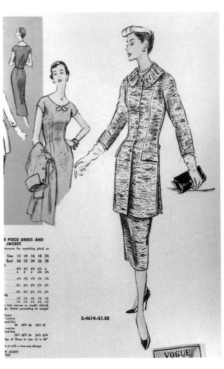

Vogue Special Design #S-4614, 1955.
Courtesy of the Butterick Archives.

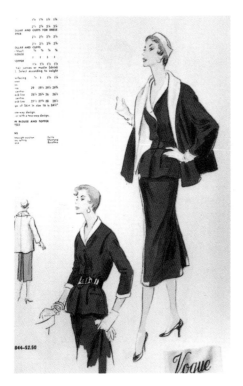

Vogue Couturier Design #844, 1955.
Courtesy of the Butterick Archives.

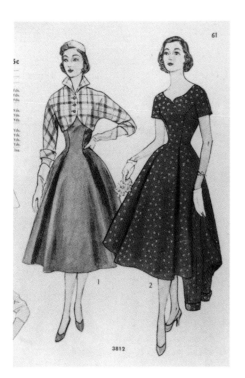

Simplicity #3812, 1952.

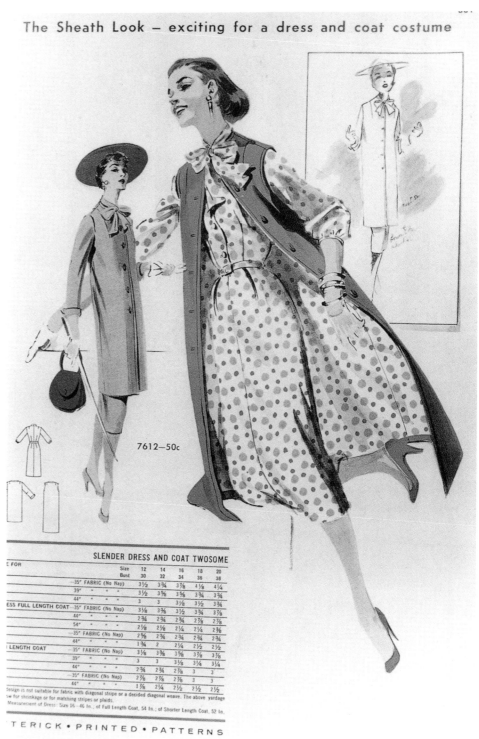

The Sheath Look – exciting for a dress and coat costume

7612–50c

SLENDER DRESS AND COAT TWOSOME							
E FOR		Size	12	14	16	18	20
		Bust	30	32	34	36	38
	—35" FABRIC (No Nap)		3½	3¾	3⅞	4⅛	4¼
	39"	" " "	3½	3⅝	3⅝	3¾	3¾
	44"	" " "	3	3	3½	3½	3¾
SS FULL LENGTH COAT—35" FABRIC (No Nap)		3⅛	3⅜	3½	3¾	3⅞	
	44"	" " "	2¾	2¾	2¾	2⅞	2⅞
	54"	" " "	2⅛	2½	2¼	2¼	2⅜
	—35" FABRIC (No Nap)		2⅝	2¾	2¾	2¾	2¾
	44"	" " "	1¾	2	2¼	2½	2½
LENGTH COAT	—35" FABRIC (No Nap)		3⅛	3⅜	3⅝	3⅞	3⅞
	39"	" " "	3	3	3½	3¼	3¼
	44"	" " "	2¾	2¾	2¾	3	3
	—35" FABRIC (No Nap)		2⅞	2⅞	2⅞	3	3
	44"	" " "	1⅞	2¼	2½	2½	2½

Design is not suitable for fabric with diagonal stripe or a decided diagonal weave. The above yardage
w for shrinkage or for matching stripes or plaids.
Measurement of Dress: Size 16 – 46 In., of Full Length Coat, 54 In.; of Shorter Length Coat, 52 In.

TERICK • PRINTED • PATTERNS

Butterick #7612, 1956. *Courtesy of the Butterick Archives.*

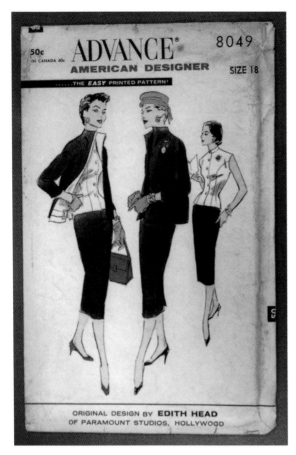

Advance American Designer by Edith Head #8049, 1956.

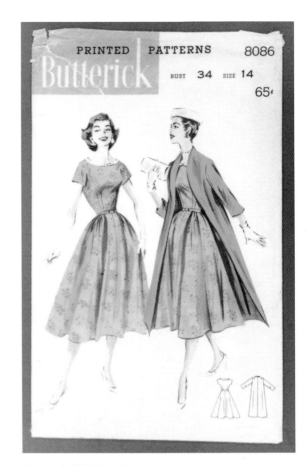

Butterick #8086, 1957.

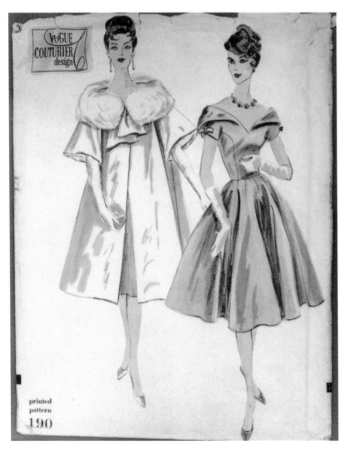

Vogue Couturier Design #190, 1959.

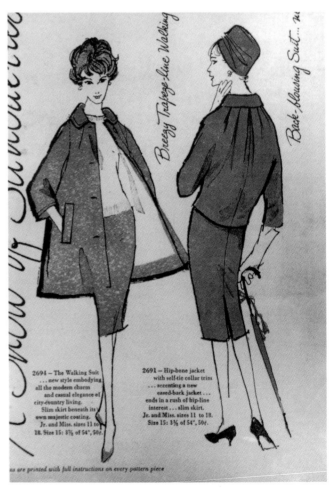

Simplicity #2694 and 2691, 1958.

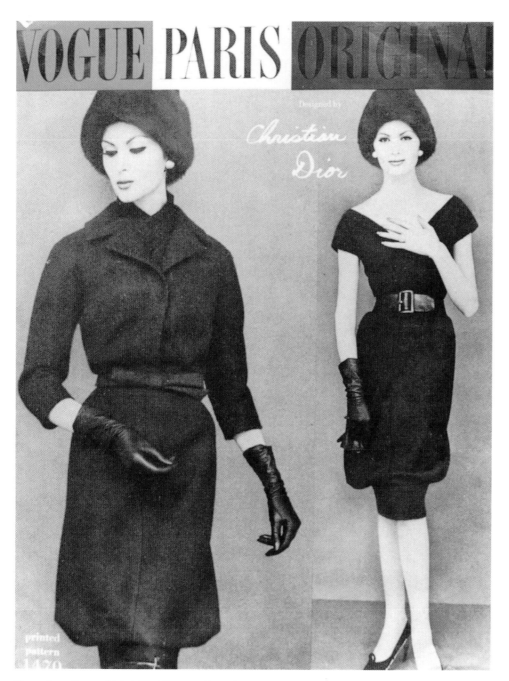

Vogue Paris Original Model by Christian Dior #1470, 1959.

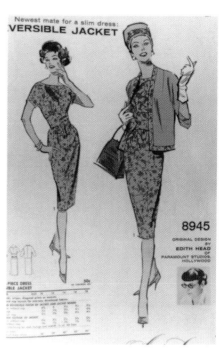

Advance American Designer by Edith Head #8945, 1959. *Courtesy of the Irene Lewisohn Costume Reference Library, Metropolitan Museum of Art.*

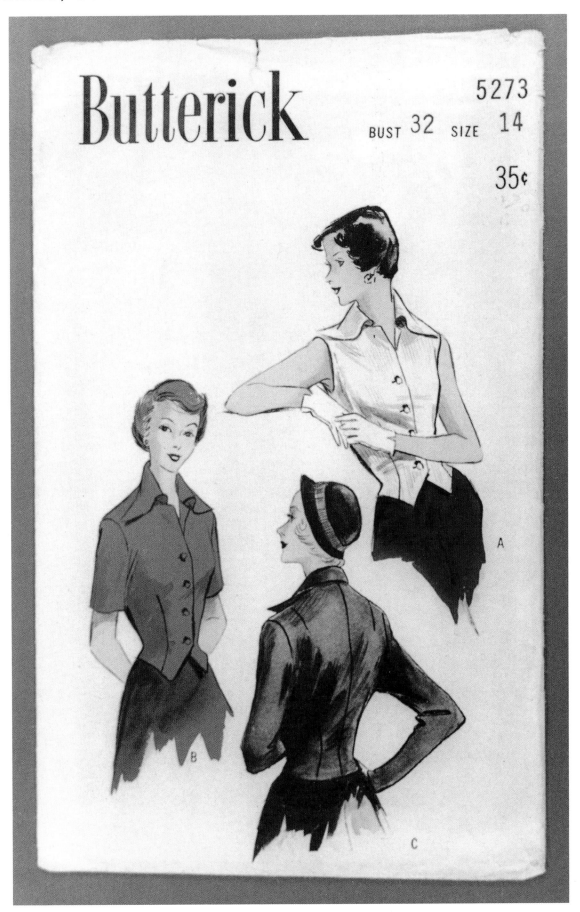

Butterick #5273, 1950.

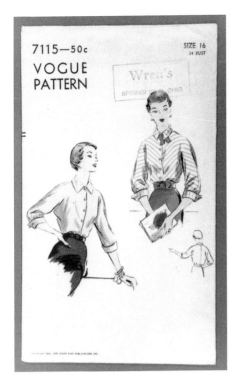

Vogue #7115, 1950.

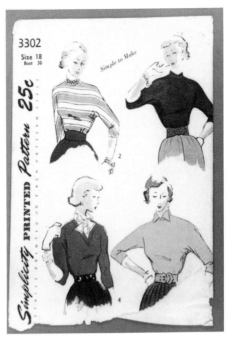

Simplicity #3302, 1950.

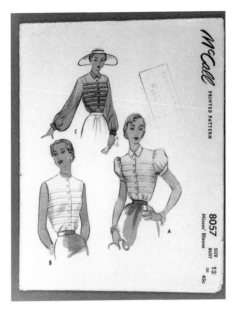

McCall #8057, 1950. *Author's collection.*
Courtesy of The McCall Pattern Company.

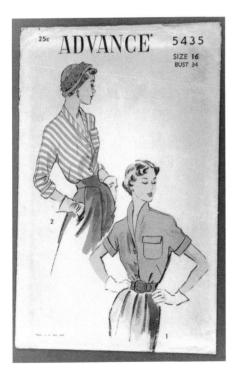

Advance #5435, 1950.

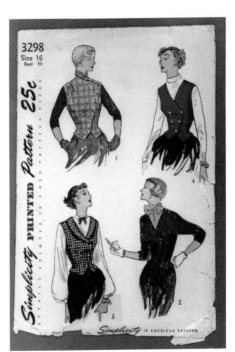

Simplicity #3298, 1950.

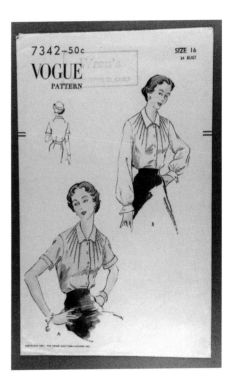

Vogue #7342, 1951.

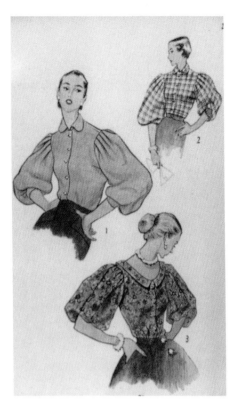

Simplicity #3740, 1951.

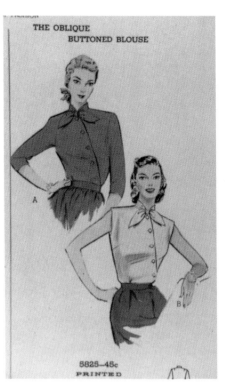

Butterick #5825, 1951. *Courtesy of the Butterick Archives.*

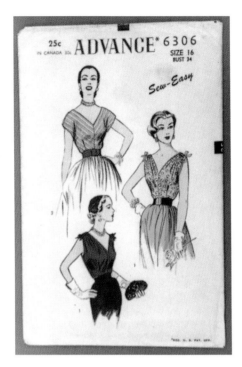

Advance #6306, 1953.

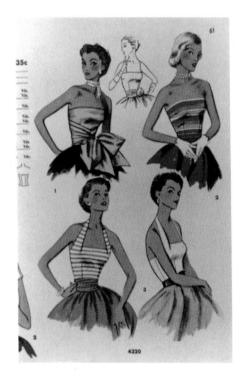

Simplicity #4320, 1953.

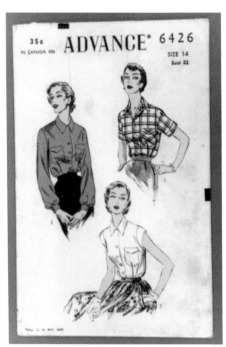

Advance 6426, 1953.

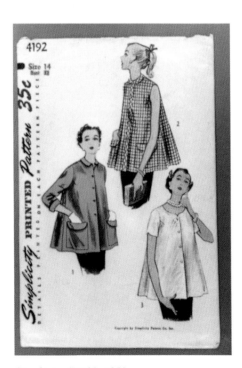

Simplicity #4192, 1953.

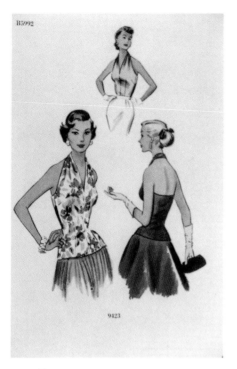

McCall's #9423, 1953. *Author's collection.*
Courtesy of The McCall Pattern Company.

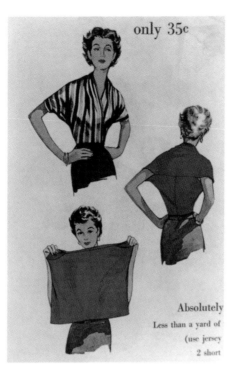

Simplicity #4538, 1954.

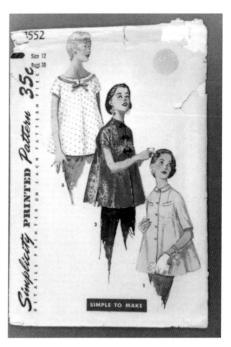

Simplicity #4552, 1954.

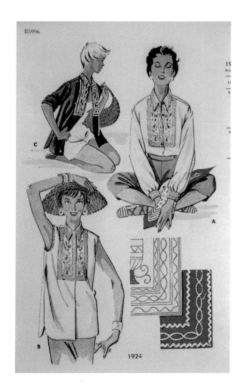

McCall's #1924, 1954. *Author's collection.*
Courtesy of The McCall Pattern Company.

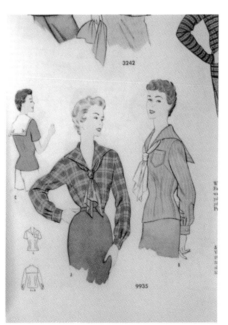

McCall's #9935, 1954. *Author's collection.*
Courtesy of The McCall Pattern Company.

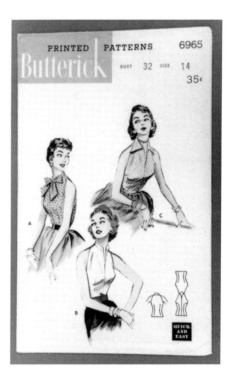

Butterick #6965, 1954.

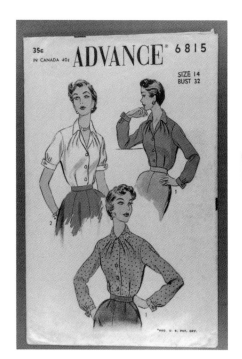

Advance #6815, 1954.

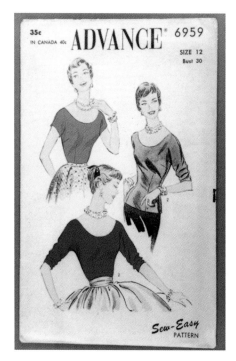

Advance #6959, 1955.

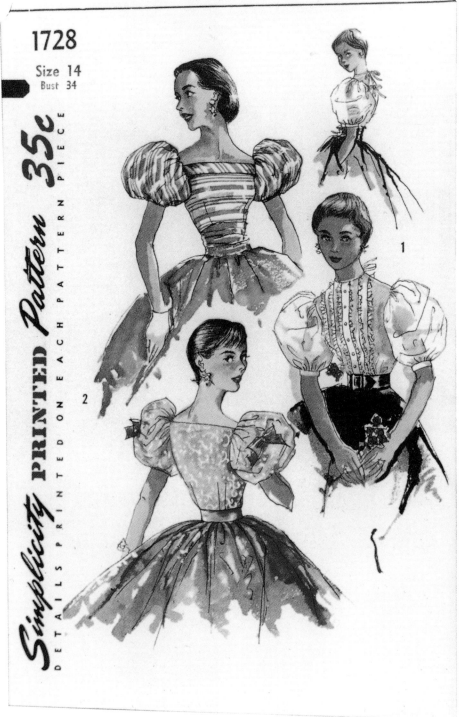

Simplicity #1728, 1956.

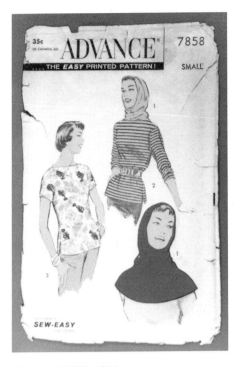

Advance #7858, 1956.

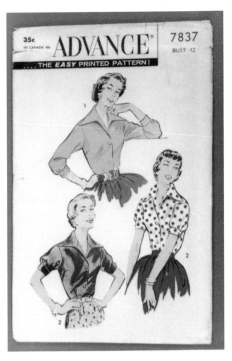

Advance #7837, 1956.

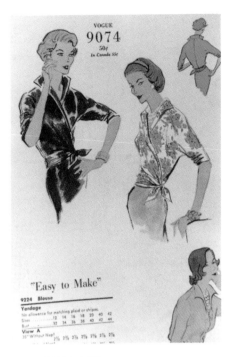

Vogue #9074, 1957.

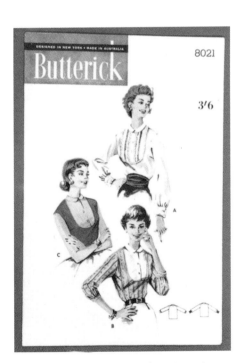

Butterick #8021, 1957. Made in Australia.
Courtesy of the Butterick Archives.

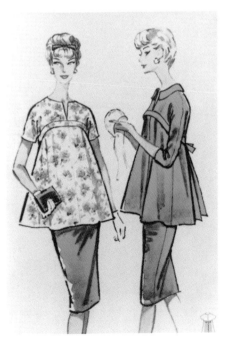

McCall's #4819, 1958. *Author's collection.*
Courtesy of The McCall Pattern Company.

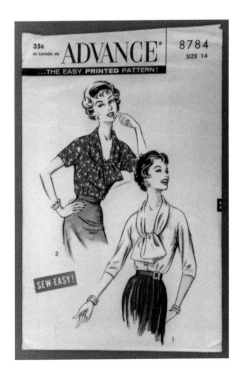

Advance #8784, 1958.

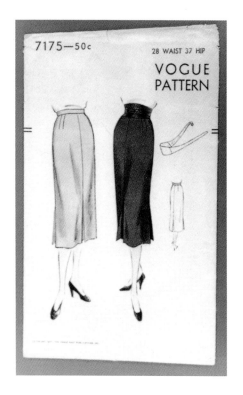

Vogue #7175, 1950.

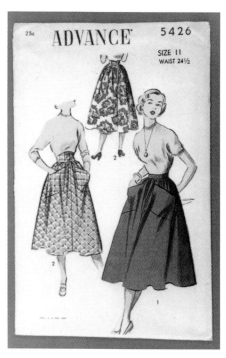

Advance #5426, 1950.

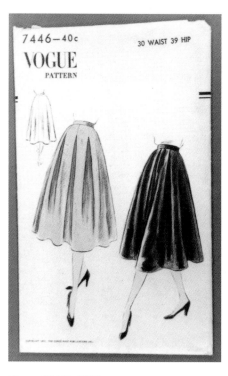

Vogue #7446, 1951.

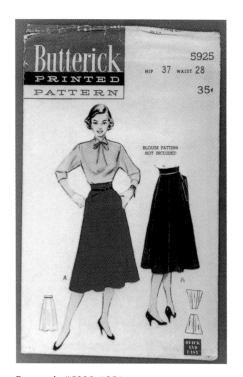

Butterick #5925, 1951.

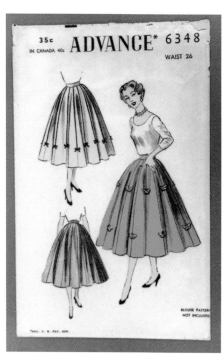

Advance #6348, 1953.

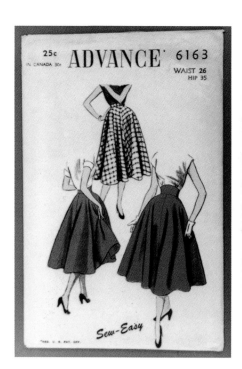

Advance #6163, 1952.

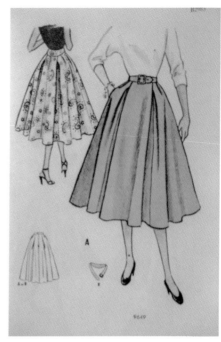

McCall's #9649, 1953. *Author's collection.
Courtesy of The McCall Pattern Company.*

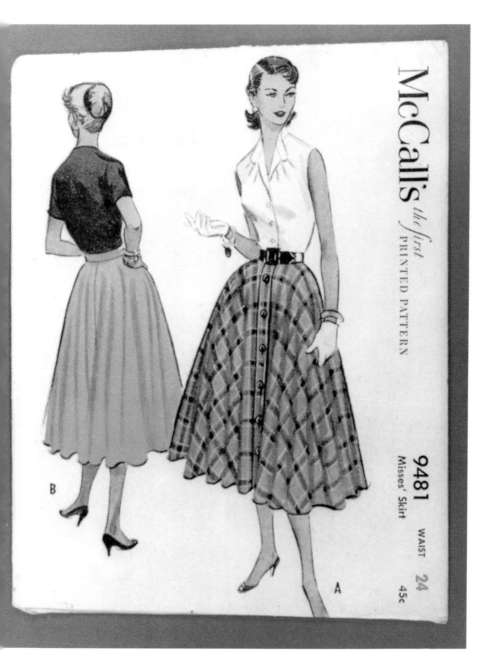

McCall's #9481, 1953. *Author's collection. Courtesy of The McCall Pattern Company.*

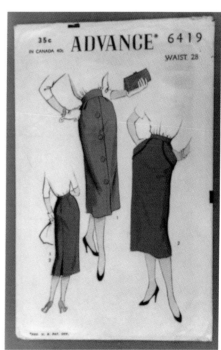

Advance #6419, 1953.

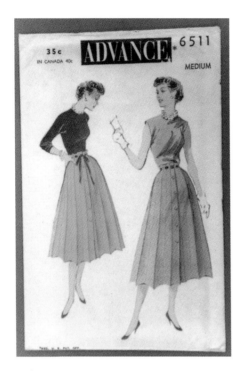

Advance #6511, 1953.

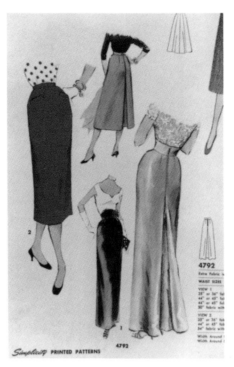

Simplicity #4792, 1954.

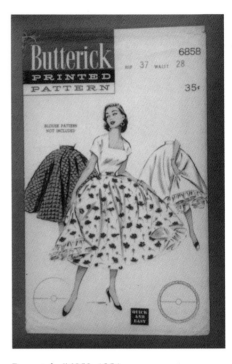

Butterick #6858, 1954.

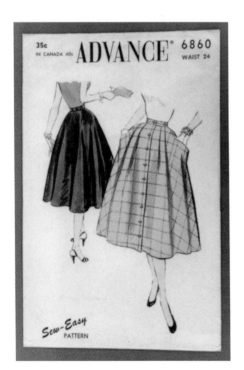

Advance #6860, 1954.

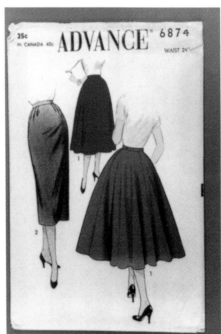

Advance #6874, 1954.

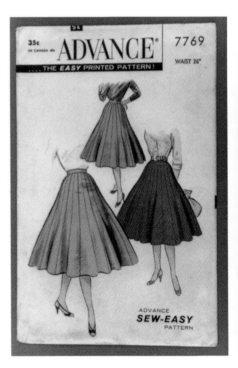

Advance #7769, 1956.

Vogue Junior #3355, 1950.

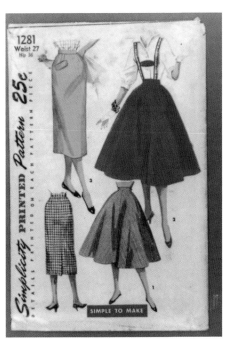

Simplicity #1281, 1955.

McCall's #3130, 1955. *Author's collection.*
Courtesy of The McCall Pattern Company.

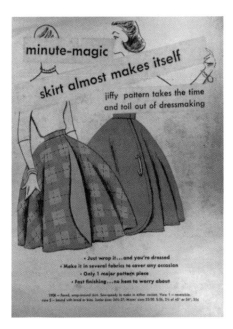

Simplicity #1908, 1957.

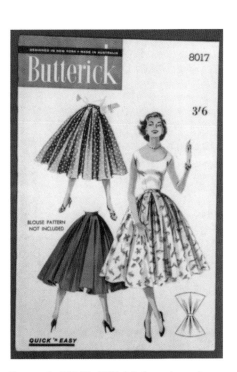

Butterick #8017, 1957. Made in Australia.
Courtesy of the Butterick Archives.

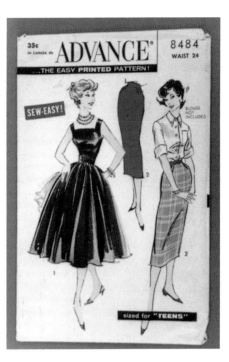

Advance #8484, 1957.

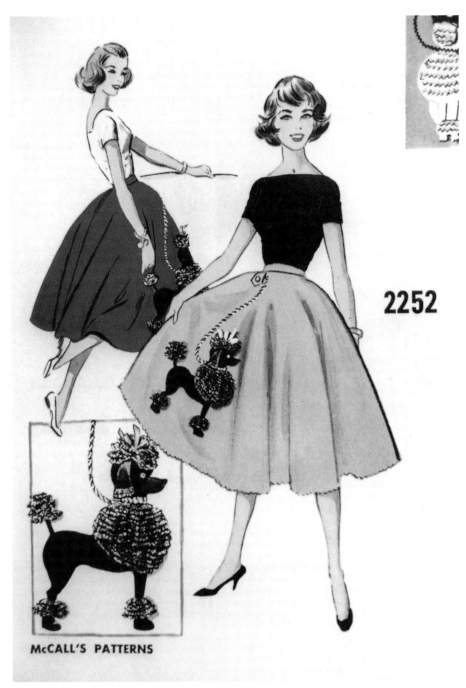

2252

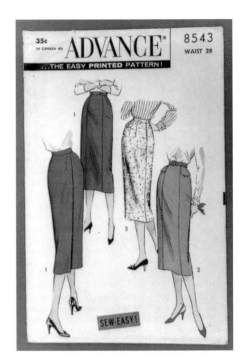

Advance #8543, 1958.

McCall's #2252, 1957. Author's collection
Courtesy of The McCall Pattern Company.

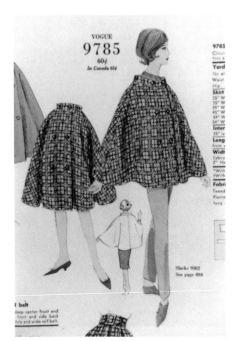

Vogue #9785, 1959.

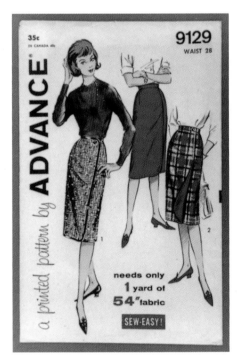

Advance #9129, 1959.

JACKETS, COATS, WRAPS

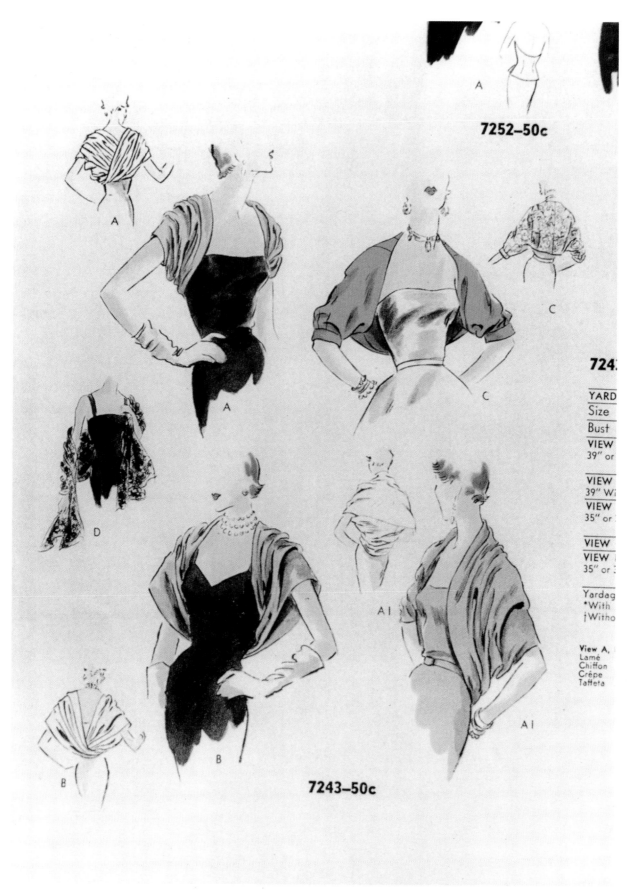

7252—50c

724[

YARD
Size
Bust
VIEW
39" or

VIEW
39" Wi
VIEW
35" or

VIEW
VIEW
35" or

Yardag
*With
†Witho

View A,
Lamé
Chiffon
Crêpe
Taffeta

7243—50c

Vogue #7243, 1950/51. *Courtesy of the Butterick Archives.*

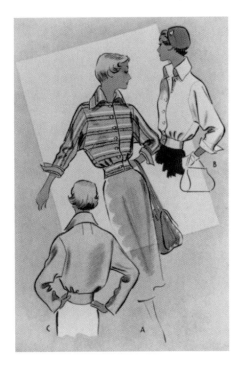

McCall #8024, 1950. *Courtesy of The McCall Pattern Company.*

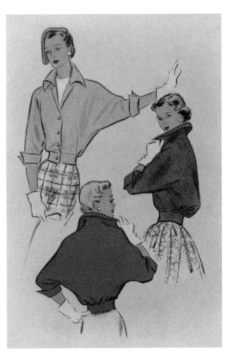

McCall #7991, 1950. *Courtesy of The McCall Pattern Company.*

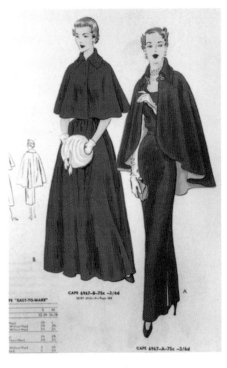

Vogue #6967, 1949/50. *Courtesy of the Butterick Archives.*

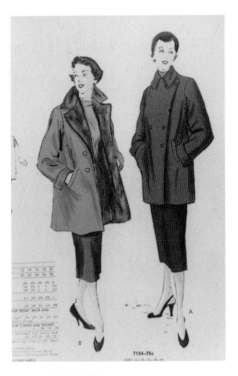

Vogue #7154, 1950.

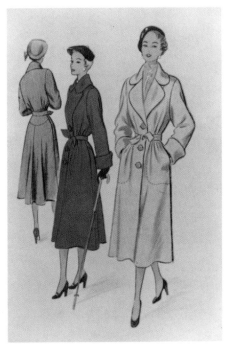

McCall #8212, 1950. *Courtesy of The McCall Pattern Company.*

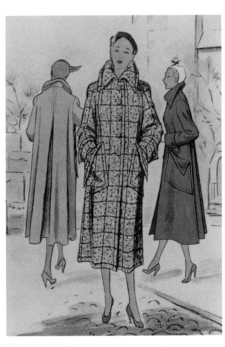

McCall #7959, 1950. *Courtesy of The McCall Pattern Company.*

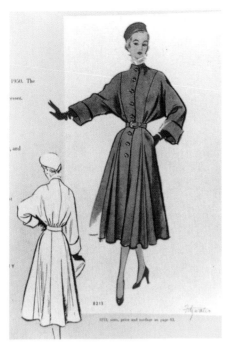

McCall #8213, 1950. *Courtesy of*
The McCall Pattern Company.

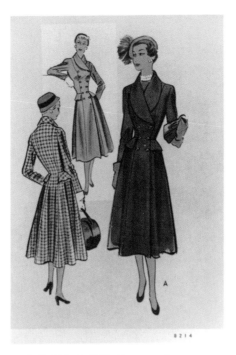

McCall #8214, 1950. *Courtesy of*
The McCall Pattern Company.

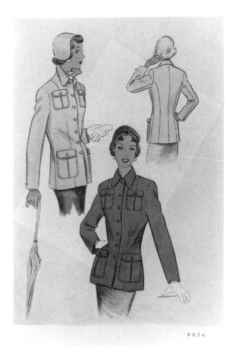

McCall #8026, 1950. *Courtesy of*
The McCall Pattern Company.

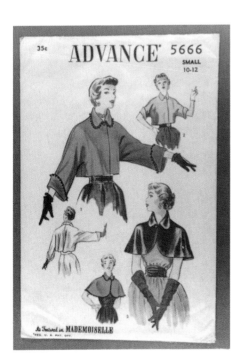

Advance #5666, 1950.

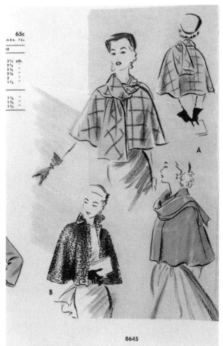

McCall's #8645, 1951. *Author's collection.*
Courtesy of The McCall Pattern Company.

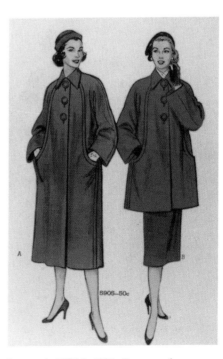

Butterick #5905, 1951. *Courtesy of*
the Irene Lewisohn Costume Reference
Library, Metropolitan Museum of Art.

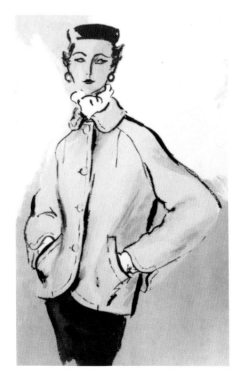

Vogue #7920, 1952/53. *Courtesy of the Butterick Archives.*

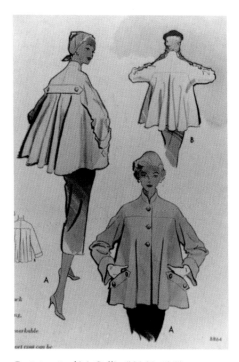

Paris inspired McCall's #8864, 1952. *Courtesy of The McCall Pattern Company.*

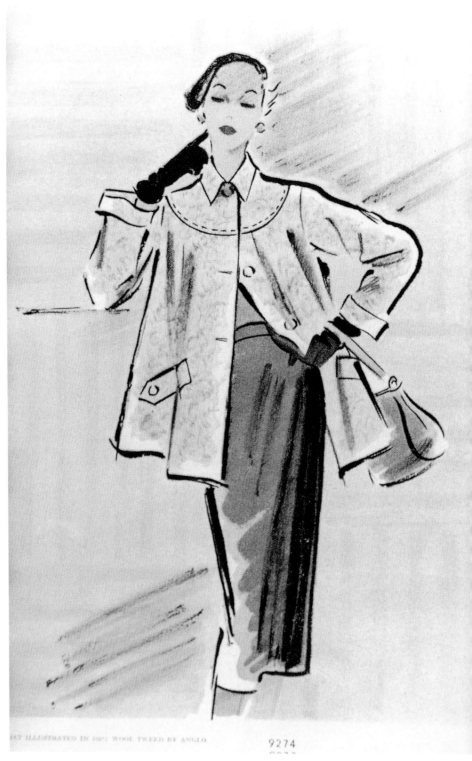

McCall's #9274, 1953. *Courtesy of The McCall Pattern Company.*

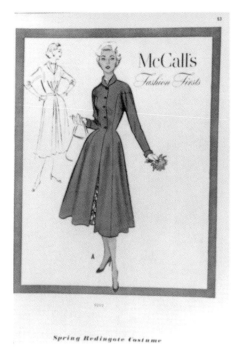

McCall's Fashion Firsts #9292, 1953.
Courtesy of The McCall Pattern Company.

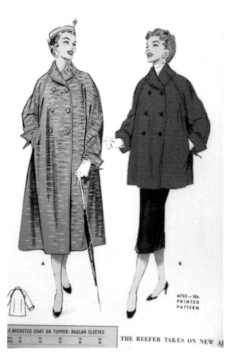

Butterick #6723, 1953. *Courtesy of the Butterick Archives.*

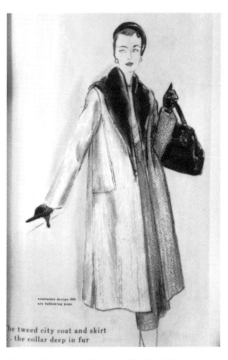

Vogue Couturier Design #830, 1954.
Courtesy of the Butterick Archives.

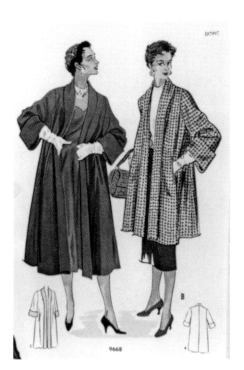

McCall's #9668, 1954. *Author's collection.*
Courtesy of The McCall Pattern Company.

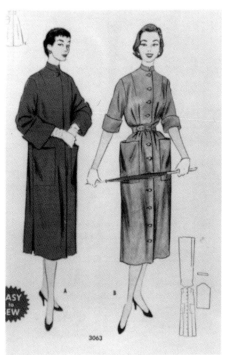

McCall's #3063, 1954. *Author's collection.*
Courtesy of The McCall Pattern Company.

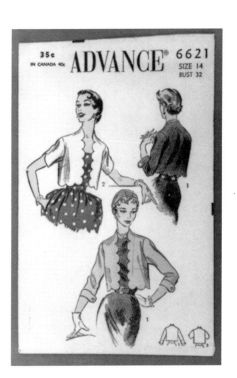

Advance #6621, 1954.

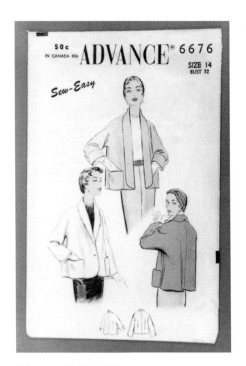

Advance #6676, 1954.

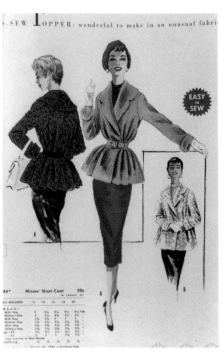

McCall's #3444, 1955. *Author's collection.*
Courtesy of The McCall Pattern Company.

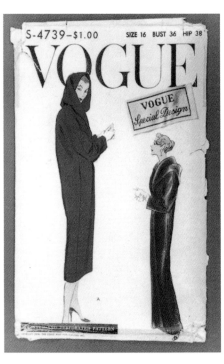

Vogue Special Design #S-4739, 1956.

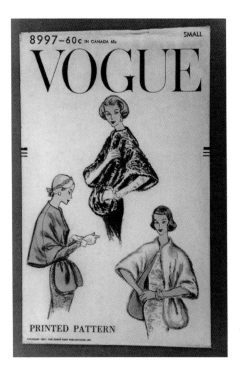

Vogue #8997, 1956.

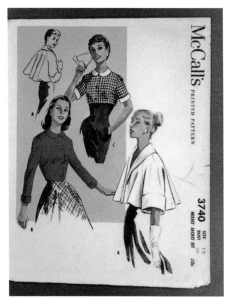

McCall's #3740, 1956. *Author's collection.*
Courtesy of The McCall Pattern Company.

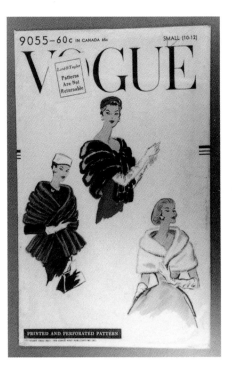

Vogue #9055, 1957.

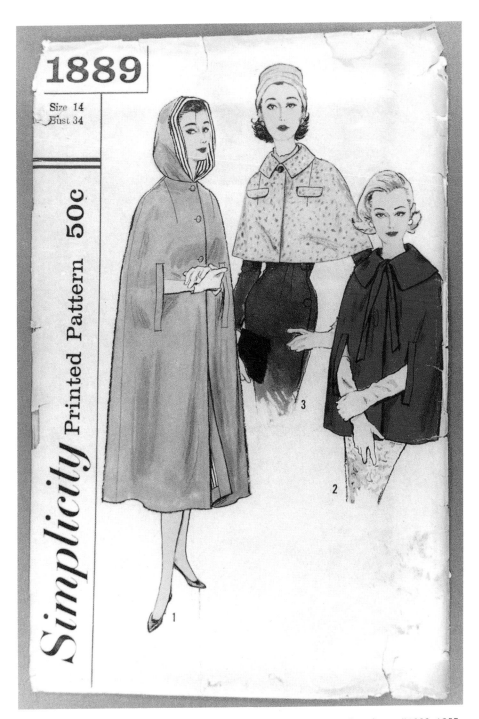

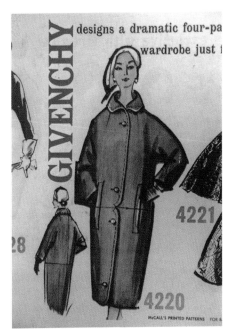

McCall's by Givenchy #4220, 1957. Author's collection. Courtesy of The McCall Pattern Company.

Simplicity #1889, 1957.

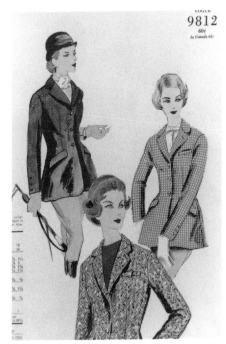

Vogue #9812, 1959.

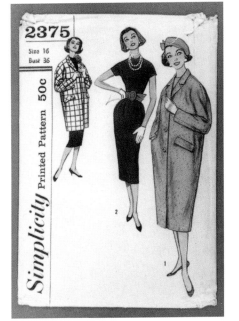

Simplicity #2375, 1958.

SPORTSWEAR

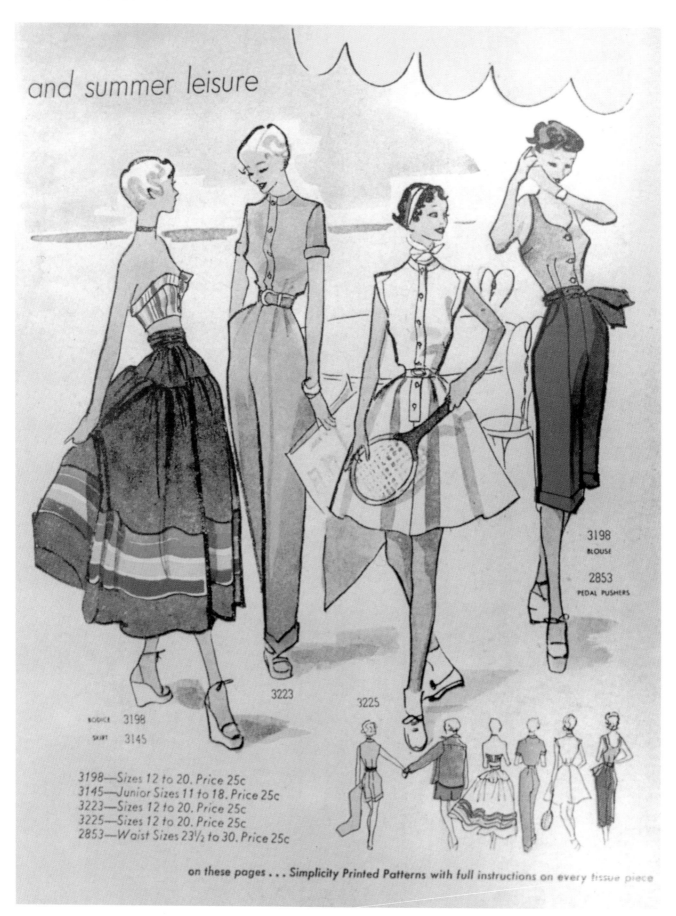

and summer leisure

3198
BLOUSE

2853
PEDAL PUSHERS

BODICE 3198
SKIRT 3145

3223

3225

3198—Sizes 12 to 20. Price 25c
3145—Junior Sizes 11 to 18. Price 25c
3223—Sizes 12 to 20. Price 25c
3225—Sizes 12 to 20. Price 25c
2853—Waist Sizes 23½ to 30. Price 25c

on these pages . . . Simplicity Printed Patterns with full instructions on every tissue piece

Simplicity leisure wear, 1950.

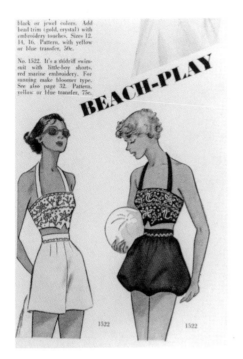

black or jewel colors. Add bead trim (gold, crystal) with embroidery touches. Sizes 12, 14, 16. Pattern, with yellow or blue transfer, 50c.

No. 1522. It's a thidriff swim-suit with little-boy shorts, red marine embroidery. For sunning make bloomer type. See also page 32. Pattern, yellow or blue transfer, 75c.

BEACH-PLAY

McCall #1522, 1950. *Author's collection. Courtesy of the McCall Pattern Company.*

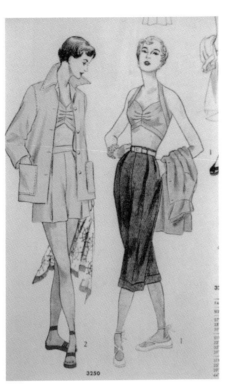

Simplicity #3250, 1950.

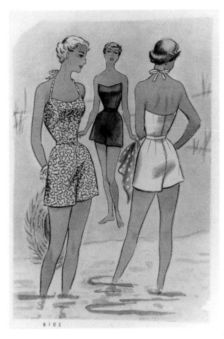

McCall #8103, 1950. *Courtesy of The McCall Pattern Company.*

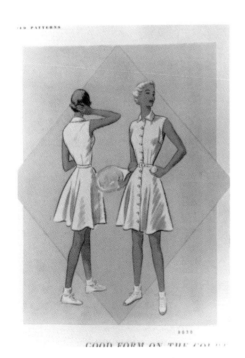

McCall #8030, 1950. *Courtesy of The McCall Pattern Company.*

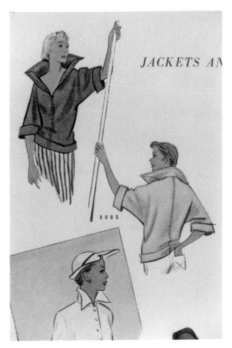

JACKETS AN

McCall #8085, 1950. *Courtesy of The McCall Pattern Company.*

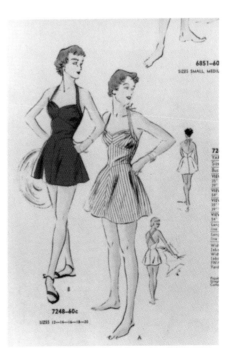

Vogue #7248, 1951. *Courtesy of the Butterick Archives.*

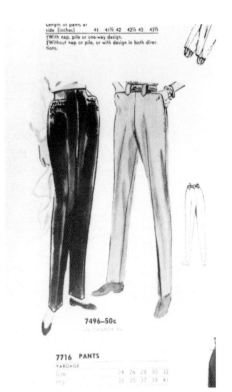

Vogue #7496, 1951. *Courtesy of the Butterick Archives.*

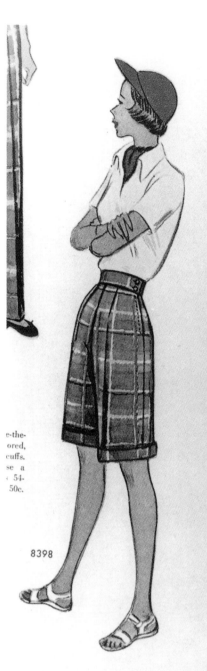

McCall #8398 and 8395, 1951. *Author's collection. Courtesy of The McCall Pattern Company.*

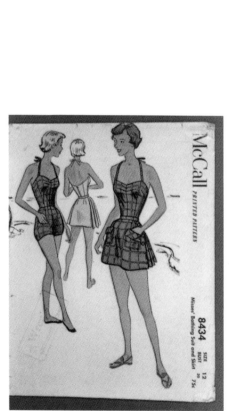

McCall #8434, 1951. *Author's collection. Courtesy of The McCall Pattern Company.*

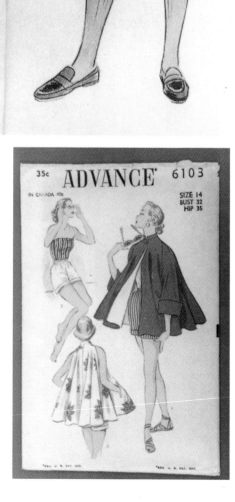

Advance #6103, 1952.

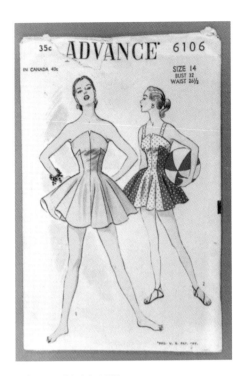

Advance #6106, 1952.

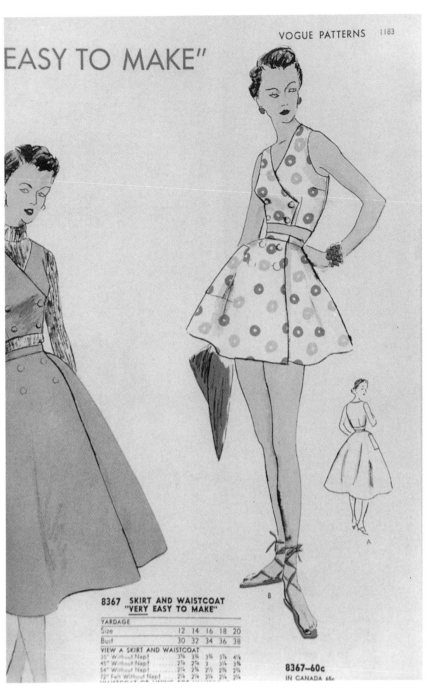

"EASY TO MAKE"

8367 SKIRT AND WAISTCOAT
"VERY EASY TO MAKE"

YARDAGE					
Size	12	14	16	18	20
Bust	30	32	34	36	38
VIEW A SKIRT AND WAISTCOAT					

8367–60c
IN CANADA 65c

Vogue #8367, 1954. Courtesy
of the Butterick Archives.

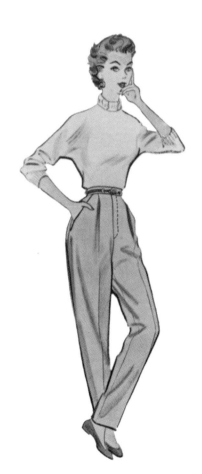

McCall's #9561, 1953. Courtesy
of The McCall Pattern Company.

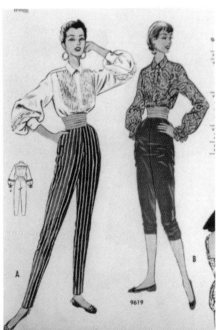

McCall's #9619, 1953.
Author's collection. Courtesy of
The McCall Pattern Company.

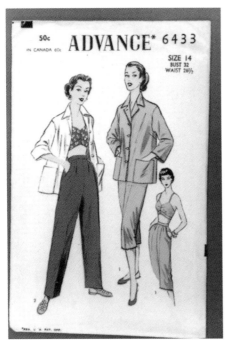

Advance #6433, 1953.

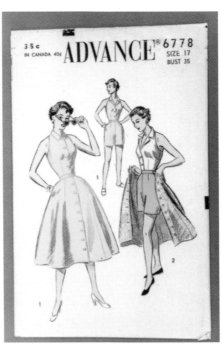

Advance #6778, 1954.

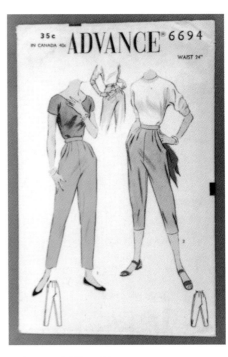

Advance #6694, 1954.

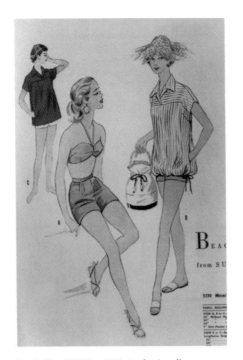

McCall's #3230, 1955. *Author's collection.*
Courtesy of The McCall Pattern Company.

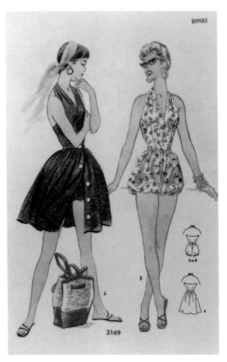

McCall's #3169, 1955. *Author's collection.*
Courtesy of The McCall Pattern Company.

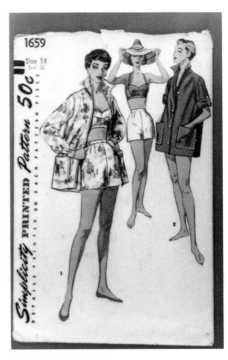

Simplicity #1659, 1956.

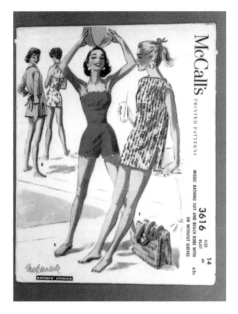

McCall's #3616, 1956. *Author's collection. Courtesy of The McCall Pattern Company.*

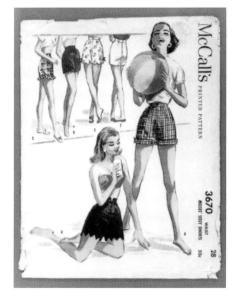

McCall's #3670, 1956. *Author's collection. Courtesy of The McCall Pattern Company.*

McCall's #5263, 1959. *Author's collection. Courtesy of The McCall Pattern Company.*

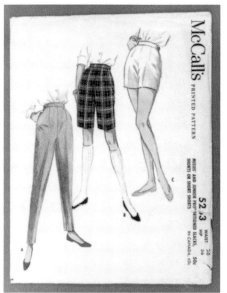

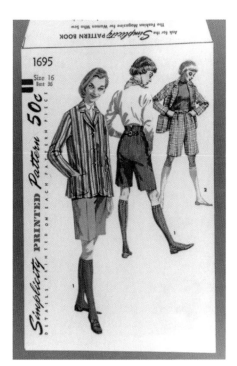

Simplicity #1695, 1956.

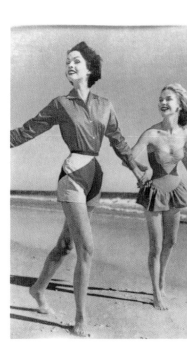

Emilio Pucci designs for McCall's #3978 and 3977, 1957. *Courtesy of The McCall Pattern Company.*

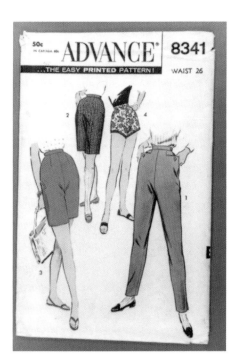

Advance #8341, 1957.

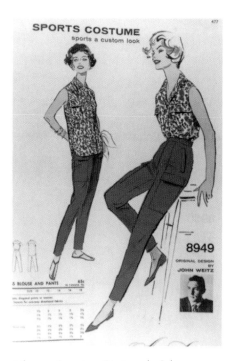

Advance American Designer by John Weitz #8949, 1959. *Courtesy of the Irene Lewisohn Costume Reference Library, Metropolitan Museum of Art.*

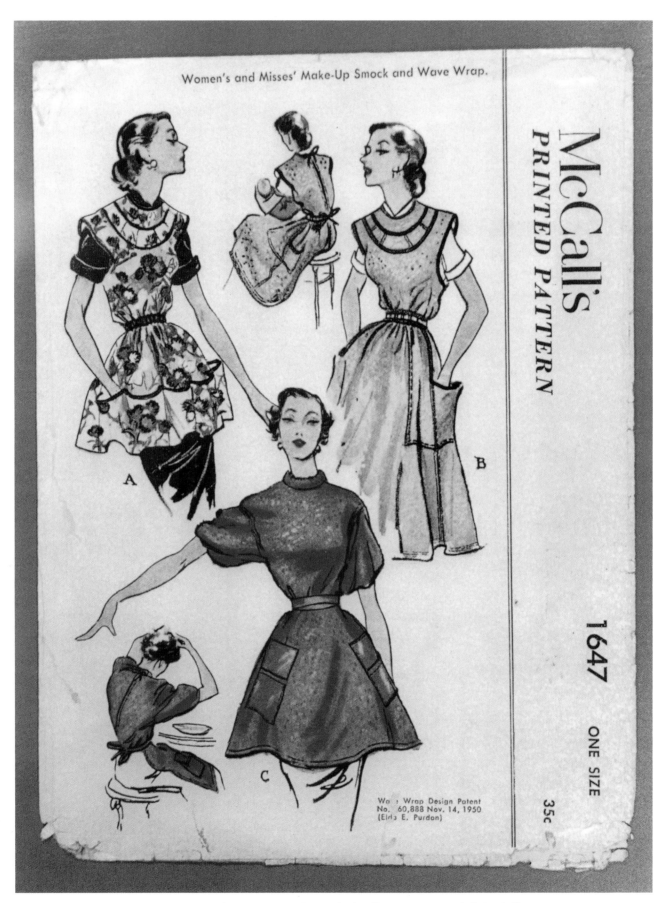

McCall's #1647, 1951. Patented Wave Wrap Design. *Author's collection. Courtesy of The McCall Pattern Company.*

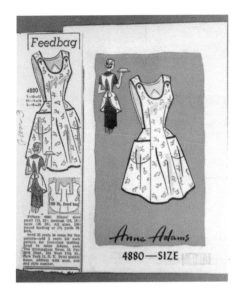

Anne Adams #4880, 1950s.

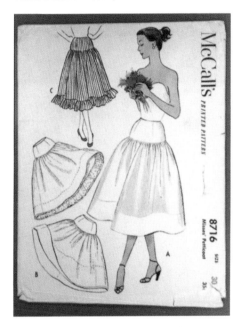

McCall's #8716, 1951. *Author's collection. Courtesy of The McCall Pattern Company.*

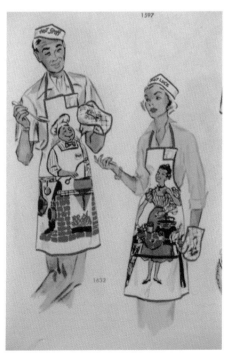

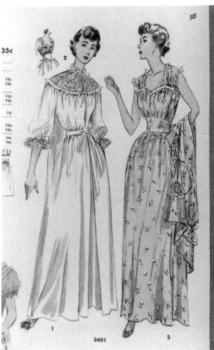

Simplicity #3401, 1951.

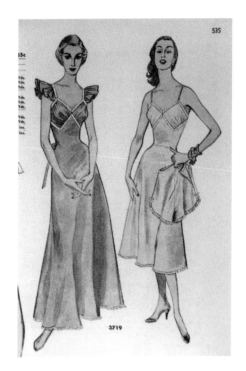

Simplicity #3719, 1951.

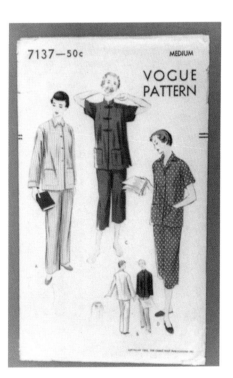

Vogue #7137, 1950.

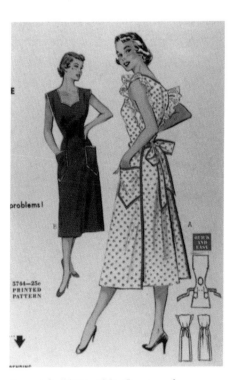

Butterick #5744, 1951. *Courtesy of the Irene Lewisohn Costume Reference Library, Metropolitan Museum of Art.*

McCall's #1632, 1951. *Author's collection. Courtesy of The McCall Pattern Company.*

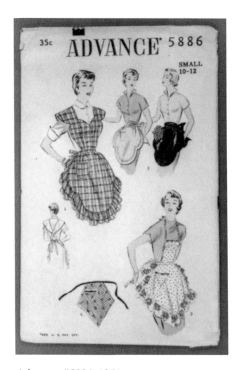

Advance #5886, 1951.

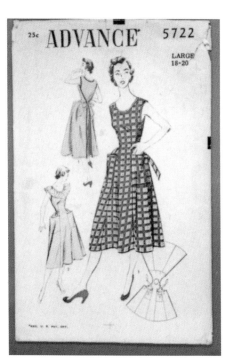

Advance #5722, 1951.

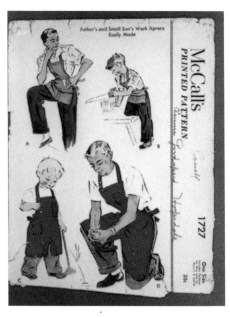

McCall's #1727, 1952. *Author's collection. Courtesy of The McCall Pattern Company.*

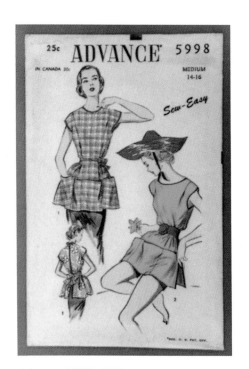

Advance #5998, 1952.

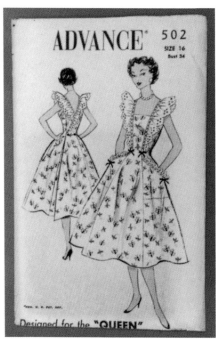

Advance #502, early 1950s.

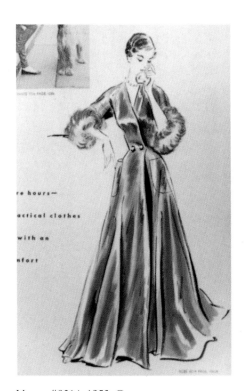

Vogue #8014, 1953. *Courtesy of the Butterick Archives.*

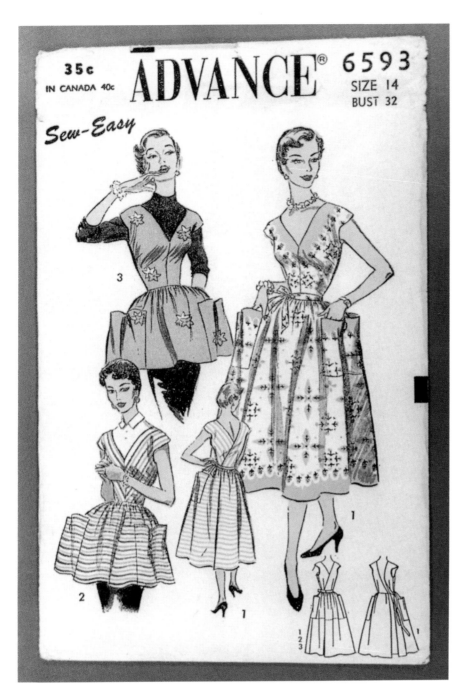

Advance #6593, 1955.

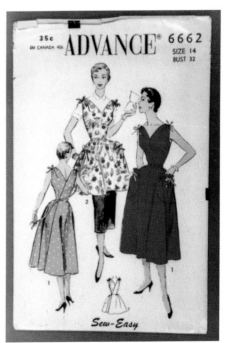

Advance #6463, 1953.

Advance #6662, 1954.

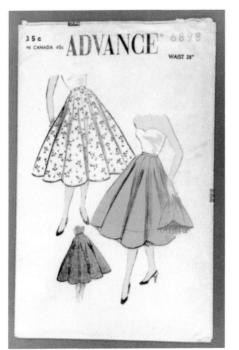

Advance #6898, 1954.

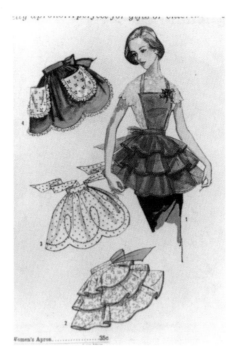

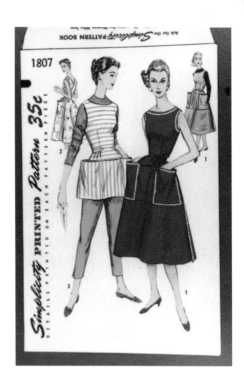

Simplicity #1102, 1955.

Simplicity #1805, 1956.

Vogue #9368, 1958.

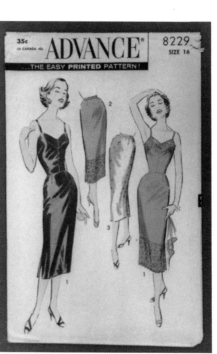
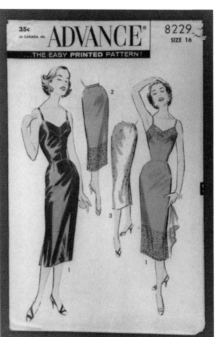

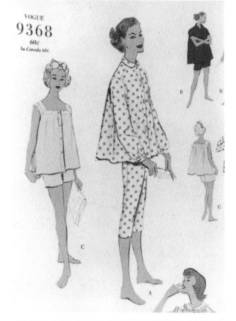

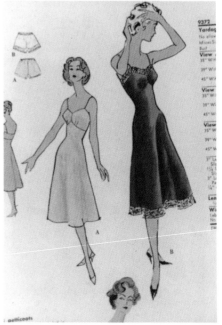

Advance #7816, 1956.

Advance #8229, 1957.

Vogue #9372, 1958.

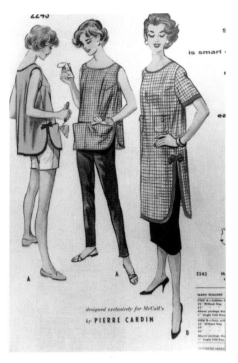

McCall's by Pierre Cardin #2243,
1958. *Author's collection. Courtesy of
The McCall Pattern Company.*

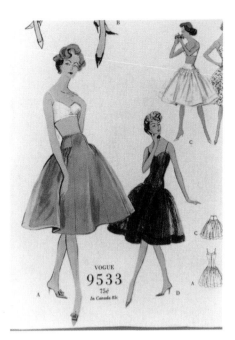

Vogue #9533, 1958.

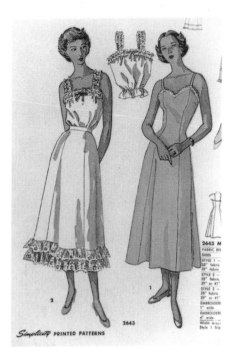

Simplicity #2643, 1958.

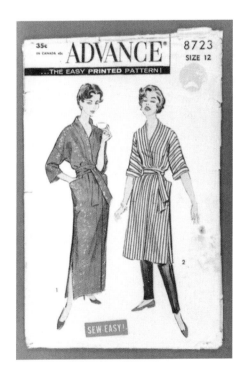

Advance #8723, 1958.

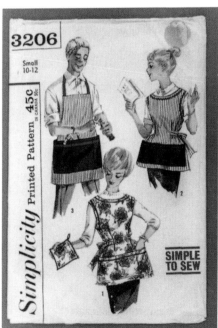

Simplicity #3206, 1959.

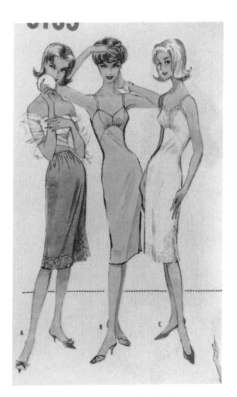

McCall's #5199, 1959. *Author's collection.
Courtesy of The McCall Pattern Company.*

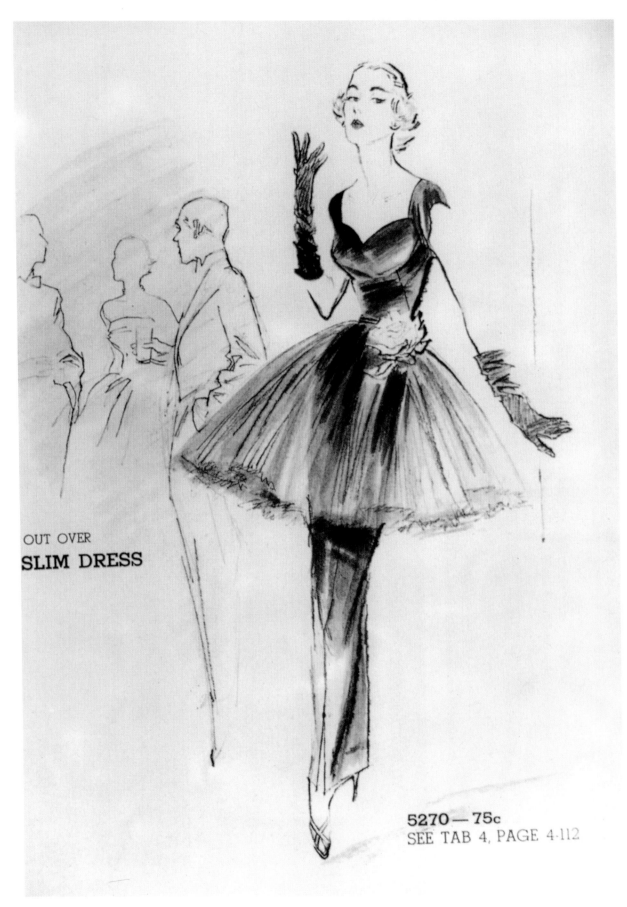

OUT OVER
SLIM DRESS

5270 — 75c
SEE TAB 4, PAGE 4-112

Butterick #5270, 1950. *Courtesy of the Butterick Archives.*

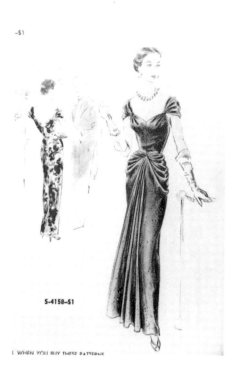

Vogue Special Design #4158, 1950.
Courtesy of the Butterick Archives.

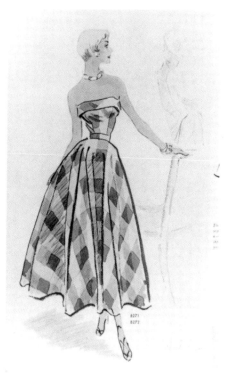

McCall #8271 and 8272, 1950. *Courtesy of The McCall Pattern Company.*

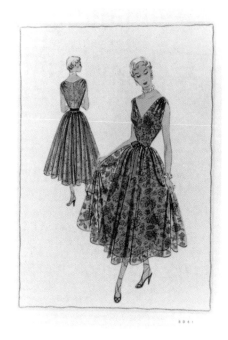

McCall #8041, 1950. *Courtesy of The McCall Pattern Company.*

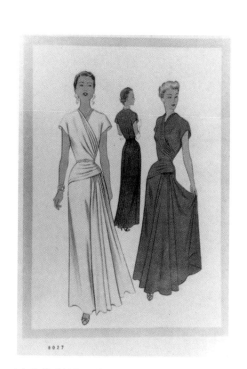

McCall #8027, 1950. *Courtesy of The McCall Pattern Company.*

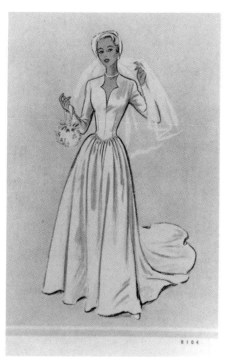

McCall #8104, 1950. *Courtesy of The McCall Pattern Company.*

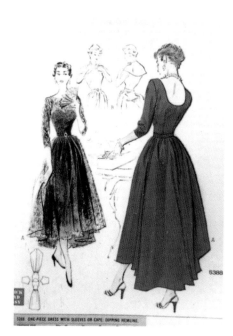

Butterick #5388, 1950. *Courtesy of the Butterick Archives.*

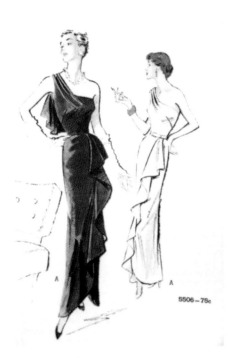

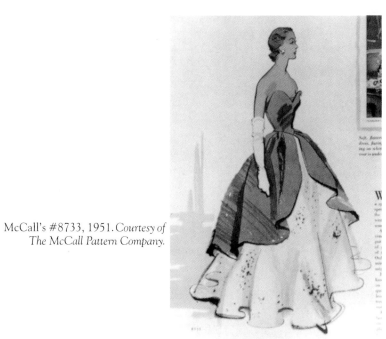

McCall's #8733, 1951. *Courtesy of The McCall Pattern Company.*

Butterick #5506, 1950. *Courtesy of the Butterick Archives.*

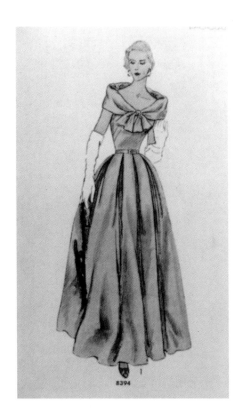

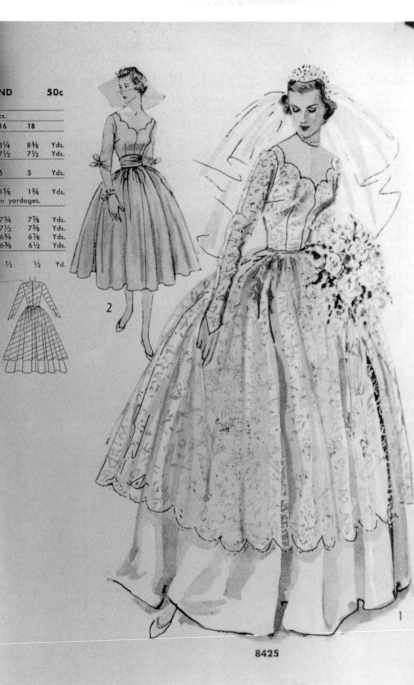

Simplicity Designer's #8394, 1951.

Simplicity Designer's #8425, 1951.

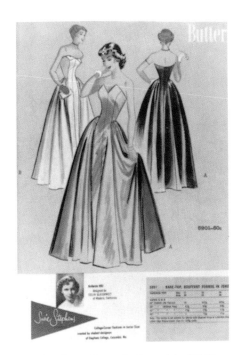

Suzie Stephens Originals, Butterick #5901, 1951. *Courtesy of the Butterick Archives.*

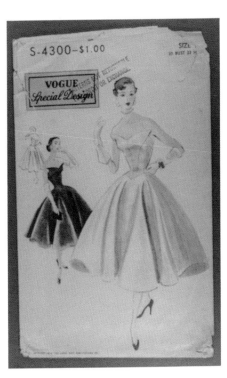

Vogue Special Design #S-4300, 1952.

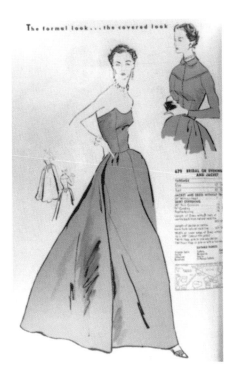

Vogue Couturier #679, 1952. *Courtesy of the Butterick Archives.*

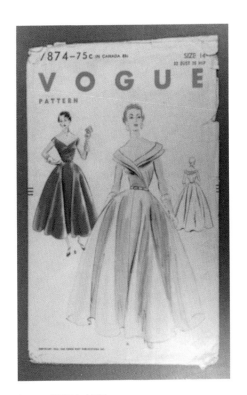

Vogue #7874, 1952.

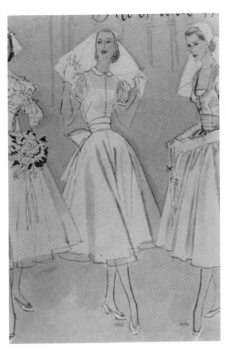

Simplicity #3765, 1952.

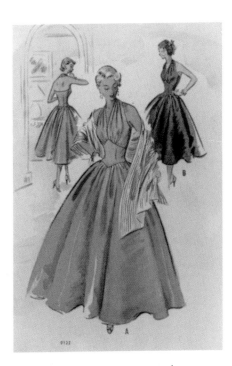

McCall's #9122, 1952. *Courtesy of The McCall Pattern Company.*

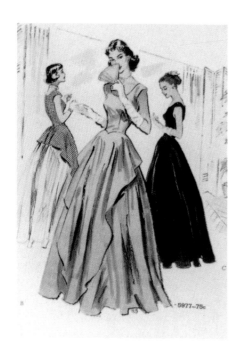

Butterick #5977, 1952. *Courtesy of the Butterick Archives.*

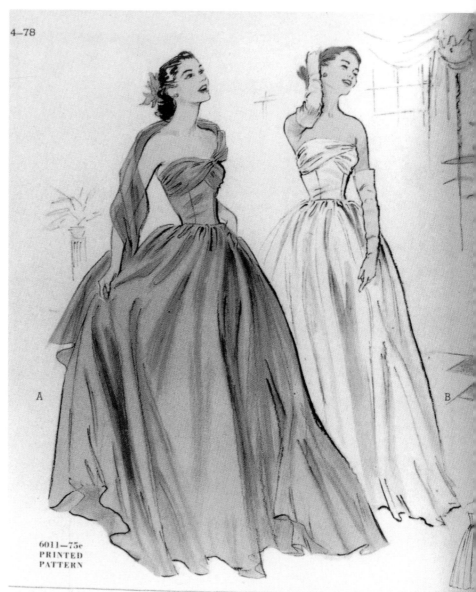

6011—75c
PRINTED
PATTERN

BEAUTIFUL... *whether* BARE-TOPPED

or beguilingly covered

with an ATTACHED STOLE

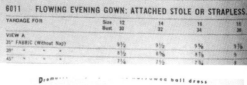

6011	FLOWING EVENING GOWN: ATTACHED STOLE OR STRAPLESS.				
YARDAGE FOR	Size	12	14	16	18
	Bust	30	32	34	36
VIEW A					
35" FABRIC (Without Nap)		9½	9½	9¾	9⅞
39"		8½	8¾	8⅞	9
45"		7¼	7½	7¾	

Butterick #6011, 1952. *Courtesy of the Butterick Archives.*

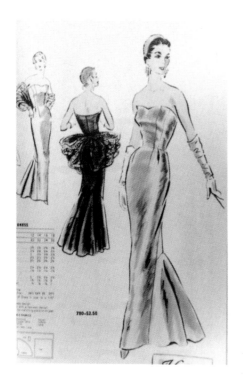

Vogue Couturier #780, 1953.
Courtesy of the Butterick Archives.

Vogue Special Design #S-4365, 1953.
Courtesy of the Butterick Archives.

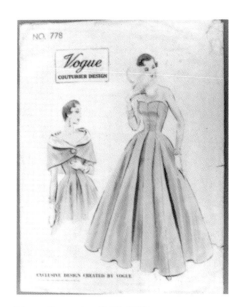

Vogue Couturier #778, 1953.

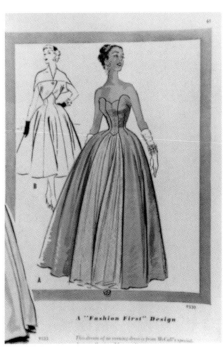

McCall's Fashion Firsts #9530, 1953.
Courtesy of The McCall Pattern Company.

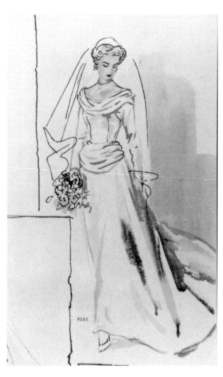

McCall's #9265, 1953. *Courtesy of The McCall Pattern Company.*

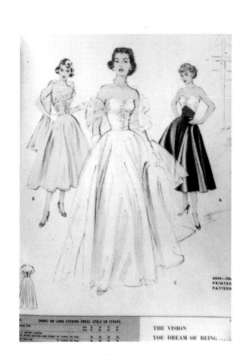

Butterick #6444, 1953. *Courtesy of the Butterick Archives.*

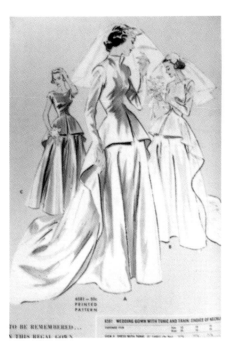

Butterick #6581, 1953. *Courtesy of the Butterick Archives.*

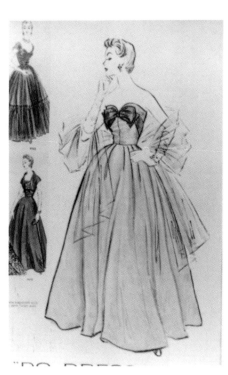

McCall's #9954, 1954. *Courtesy of The McCall Pattern Company.*

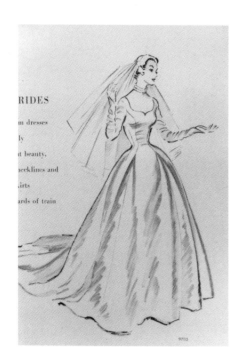

RIDES

m dresses
ly

t beauty,

necklines and

irts

ards of train

McCall's #9703, 1954. *Courtesy of*
The McCall Pattern Company.

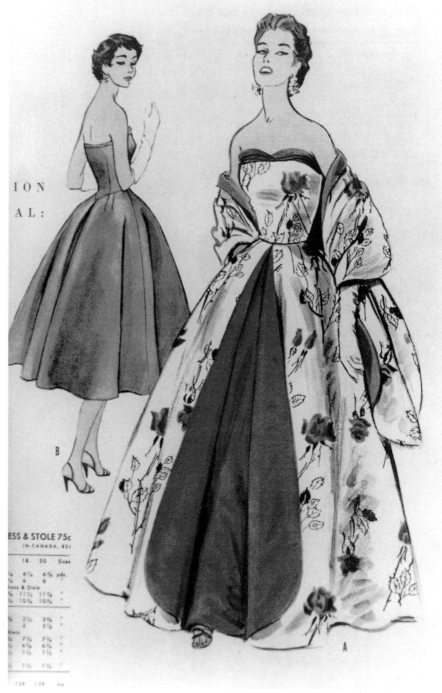

ION
AL:

ESS & STOLE 75c
IN CANADA, 85¢

| | 18 | 20 | Sizes |

McCall's #3106, 1954. *Courtesy of*
The McCall Pattern Company.

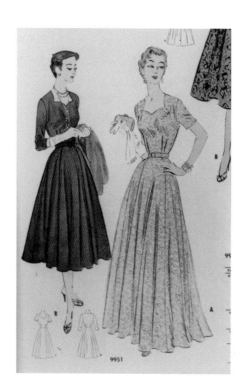

McCall's #9951, 1954. *Author's collection.*
Courtesy of The McCall Pattern Company.

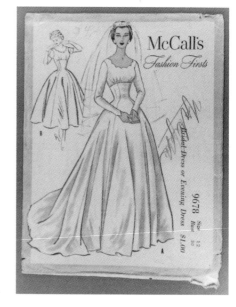

McCall's Fashion Firsts #9678, 1954.
Courtesy of The McCall Pattern Company.

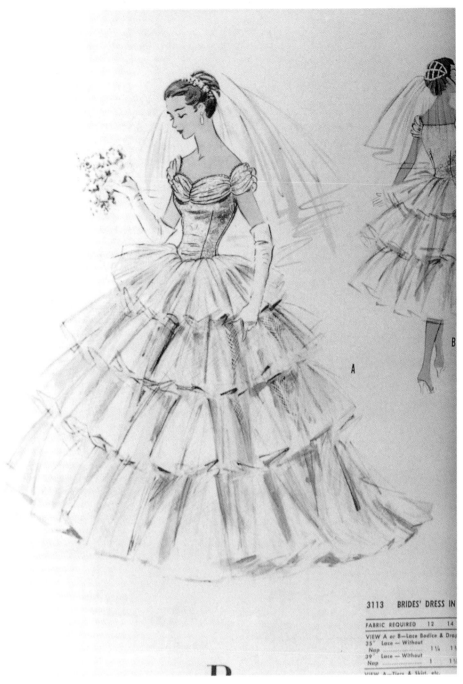

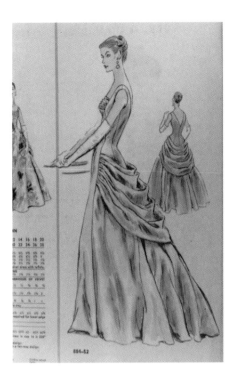

Vogue Couturier #884, 1955.
Courtesy of the Butterick Archives.

McCall's #3113, 1954. *Author's collection.*
Courtesy of The McCall Pattern Company.

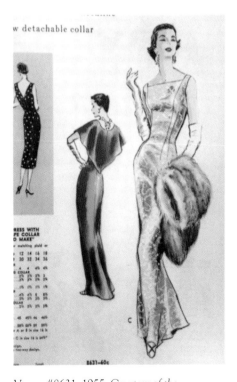

Vogue #8631, 1955. *Courtesy of the
Butterick Archives.*

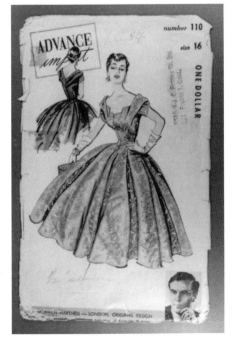

Advance Import by Norman
Hartnell, #110, mid-1950s.

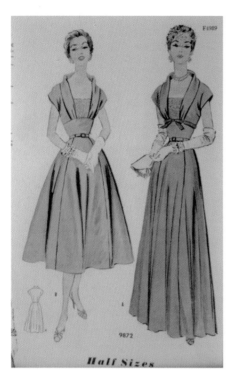

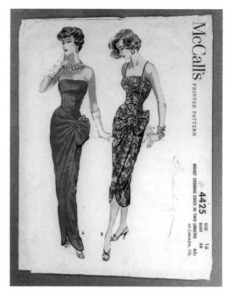

McCall's #4425, 1958. *Author's collection.*
Courtesy of The McCall Pattern Company.

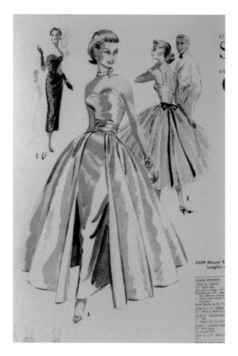

McCall's #9872, 1954. *Author's collection.*
Courtesy of The McCall Pattern Company.

McCall's #3439, 1955. *Author's collection.*
Courtesy of The McCall Pattern Company.

Vogue Special Design #S-4747, 1956.

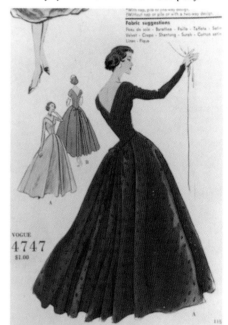

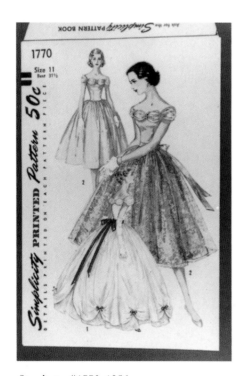

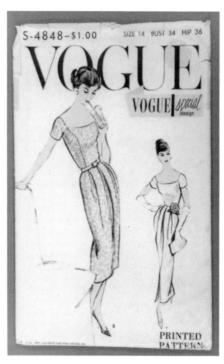

Simplicity #1770, 1956.

Vogue Special Design #S-4848, 1957.

Pauline Trigère design for McCall's
#4258, 1957. *Author's collection.*
Courtesy of The McCall Pattern Company.

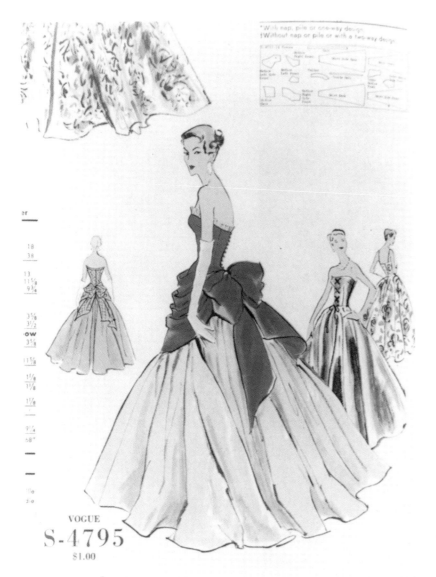

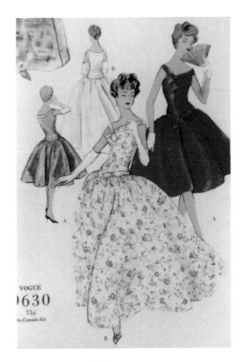

Vogue #9630, 1959.

Vogue Special Design #S-4795, 1957.

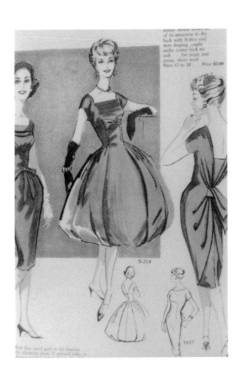

Modes Royale #S-214, late 1950s.

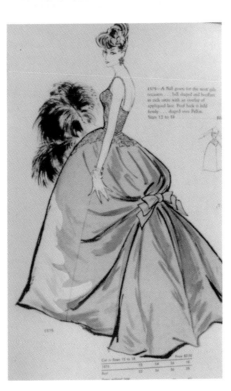

Modes Royale #1575, late 1950s.

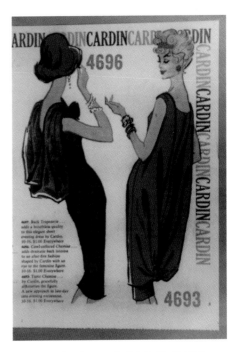

Pierre Cardin designs for McCall's #4693 and 4696, 1959. *Author's collection. Courtesy of The McCall Pattern Company.*

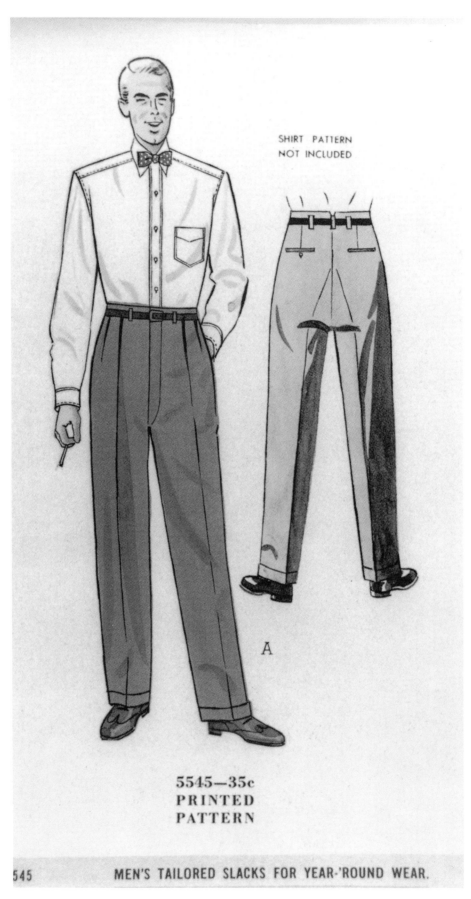

SHIRT PATTERN
NOT INCLUDED

A

5545—35c
PRINTED
PATTERN

545 MEN'S TAILORED SLACKS FOR YEAR-'ROUND WEAR.

Butterick #5545, 1950. *Courtesy of the Irene Lewisohn Costume Reference Library, Metropolitan Museum of Art.*

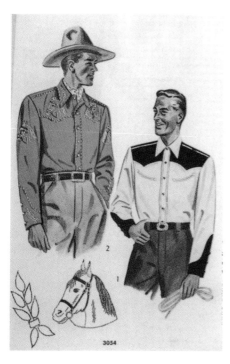

Simplicity #3054, 1950.

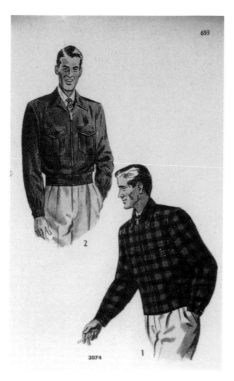

Simplicity #3074, 1950.

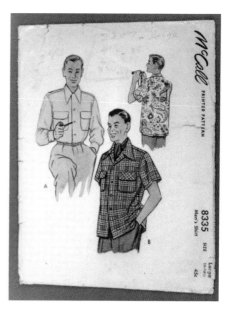

McCall #8335, 1950. *Author's collection.*
Courtesy of The McCall Pattern Company.

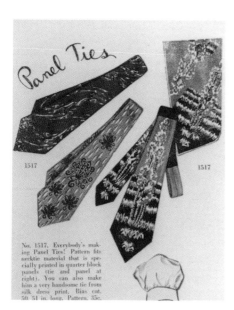

McCall #1517, 1950. *Author's collection.*
Courtesy of The McCall Pattern Company.

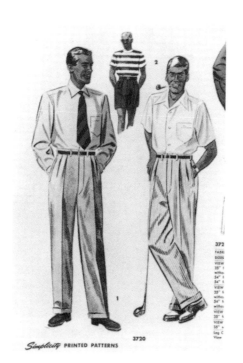

Simplicity #3720, 1950.

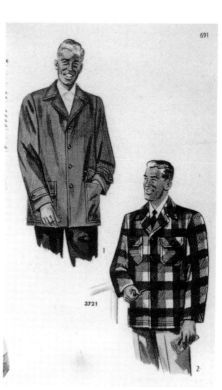

Simplicity #3721, 1950.

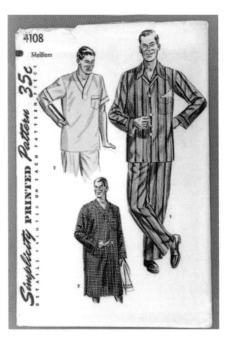

Simplicity #4108, 1952.

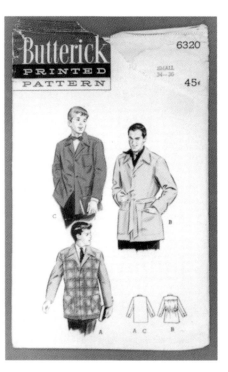

Butterick #6320, 1952.

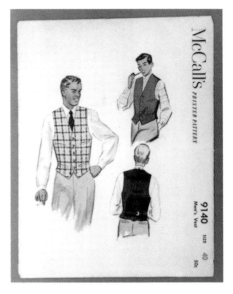

McCall's #9140, 1952. *Author's collection. Courtesy of The McCall Pattern Company.*

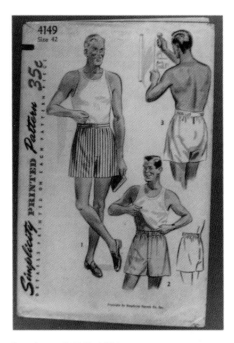

Simplicity #4149, 1953.

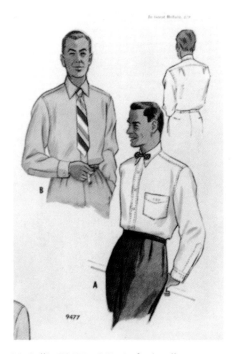

McCall's #9477, 1953. *Author's collection. Courtesy of The McCall Pattern Company.*

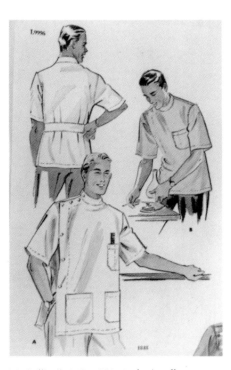

McCall's #1848, 1953. *Author's collection. Courtesy of The McCall Pattern Company.*

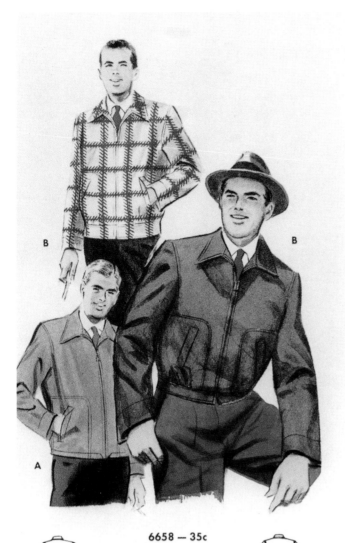

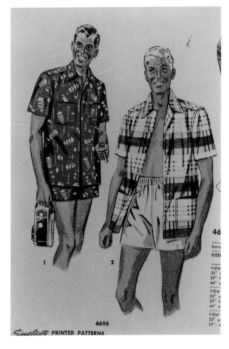

Simplicity #4696, 1954.

Butterick #6658, 1953. *Courtesy of the Butterick Archives.*

6658 — 35c

6658

YARDAGE FOR

MEN'S JACKET: SLIDE FASTENER CLOSING

Small Medium

McCall's #1889, 1954. *Author's collection. Courtesy of The McCall Pattern Company.*

Advance #6733, 1954.

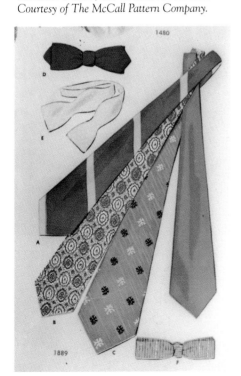

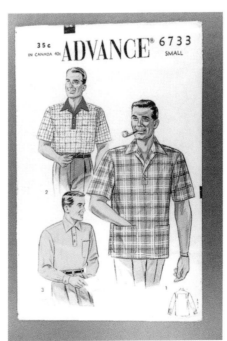

Simplicity #1630, 1956.

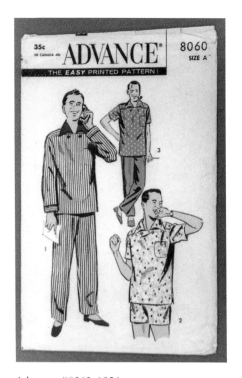

Advance #8060, 1956.

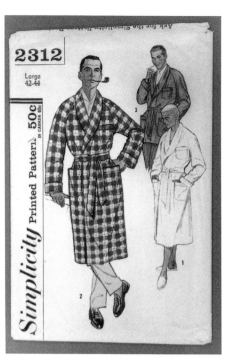

Simplicity #2312, 1957.

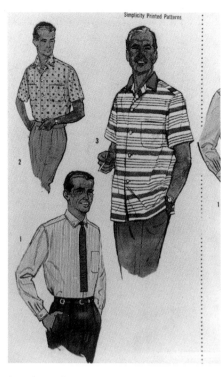

Simplicity #2081, 1957.

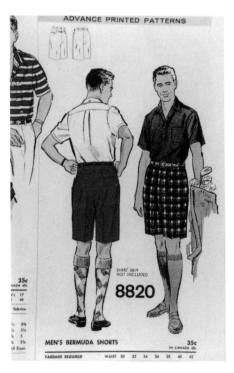

Advance #8820, 1958. *Courtesy of the Irene Lewisohn Costume Reference Library, Metropolitan Museum of Art.*

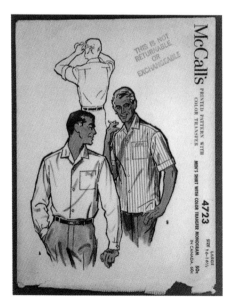

McCall's #4723, 1958. *Author's collection. Courtesy of The McCall Pattern Company.*

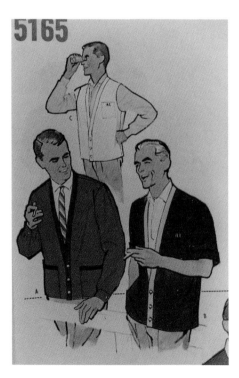

McCall's #5165, 1959. *Author's collection. Courtesy of The McCall Pattern Company.*

ACCESSORIES

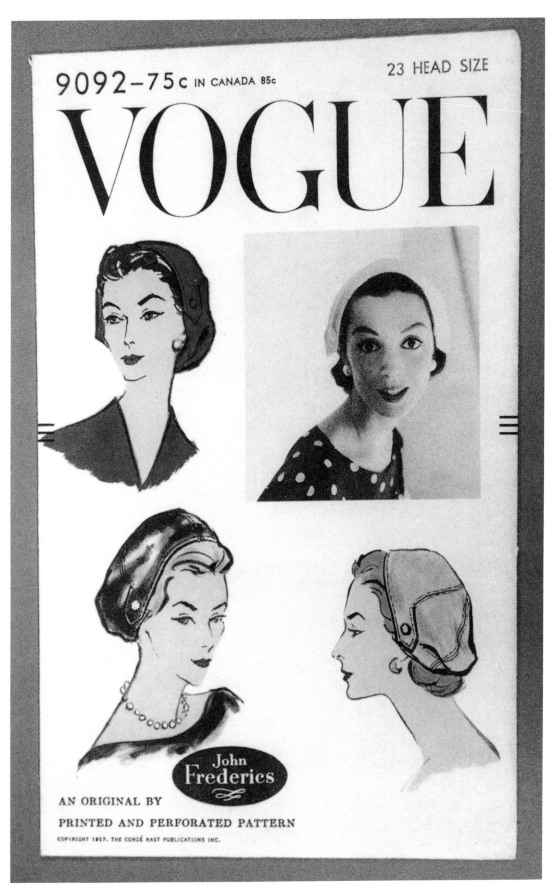

John Frederics for Vogue #9092, 1957.

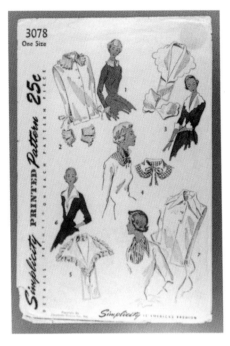

Simplicity #3078, 1950.

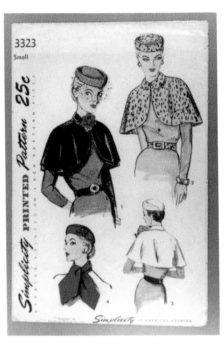

Simplicity #3323, 1950.

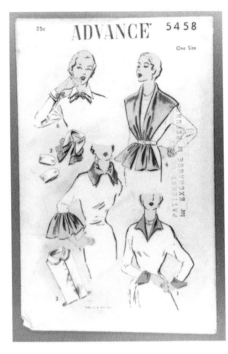

Advance #5458, 1950.

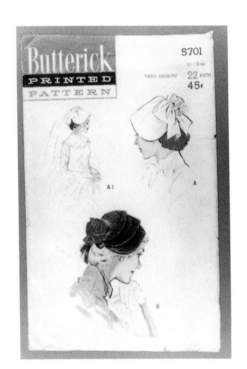

Butterick #5701, 1951.

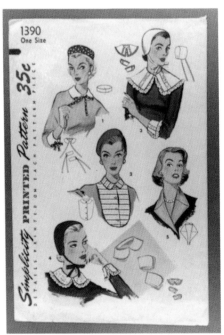

Simplicity #1390, 1955.

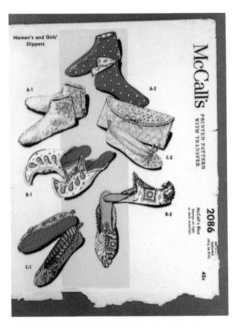

McCall's #2086, 1956. *Author's collection.*
Courtesy of The McCall Pattern Company.

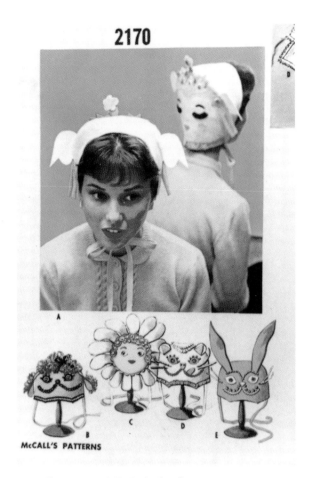

2170

McCALL'S PATTERNS

McCall's #2170, 1957. *Author's collection.*
Courtesy of The McCall Pattern Company.

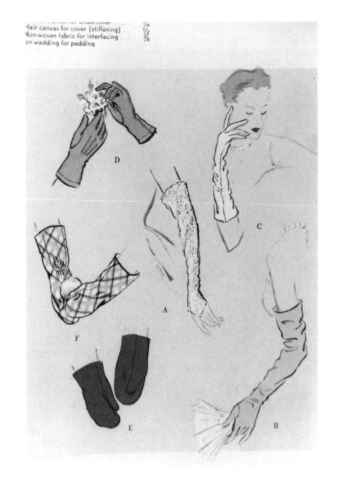

Vogue #9198, 1957.

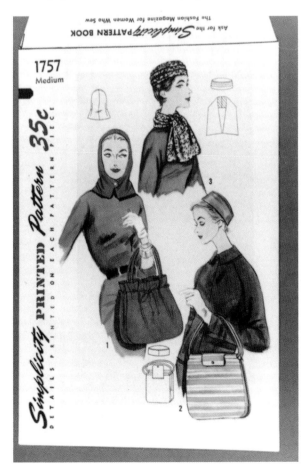

Simplicity #1757, 1956.

Vogue #9576, 1958.

Simplicity #4035, 1952.

Butterick #5516, 1950. *Courtesy of the
Irene Lewisohn Costume Reference Library,
Metropolitan Museum of Art.*

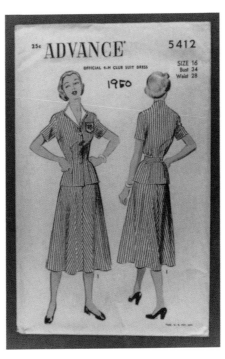

Advance #5412, 1950. *Courtesy of
the Betty Williams Pattern Archives.*

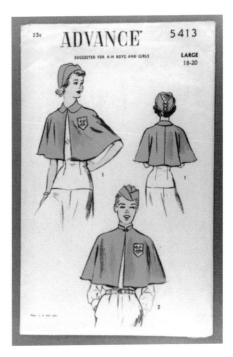

Advance #5413, 1950.

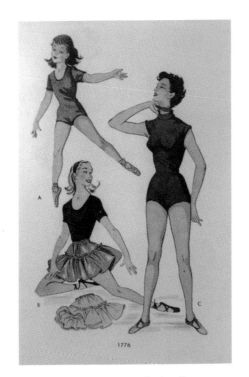

McCall's #1776, 1953. *Author's collection.
Courtesy of The McCall Pattern Company.*

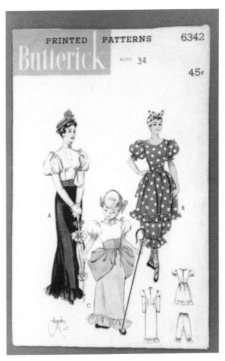

Butterick #6342, 1952.

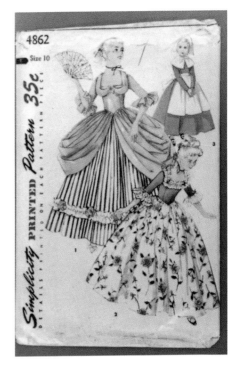

Simplicity #4862, 1954.

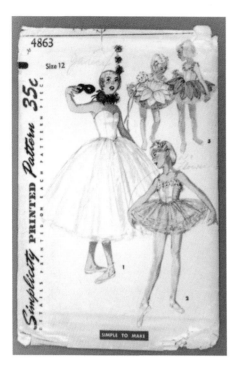

Simplicity #4863, 1954.

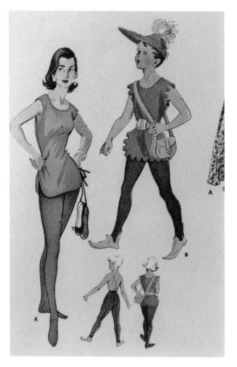

McCall's #9897, 1954. *Author's collection.*
Courtesy of The McCall Pattern Company.

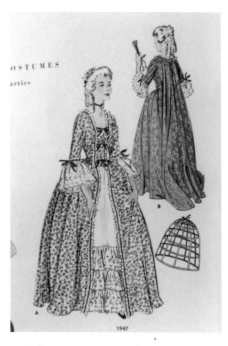

McCall's #1947, 1955. *Author's collection.*
Courtesy of The McCall Pattern Company.

McCall's #1978, 1955. *Author's collection.*
Courtesy of The McCall Pattern Company.

McCall's #1890, 1954. *Author's collection.*
Courtesy of The McCall Pattern Company.

Style approved by Capezio, Famous Makers of
Dance Accessories, McCall's #1951, 1955.
*Author's collection. Courtesy of The McCall
Pattern Company.*

Butterick #7569, 1956.

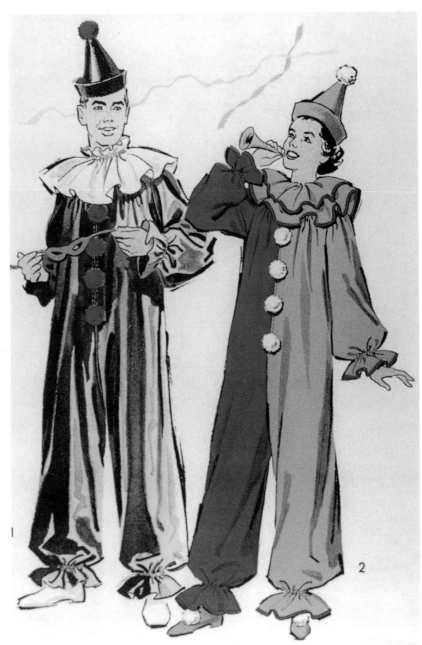

Advance #701, late 1950s.

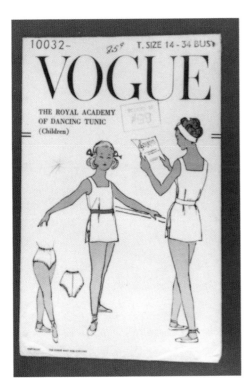

Vogue #10032, 1957.

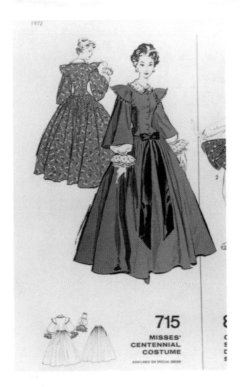

Advance #715, late 1950s. *Courtesy of the Irene Lewisohn Costume Reference Library, Metropolitan Museum of Art.*

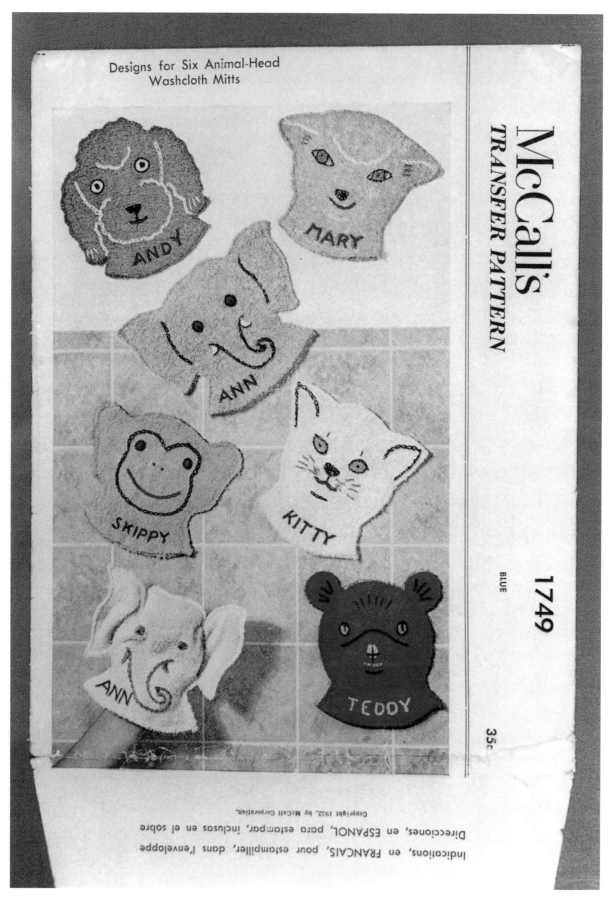

McCall's #1749, 1952. *Author's collection. Courtesy of The McCall Pattern Company.*

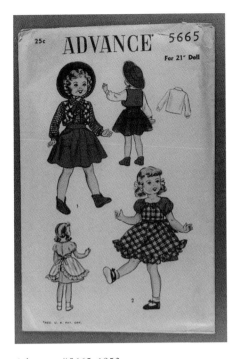

Advance #5665, 1950.

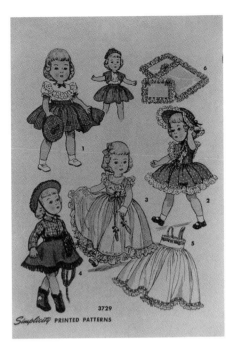

Simplicity #3729, 1951.

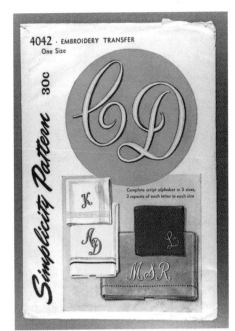

Simplicity #4042, 1952.

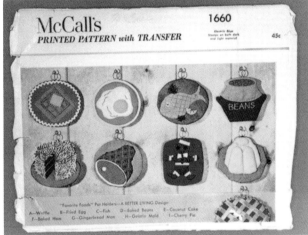

McCall's #1660, 1951. *Author's collection.*
Courtesy of The McCall Pattern Company.

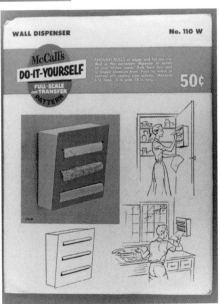

McCall's Do-It-Yourself #110W, 1954.
Courtesy of The McCall Pattern Company.

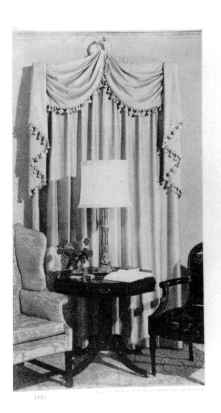

McCall's #1771, 1952. *Courtesy of*
The McCall Pattern Company.

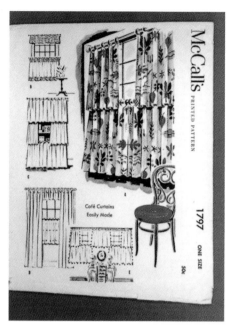

McCall's #1797, 1953. *Author's collection.*
Courtesy of The McCall Pattern Company.

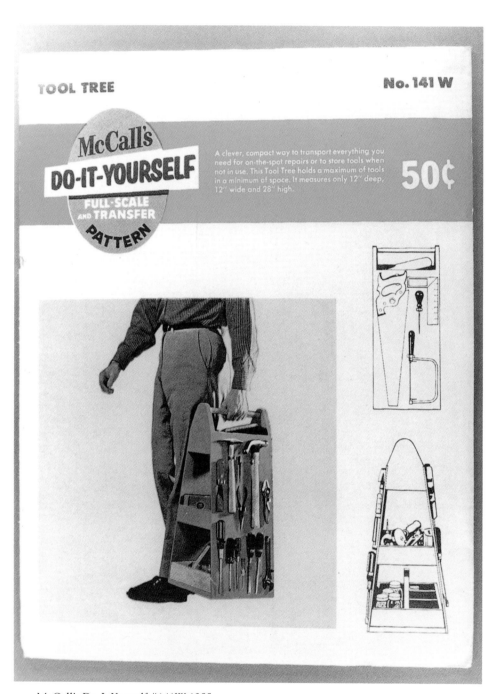

TOOL TREE

No. 141 W

McCall's DO-IT-YOURSELF FULL-SCALE AND TRANSFER PATTERN

A clever, compact way to transport everything you need for on-the-spot repairs or to store tools when not in use. This Tool Tree holds a maximum of tools in a minimum of space. It measures only 12″ deep, 12″ wide and 28″ high.

50¢

McCall's Do-It-Yourself #141W, 1955.
Courtesy of The McCall Pattern Company.

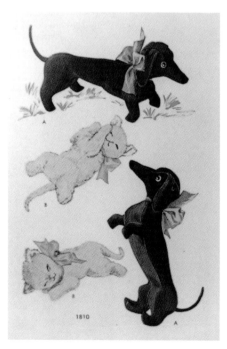

Betsy McCall's dog Nosy. McCall's #1810,
1953. *Author's collection. Courtesy of The*
McCall Pattern Company.

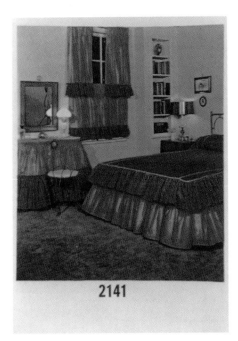

McCall's #2141, 1957. *Author's collection.*
Courtesy of The McCall Pattern Company.

McCall's #2277, 1958. *Author' s*
collection. Courtesy of The McCall
Pattern Company.

Advance #7603 and 7607, late 1950s.
Courtesy of the Irene Lewisohn Costume
Reference Library, Metropolitan Museum of
Art.

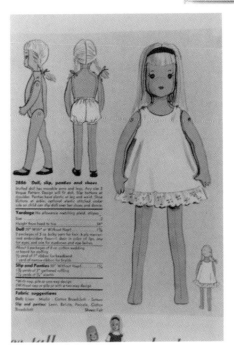

Vogue #2886, 1959.

Simplicity #2745, 1958.

McCall's #2338, 1959. *Author's collection.*
Courtesy of The McCall Pattern Company.

Chapter 6
Archival Information

Conservation

This chapter is intended as a general guide to the options available for conserving your collection. It is not intended to be an in depth study of what is a very technical field. The amount of time, energy, and money expended on collecting should be taken into consideration with regard to the importance of safeguarding and preserving your collection. This can prove to be an expensive proposition, but one that should be considered with great care.

Storage systems are the most important aspect of preventing or minimizing a collection's deterioration, and awareness of the elements that can harm a pattern's longevity will help a collector make informed decisions about housing and storage. These elements include light, temperature, humidity, pollution, and biological attack.

Sunlight, fluorescent light, and incandescent light all produce ultraviolet (UV) rays that can cause irreversible damage to paper. Exposure to light causes paper to discolor and become brittle. Heat and low humidity increase the rate at which chemicals such as acids attack books and cause embrittlement. On the other hand, high humidity can cause the formation of mold, which weakens the fiber components of paper, causes it to discolor, and, in some cases, to stick together. Pollution interacts with the impurities in paper, degrading the components and causing deterioration. Finally, insects and rodents eat paper and adhesives.

Acidity can be another reason for paper's demise, causing a loss of flexibility and brittleness. Acidity is caused by a polluted atmosphere, airborne acids, the manufacturing process, and impurities in the materials. Generally, paper becomes more acidic over time. Another cause of acidity is close association with acidic secondary materials: adhesives, cardboard, acid sizing, unstable plastic sheeting, etc. Acidity migrates from one material to another, especially when in close and prolonged contact.

Improper handling and storage also account for deterioration. Temperature and humidity should be kept as low and uniform as possible. Large fluctuations in either should be avoided, as these can cause swelling and contracting. Areas such as basements and attics, where temperature and humidity levels vary widely, should not be used for long term storage. A cool, dark and dry storage area is ideal.

Storage Systems

Complicated monitoring devices are used in museums and galleries, but for the everyday collector these options are too expensive in most cases. However, deterioration can be slowed with proper handling and storage.

Avoidance of extremes is the most important factor in providing a sound environment for your collection. Proper storage materials provide physical support as well as protection from unstable elements. Materials that are not archivally approved for storage or repairs should not be used. These includes pressure-sensitive tapes, adhesives, rubber bands, paper clips, staples, pins, and self-sticking memorandum notes. In addition, all hazardous materials left by previous owners should immediately be removed from any new acquisitions.

Protective enclosures for the rarest items in your collection will prolong their lives, maintain them in good condition, and insure that they will be less affected by UV light and pollutants. Protective dust jackets made of polyester film help protect books from dust and abrasion. Newspaper clippings can be photocopied on acid-free paper or kept in acid-free folders.

De-acidification solutions can be used to prevent documents, newspaper clippings, and works on non-archival paper from yellowing and deteriorating. These solutions impregnate the paper, neutralizing existing acids and minimizing the effects of future acids. Plastic enclosures allow viewing of the article while reducing damage from handling and protecting it from pollutants. Chemically stable polypropylene and polyethylene are used for a number of storage options that include water-resistant boxes and sleeves. Avoid using products made from polyvinyl chloride (PVC) because it is not chemically stable and could have damaging effects on items stored in it.

Long-term archival protection can be customized to meet the individual requirements of each collection. There are numerous artifact storage systems that give collectors maximum flexibility with varying sizes and shapes. Acid-free corrugated storage boxes are excellent for long term storage of collections. Storage boxes and folders should be comfortably filled, never stuffed.

Finally, in storing a pattern, the three pattern components (envelope, guide sheet, and tissue pattern) should arranged so that the acidity from the guide sheet does not transfer to the pattern envelope. I accomplish this by removing the pattern and guide sheet from the envelope, then sandwiching the pattern tissue between the envelope and the guide sheet, as the tissue seems to be less likely to absorb the acid from the guide sheet.

Cataloging

My pattern collection is cataloged in binders, categorized by company, year, and pattern number. The binders contain photocopies of all pattern envelope fronts in my collection. In addition, I have binders containing assorted copies of others' collections for research purposes. The patterns themselves are stored in the same sequence—company, year, number—which facilitates locating a specific pattern with ease.

Appendix A
Dating

This appendix gives a general outline of the pattern company numbering systems, the high and low number issued each year, and the envelope graphic styles during the 1950s. This information, when used together, can serve as a basic guideline to dating patterns. All three elements are important, because the pattern companies regularly reused pattern numbers. To date a pattern properly, therefore, the pattern needs to be put in the proper context with the company's logo, envelope graphics, and pattern number.

Pattern Line	Year	Low No.	High No.	New No.	Series
Advance	1949	5052	5370		
	1950	5371	5678		
	1951	5679	5996		
	1952	5997	6266		
	1953	6267	6609		
	1954	6610	6939		
	1955	6940	7135*		
	1956	7701	8185**		
	1957	8186	8507		
	1958	8508	8868		
	1959	8869	9242		
	1960	9243	9630		

*skips to 7700
**began printing patterns in 1956

Also note that Advance had a few pattern lines with their own numbering sequences:

• Costumes (unprinted): 700s number series, early 1950s
• Costumes—special order (printed patterns): 700s number series, mid 1950s
• Decorator Series (unprinted): 7500s number series, mid-1940s
• Decorator Series (printed patterns): 7600s number series, mid-1950s
• Import Adaptations: double digit #–100s number series, late 1940s
• Imports: double digit #–100s number series, early to mid-1950s

A 500s number series was also issued, but not enough information has surfaced to accurately date these.

Pattern Line	Year	Low No.	High No.	New No.	Series
Butterick	1949	4739	5117		
	1950	5118	5554*		
	1951	5555	5971		
	1952	5972	6350		
	1953	6351	6765		
	1954	6766	7160		
	1955	7161	7566		
	1956	7567	7979		
	1957	7980	8349		
	1958	8350	8763		
	1959	8764	9157		

* began printing patterns in 1950

Pattern Line	Year	Low No.	High No.	New No.	Series
McCall	1949	7454	7867		
	1950	7876	8335		

McCall's (the 's was added in 1951)

	Year	Low No.	High No.	New No.	Series
	1951	8372	8764		
	1952	8814	9252		
	1953	9267	9640		
	1954	9661	9997	3017	3125
	1955	3126	3504		
	1956	3505	3920		
	1957	3995	4413		
	1958	4430	4866		
	1959	4871	5307		
McCall NeedleWork	1949	1438	1498		
	1950	1521	1585		
	1951	1610	1647		
	1952	1684	1749		
	1953	1781	1827		
	1954	1849	1939		
	1955	1947	2031		
	1956	2075	2123		
	1957	2130	2184		
	1958	2185	2333		
	1959	2334	2368		

McCall's patterns contain a copyright date on the envelope.

	Year	Low No.	High No.	New No.	Series
Simplicity	1949	2689	3043		
	1950	3057	3379		
	1951	3380	3758		
	1952	3759	4136		
	1953	4137	4520		
	1954	4521	4956	1000	1026
	1955	4957	4999	1027	1408
	1956	1409	1865		
	1957	1866	2330		
	1958	2331	2791		
	1959	2792	3296		
	1960	3299	3734		
Simplicity Designer's	1949	8000	8220		
	1950	8221	8332		
	1951	8333	8461		
	1952	8447	8496		

Simplicity Patterns began including a copyright date on the guide sheet in 1943.

Pattern Line	Year	Low No.	High No.	New No.	Series		Pattern Line	Year	Low No.	High No.	New No.	Series
Vogue Regular	1949	6674	6953				Vogue Paris	1949	1050	1081		
	1950	6973	7241				Original Model	1950	1082	1121		
	1951	7248	7555					1951	1122	1161		
	1952	7556	7874					1952	1162	1201		
	1953	7928	8171					1953	1202	1241		
	1954	8176	8481					1954	1258	1281		
	1955	8492	8736					1955	1287	1314		
	1956	8786	9019					1956	1319	1352		
	1957	9025	9347					1957	1354	1391		
	1958	9352	9640					1958	1398	1431		
	1959	9641	9872					1959	1434	1472		
								1960	1473	1494	1000	1023
Vogue	1949	475	533									
Couturier	1950	544	596				Vogue Junior	1949	3261	3324		
	1951	606	656					1950	3333	3392		
	1952	660	719					1951	3398	3445		
	1953	729	778					1952	3452	3498		
	1954	786	833					1953	3504	3547		
	1955	841	885					1954	3553	3591	1500	1571
	1956	889	938*					1955	3601	3625	1515	1547*
	1957	953	998					1956	3636	3641	1551	1566
	1958	999	100	142				1957	1571	1592		
	1959	144	196					1958	1606	1629		
	1960	198	211					1959	1633	1643		

*began including European Designers in 1956

*Junior line replaced by Teen line in 1955

Vogue Patterns included a copyright date on their envelopes from 1950-1958.

Pattern Line	Year	Low No.	High No.	New No.	Series
Vogue Special	1949	S4947	S4998		
	1950	S4000	S4160		
	1951	S4176	S4273		
	1952	4274	S4360		
	1953	S4361	S4464		
	1954	S4481	S4560		
	1955	S4581	S4656		
	1956	S4667	S4742		
	1957	S4749	S4849		
	1958	S4850	S4933	4935	4940
	1959	4957	S4999	4000	4063

Advance #5376, 1950. 8-3/16" x 5-7/16".
Graphic design carried over from the 1940s.

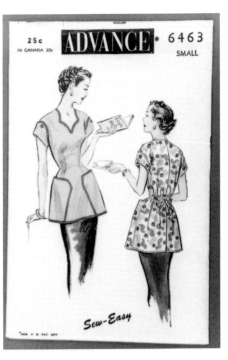

Advance #6463, 1953.
White type in black box.

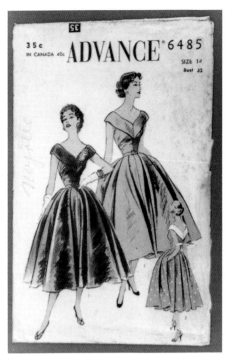

Advance #6485, 1953. Addition
of ® trademark symbol.

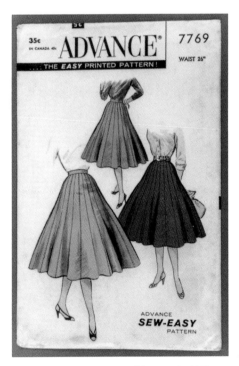

Advance #7769, 1956. Addition of "THE
EASY PRINTED PATTERN!" following
their conversion to printed patterns in 1956.

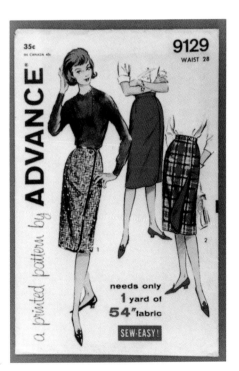

Advance #9129, 1959. New graphic design.

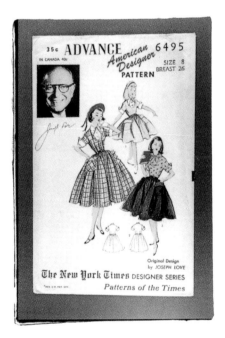

Advance American Designer Pattern by
Joseph Love #6495, 1953. *The New
York Times* Designer Series, Pattern of
the Times. Included designer's signa-
ture. This series began in 1949.

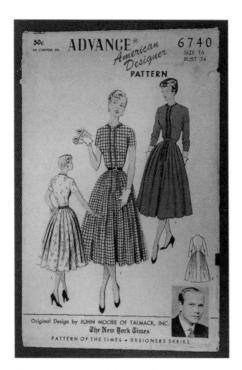

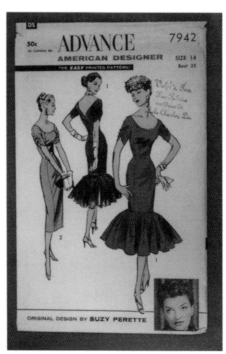

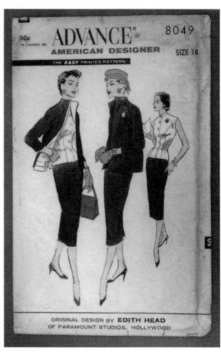

Advance American Designer Pattern by John Moore of Talmack, Inc. #6740, 1954. *The New York Times* Designer Series, Pattern of the Times. New graphic design, reduction of *The Times* logo and elimination of designer's signature.

Advance American Designer by Suzy Perette #7942, 1956. New graphic typeface and the omission of *The New York Times* Designer Series, Pattern of the Times.

Advance American Designer by Edith Head #8049, 1956. Omission of designer's photo.

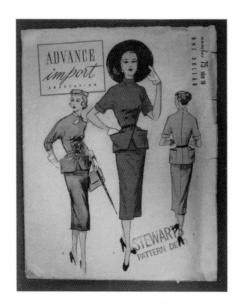

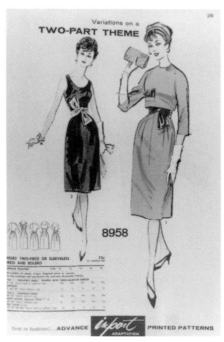

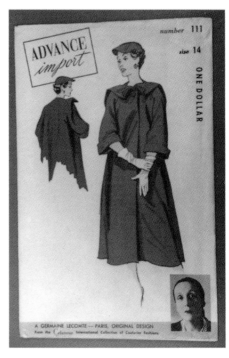

Advance Import Adaptation #75, early 1950s. Larger 8-1/2" x 10-1/2" envelope.

Example of Import Adaptation logo from the late 1950s. Pattern envelopes were reduced to the same size as the regular line, 8-3/16" x 5-7/16".

Advance Import by Germaine Lecomte #111. Not enough information available to date.

Advance #701, late 1940s-early 1950s. Unprinted pattern.

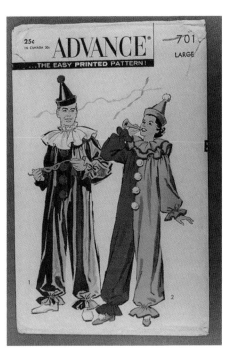

Advance #701, post 1956. Printed pattern.

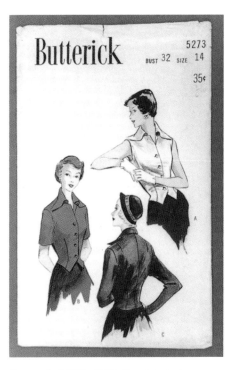

Butterick #5273, 1950. Graphic design carried over from the late 1940s.

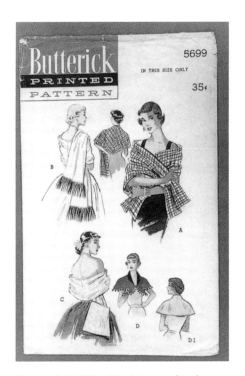

Butterick #5699, 1951. New graphic design for their conversion to printed patterns in 1950.

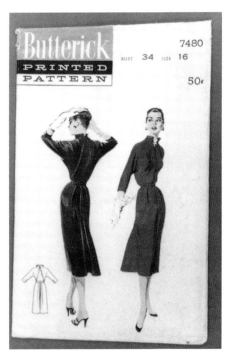

Butterick #7480, 1955. Different packaging colors.

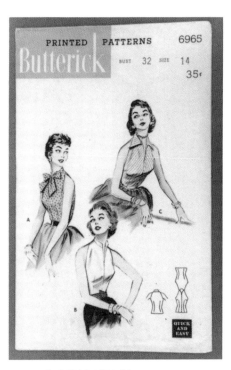

Butterick #6965, 1954. New graphic composition.

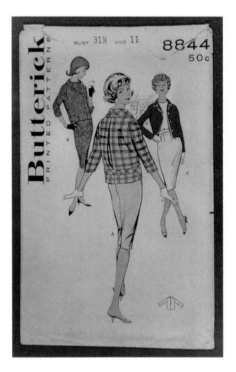

Butterick #8844, 1959. New
typeface and envelope style.

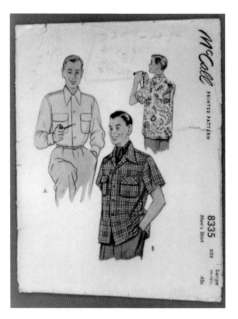

McCall #8335, 1950. Graphic
design carried over from the 1940s.

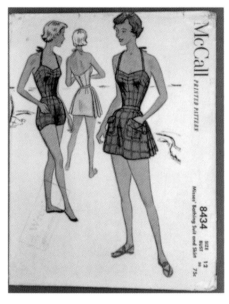

McCall #8434, 1951. New
typeface and graphics.

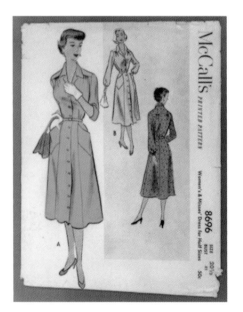

McCall's #8696, 1951. Addition of
's to the company name.

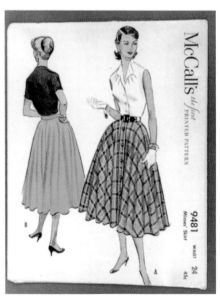

McCall's #9481, 1953. Addition of
the words *the first* with the logo.

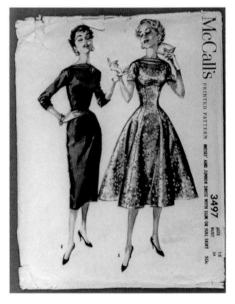

McCall's #3497, 1955. Elimination of
the first and slightly bolder type.

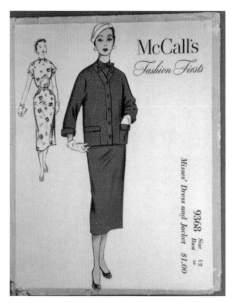

McCall's Fashion Firsts #9368, 1953.
Unique graphic design for this line.

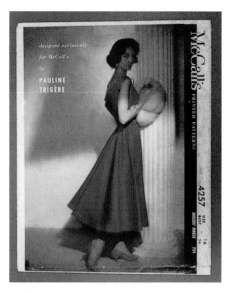

Designed exclusively for McCall's by
Pauline Trigère #4257, 1957. Black and
white border on right side of envelope and
large photograph instead of illustration.

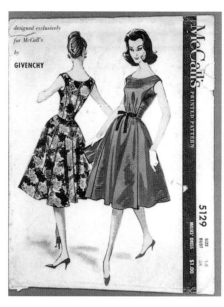

Designed exclusively for McCall's by
Givenchy #5129, 1959. Style shown in
illustration instead of photograph.

McCall #1585, 1950. Needle-
work pattern graphic design
carried over from the late 1940s.

McCall's #1647, 1951. New typeface and
the addition of ' s to the company name.

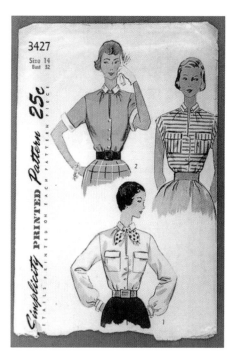

Simplicity #3427, 1951. Graphic
design carried over from the 1940s.

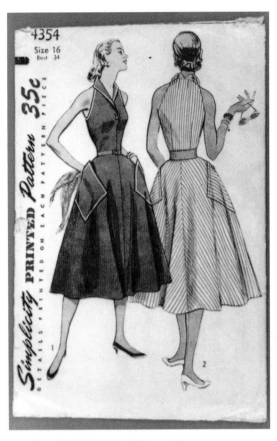

Simplicity #4354, 1953. Addition of
single black bar above 35¢ price.

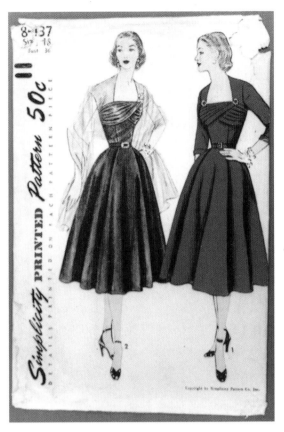

Simplicity #8437, 1951. Addition of
double black bars above 50¢ price.

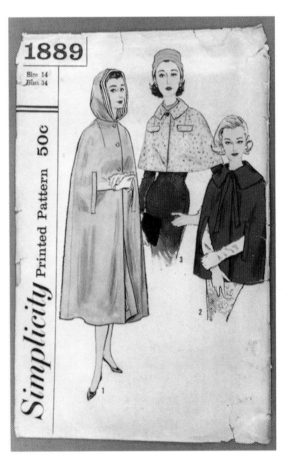

Simplicity #1889, 1957. New
Typeface and graphic design.

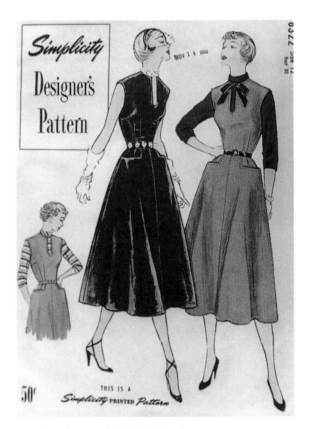

Simplicity Designer's #8322. Graphic
design carried over from the 1940s.

Simplicity Embroidery Transfer
#4042, 1952. Larger type for logo.

Vogue #7175, 1950. Graphic design
carried over from the 1940s.

Vogue #7342, 1951. New serif typeface.

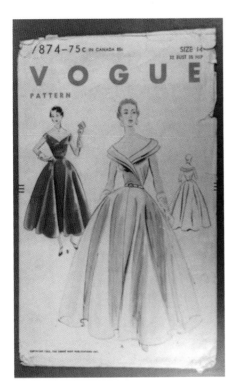

Vogue #7874, 1952. New san
serif typeface and graphic design.

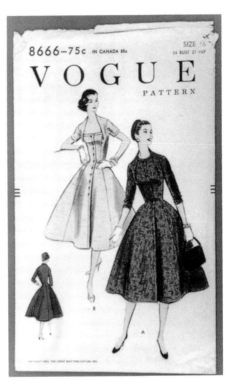

Vogue #8666, 1955. Typeface change.

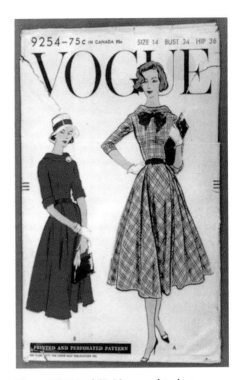

Vogue #9254, 1957. New graphic design
for their conversion to printed patterns.

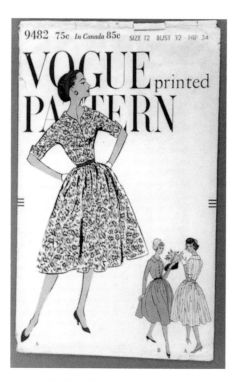

Vogue #9482, 1958. New graphic design.

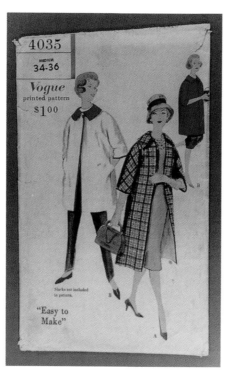

Vogue #4035, 1960s. New graphic design in 1959.

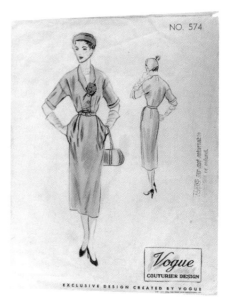

Vogue Couturier Design #574, 1950. Graphic design carried over from the 1940s.

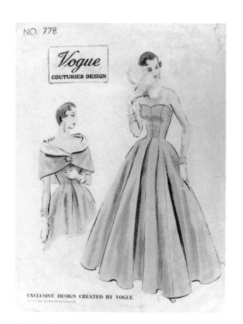

Vogue Couturier Design #778, 1953. Typeface change for *Exclusive design created by Vogue.*

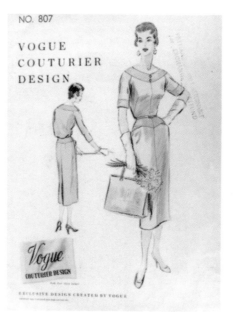

Vogue Couturier Design #807, 1954. Addition of *Vogue Couturier Design* in serif typeface. Label photographed with shadows to add dimension. *Ask for this label* added.

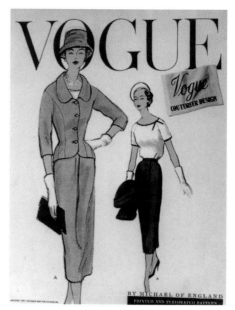

Vogue Couturier Design by Michael Of London, #974, 1957. New graphic design for their conversion to printed patterns.

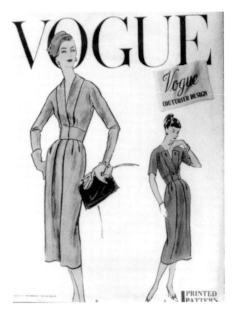

Vogue Couturier Design #989,
1957. Elimination of *perforated*.

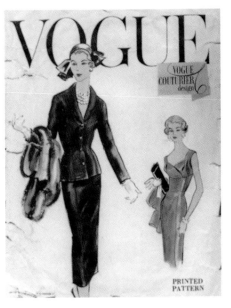

Vogue Couturier Design #981, 1957.
New label design pictured on envelope.

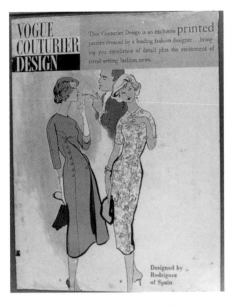

Vogue Couturier Design #107, 1958.
New graphic design for European
designers included in the Couturier line.

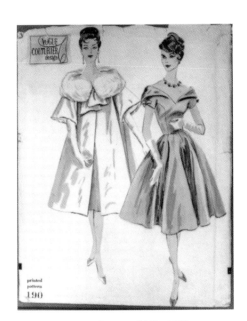

Vogue Couturier Design #190, 1959.
Elimination of the large Vogue logo.

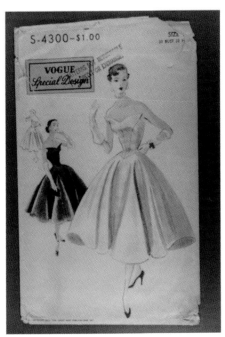

Vogue Special Design #S-4300, 1952.
Graphic design carried over from the 1940s.

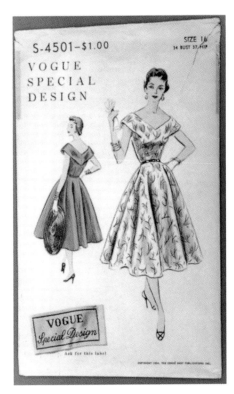

Vogue Special Design #S-4501, 1954.
Addition of *Vogue Special Design* in serif
typeface. Label photographed with shadows
to add dimension. *Ask for this label* added.

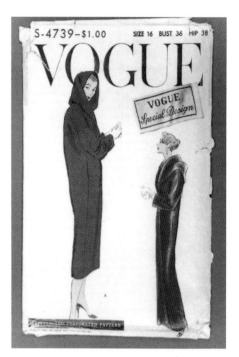

Vogue Special Design #S-4739, 1956. New graphic design for their conversion to printed patterns.

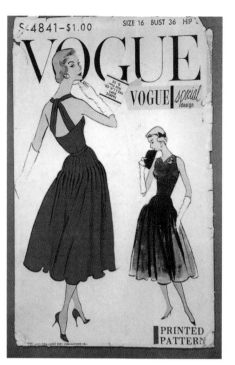

Vogue Special Design #S-4841, 1957. New graphic design for their conversion to printed patterns. New label design pictured on envelope.

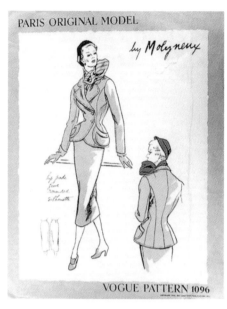

Vogue Paris Original Model by Molyneux #1096, 1950. Graphic design carried over from the 1940s.

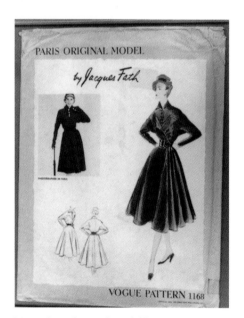

Vogue Paris Original Model by Jacques Fath #1168, 1952. Addition of photo.

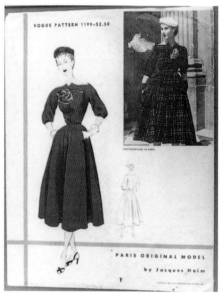

Vogue Paris Original Model by Jacques Heim #1199, 1952. New graphic design.

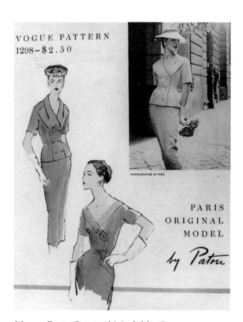

Vogue Paris Original Model by Patou #1298, 1955. New graphic design.

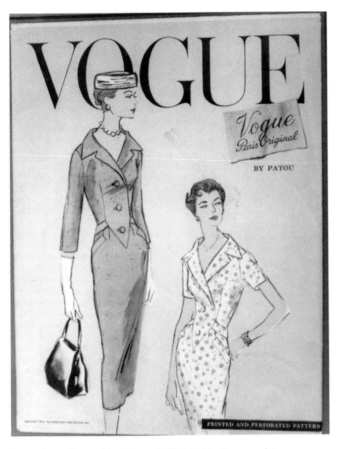

Vogue Paris Original by Patou #1326, 1956. New graphic design for their conversion to printed patterns. Elimination of *Model* from the pattern line name.

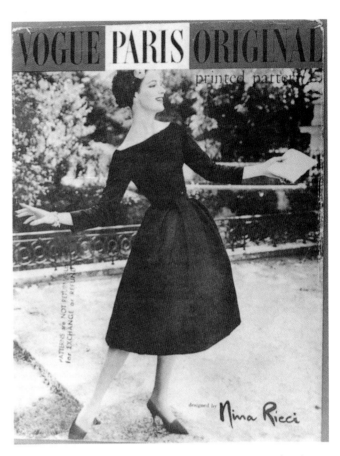

Vogue Paris Original by Nina Ricci #1388, 1957. New graphic design with large photo and red, white and blue color band behind logo.

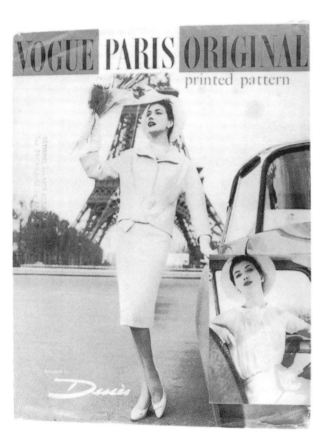

Vogue Paris Original by Dessès #1413, 1958. Reversal of color band to blue, white, red.

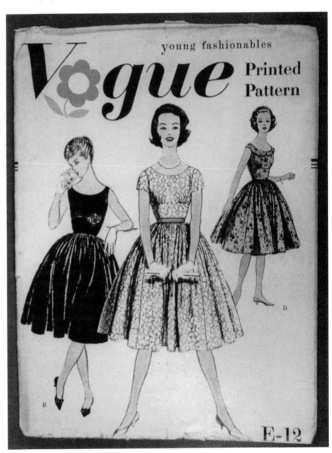

Vogue Young Fashionables #E-12, 1959. Unique graphic design for this line.

Price Guidelines

All prices are based on mint condition, unused patterns. Values vary immensely according to the condition of the item, the location of the market, and the overall quality of the design and manufacture. Condition is always of paramount importance in assigning value. The prices listed in this guide are for individual items that are in mint condition. Prices in the Midwest may differ from those in the West or East, and those at specialty shows may vary from those at general shows. And, of course, being at the right place at the right time can make all the difference.

The value ranges that appear here are derived from compiled sources and were not supplied by the people acknowledged in the credit lines. The ranges were conscientiously determined to reflect the market at the time this work was compiled. No responsibility for their future accuracy is accepted by the author, the publisher, or the people or companies credited with the photographs.

General Patterns
1930s: $10-40
1940s: $4-18
1950s: $2-10

Specialty Patterns
McCall Couturier, 1920s-1930s: $15-25
Vogue Couturier, 1930s-1940s: $25-65
Vogue Couturier, 1950s: $15-30
Vogue Paris Originals, 1949-1950: $35-75
Vogue Paris Originals, 1950s: $15-40
Girl Scout Uniforms, 1930s-1940s: $10-25
4-H Uniforms, 1930s-1940s: $10-15
Licensed Designers, Characters and Celebrities: These prices vary **greatly** depending on the collectibility of the subject.

Counter Books
1930s: $100-150
1940s: $75-150
1950s: $25-50
1960s: $25-45

Pattern Magazines
1930s: $25-50
1940s: $15-30
1950s: $10-20

Pattern Giveaway Catalogs
1930s: $8-12
1940s: $4-8
1950s: $2-4

Sewing Books
1930s-1940s: $5-30
1950s: $3-20

Sewing Booklets/Pamphlets
1930s-1940s: $5-15
1950s: $2-8

Advertising Posters
1930s: $25-40
1940s: $25-40

Dolls
Display manikins with stand: $200-450
Junior Designer manikins: $75-150 (complete set in original box)

Miscellaneous
Vogue woven labels: $4-6
Singer Molded-To-You dress form: $35-85

Endnotes

1. Williams, Betty, "On The Dating of Tissue Paper Patterns," *Cutters' Research Journal*, Vol. II No. 2, Fall 1990.

2. McCall Corporation, "The Woman Who Sews as a Woman of Fashion," 1954. This consumer survey polled 5,523 women from all sections of the United States. The survey showed that the average woman who sewed was a married housewife between the ages of 20 and 39, with one or two children.

Home Sewing Report, *American Fabrics* No. 34, Winter 1954-1955. This very informative 14 page report about the home sewing industry contains statistics throughout, which included: 90,000,000 patterns bought every year; 52,000,000 women and girls in the U.S.A. sew at home; and 25,000 stores in the U.S.A. sell patterns.

3. "Home Sewing Never Had it so Good," *American Fabrics* No. 34, Winter 1954-1955, 79-81.

4. Johnson, Doris, "A New Direction in Clothing Construction," *Journal of Home Economics*, Nov. 1960: 752-753.

5. *The Mary Brooks Picken Method of Modern Dressmaking* (New York: The Pictorial Review Company, 1925), 39.

6. Personal history letter by Edward B. Emory, 1948. *Courtesy of the Butterick Archives*.

7. See note 3, 38.

8. *Otto Kleppner's Advertising Procedure*, Vol. 9, Thomas Russell and Glen Verrill, ed. (Englewood Cliffs, NJ, 1986), 45.

9. Henry Campbell Black et al., *Black's Law Dictionary*, Sixth ed. (St. Paul, MN: West Publishing Co., 1990), 1125.

10. *The New Butterick Dressmaker*, (New York: The Butterick Publishing Co., 1927), 3.

11. United States Patent #1,387,723 for McCall Printed Patterns, Patented Aug. 16, 1921.

12. From a Pictorial Review Pattern envelope from the 1920s.

13. See note 5, 48.

14. See note 11.

15. These claims were printed directly on the tissue paper pieces of a Pictorial Review Pattern from the 1920s.

16. Ruppell, G.A., *The Story Of Butterick* (New York: Butterick Publishing, 1929), parts 3 - 10.

17. Simplicity's early printed patterns look exactly like Pictorial Review's printed patterns and they are printed with the numerous patent numbers attributed to the Excella/Pictorial Review Pattern Companies.

18. *Paris Frocks At Home* (New York: Butterick Publishing,1930), 38.

19. Butterick v. Conde Nast, E 45-47 (S.D.N.Y. 1931) (mem.).

20. Id.

21. Unidentified article, Butterick Archives.

22. An Outline of The Reasons For McCall Pattern Supremacy (New York: McCall Pattern Company, 1927).

23. Id.

24. *Basic Fashion Fall & Winter '56*, Famous Features Syndicate.

25. Id.

26. McCall's advertisement, *Practical Home Economics*, September 1954.

27. *McCall Spirit*, May-June 1954. pg. 5. This article introduced this new feature to the McCall's employees in their company newsletter.

28. *McCall's Pattern Catalog*, August 1960, 525.

29. "The Creative Spark Plug," *American Fabrics* No. 34, Winter 1954-1955, 89-90.

30. "NEA Patterns; Service For Your Readers — Response For Your Newspapers," 4. 1950s sales brochure issued to syndicated newspapers by the Newspaper Enterprise Association..

31. *Basic Fashion Spring & Summer '58*, Famous Features Syndicate.

32. *McCall's Pattern Book*, Summer 1953, 43.

33. "Smart New Styles From McCall's," *McCall Spirit,* March 1952.

34. "Know Your Vogue Patterns," *Conde Nast*, 1953, 5.

35. Id., 4.

36. *Practical Home Economics.*

37. Advance Pattern #7821 guide sheet, Learn to Sew For Children.

38. "What Butterick Means By Quick & Easy," *Butterick Pattern Book*, 1950, 24.

39. "McCall's Makes Sewing Easier," *McCall's Pattern Book*, Fall 1955, 17.

40. Id.

41. See note 34.

42. Vogue Pattern Service Educational Department advertisement, *Journal Of Home Economics*, Sept. 1956, 476.

43. "A New Pattern Is Born," *McCall Spirit*, February 1955.

44. *McCall Spirit*

45. "McCall's Printed Patterns," *Fashion Digest and Fabric News*, November, 1958, 13.

46. See note 29.

47. See note 29.

48. "American Designers," *Practical Home Economics*, 1952.

49. Pope, Virginia, "Smartness Marks Pattern For Toga: Design by Bonnie Cashin Is Offered as First in Series to Be Shown Monthly," *The New York Times*, Monday, April 3, 1950, 26. The pattern featured was Advance #5557.

50. "Paul Poiret Praises McCall Printed Pattern; Creates Two Designs for 'Faultless Pattern,'" *McCall's Ad-Sheet*, April 1923.

51. See Betty Williams' article about her discoveries concerning licensed patterns, "1920s Couture Patterns and the Home Sewer," published in *Cutters' Research Journal*, Vol. VI No. 4, Spring 1995, 1, 6-7, 11-12.

52. Howard, Toni, "High Fashion for Housewives," *The Saturday Evening Post*, 1962, 34-37.

53. Id.

54. Id.

55. *This Fabulous Century, 1950-1960*, Vol. VI, (New York: Time-Life Books, 1970), 197.

56. The Modéle Parisien Pattern line was most likely a specialty line issued by Excella/Pictorial Review Pattern Company. This line was a monthly feature in *Pictorial Review Magazine*, and it seems unlikely that Pictorial Review Pattern Company would publicize a competing pattern company in any of their publications.

57. See note 34, 1.

58. McCall's Ad-Sheet, August 1923, pg. 4.

59. "Why? When a woman gets a notion to sew, 8 times out of 10 you'll sell her Coats & Clark's," sales brochure from the mid 1960s.

60. Davis, Emily C., "TV—a new world to explore," *Practical Home Economics*, March 1951, 119.

61. "A Statement by the Publisher," *McCall's Pattern Book,* Spring 1956, 56.

62. See note 2.

63. McCall's Basic Teaching Pattern envelope, 1953.

64. Vogue Young Fashionables Pattern advertisement, *Journal Of Home Economics*, September, 1956, 476-477.

65. See note 29.

66. *Butterick Bulletin*, Published For And By The Butterick Company, July-August, 1958. Vol. 5 No. 6, 1.

67. Bogart, Max, "Merchandising Those Tricky Transitionals," *McCall's Piece Goods, Yarn & Notions Merchandiser*, April May 1961.

68. See note 3.

Bibliography

Books and Articles

Brooks Picken, Mary. *The Mary Brooks Picken Method of Modern Dressmaking.* New York: The Pictorial Review Company, 1925.

The Butterick Publishing Company. *The Dressmaker, Second Edition.* New York: The Butterick Publishing Company, 1916.

The Butterick Publishing Company. *The New Butterick Dressmaker.* New York: The Butterick Publishing Company, 1927.

Clapp, Anne F. *Curatorial Care of Works of Art on Paper.* New York: Nick Lyons Books, 1987.

Greenfield, Jane. *The Care of Fine Books.* New York: Nick Lyons Books, 1988.

Kleppner, Otto, ed., Thomas Russell, and Glen Verrill, *Otto Kleppner's Advertising Procedure,* Vol. 9, Englewood Cliffs, NJ: Prentice-Hall, 1986.

McCall's Pattern Company. *The Handbook of Piece Goods Merchandising.* New York, McCall's Pattern Company, 1970.

Ruppell, G. A. *Butterick In Chicago.* Unpublished paper.

——. *The Story of Butterick.* New York: Butterick Publishing, 1929.

Tucker, Philip W. *Recollections Of My Forty Years With Butterick.* Unpublished paper, 1960s.

Williams, Betty. "1920s Couture Patterns and the Home Sewer." *Cutters' Research Journal* Vol. VI No. 4, Spring 1995. United States Institute For Theatre Technology.

——. "On The Dating of Tissue Paper Patterns: Part One." *Cutters' Research Journal* Vol. II No. 2, Fall 1990. United States Institute For Theatre Technology.

——. "On The Dating of Tissue Paper Patterns: Part Two." *Cutters' Research Journal* Vol. II No. 3, Winter 1990. United States Institute For Theatre Technology.

Periodicals and Catalogs

Advance Fashion News, 1950s.
Advance Pattern Book, 1950s.
American Fabrics, 1950s.
Butterick Pattern Book, 1950s.
Butterick Printed Patterns, 1950s.
The Journal of Home Economics, 1949-1960.
McCall Ad-Sheet, 1920s-1930s.
McCall's Pattern Book/Pattern Fashions, 1950s.
McCall's Style News/Fashion Digest, 1950s.
The New York Times, 1950s.
Penney's Fashions and Fabrics, 1951.
Practical Home Economics, 1950s.
Simplicity Fashion Prevue, 1950s.
Smart Sewing, 1950s.
Vogue Pattern Book, 1950s.
Women's Wear Daily, 1950s.
Assorted company counter catalogs.

Archive Resources

Butterick Archives, New York, New York.
Fashion Institute of Technology Special Collections, New York, New York.
Irene Lewisohn Costume Reference Library, The Metropolitan Museum of Art, New York, New York.
The McCall Pattern Company Archives, New York, New York.
National Museum of American History, Washington, D.C.
The New York Public Library, New York, New York.
Teachers College Special Collections, New York, New York.
The Betty Williams Pattern Archives, University of Rhode Island, Kingston, Rhode Island.